Nonfiction Sound and Story for Film and Video

This book guides nonfiction storytellers in the art of creatively and strategically using sound to engage their audience and bring stories to life.

Sound is half of film and video storytelling, and yet its importance is often overlooked until a post-production emergency arises. Written by two experienced creators—one a seasoned nonfiction producer/director with a background in music, and one a sound designer who owns a well-regarded mix studio—this book teaches nonfiction producers, filmmakers, and branded content creators how to reimagine their storytelling by improving sound workflow from field to post. In addition to real-world examples from the authors' own experiences, interviews with and examples from industry professionals across many genres of nonfiction production are included throughout.

Written in a conversational style, the book pinpoints practical topics and considerations like 360 video and viewer accessibility. As such, it is a vital point of reference for all nonfiction filmmakers, directors, and producers, or anyone wanting to learn how to improve their storytelling.

An accompanying Companion Website offers listening exercises, production sound layout diagrams, templates, and other resources.

Amy DeLouise is an experienced nonfiction digital storyteller and video director/producer. With more than 400 productions to her credit, Amy is a leader in the field of short form digital storytelling for large surfaces at live events as well as small screens for mobile, web, and social platforms. Amy is a sought-after speaker at international media conferences and teaches popular online courses on LinkedIn Learning. She is the author of *The Producer's Playbook: Real People on Camera* (Routledge, 2016). For more resources and tips from Amy, visit her website at www.amydelouise.com.

Cheryl Ottenritter, senior mixer and founder of Ott House Audio, has over twenty years of audio experience. Cheryl has worked on projects for PBS, National Geographic, Smithsonian Channel, TV One, and Discovery Channel; has mixed for Dolby Atmos® theatrical delivery; and has been part of the 360 and VR revolution, mastering the latest from tetrahedral, binaural, and ambisonic sources. Over the past two decades, Cheryl has been making a name for herself in the industry and has been featured in tech podcasts, in publications, and keynotes at prestigious events like NAB Show, Editors Retreat, and GV Expo. Learn more at www.otthouseaudio.com

Nonfiction Sound and Story for Film and Video

A Practical Guide for Filmmakers and Digital Content Creators

Amy DeLouise & Cheryl Ottenritter

Routledge
Taylor & Francis Group

NEW YORK AND LONDON

First published 2020
by Routledge
52 Vanderbilt Avenue, New York, NY 10017

and by Routledge
2 Park Square, Milton Park, Abingdon, Oxon, OX14 4RN

Routledge is an imprint of the Taylor & Francis Group, an informa business

Library of Congress Cataloging-in-Publication Data
A catalog record for this title has been requested

ISBN: 978-1-138-34308-5 (hbk)
ISBN: 978-1-138-34309-2 (pbk)
ISBN: 978-0-429-43938-4 (ebk)

Typeset in Warnock Pro
by codeMantra

Visit the companion website: www.routledge.com/cw/delouise

Contents

Preface by Jeff I. Greenberg

I wish this book existed when I was in film school.

Or when I started in production.

Or when I worked on documentaries and narrative works.

Or the most recent gig I was on.

This book puts into concrete concepts, *the marriage of sound and story*. It talks about the theory and the practical not just to get sound right, but to make it serve your creative work.

When something is wrong with the sound, the audience knows it, regardless of their fluency in production. Up until now, nobody has created a guide explaining how sound relates to story and how to handle the sound well and *with authenticity*.

What you hold in your hands is a rare chance to become a better storyteller. By understanding and planning the sound that sells your stories at every level.

If you're a creative beginning the journey, every chapter is a gem. You'll gain insights on how to do the job right the first time. How to properly plan a story and the sound that goes with it. How to get good location sound. Narration that feels right.

When should you prefer a boom over a lav? How can pre-interviewing a film's subject help you focus on the quality of your sound and stay true to your story?

There's a great focus on mixing beyond simply adding music. How do you use sound—*including silence*—to add emphasis? And grabbing the audience's attention with "Red Umbrella moments."

If you're an experienced creative, each chapter has moments that will either reinforce good practices or point out where you might have a gap in your knowledge base.

The authors answer questions about budgeting for sound, both in time and money. And they include a cutting edge chapter on the newest sound technology for immersive sound and how it can better serve story. The specifics in the music licensing chapter make it a must-read.

We can't be experts at everything. Here's your chance to vault your knowledge ahead by mining the expertise of these two industry-leading creatives. Each chapter addresses important technical issues, storytelling ideas, and how they're intertwined.

From preproduction to on set; from studio narration to post, this book has you covered. I envy the journey you're about to undertake.

Go tell great stories.

Jeff I. Greenberg
Author, Post Consultant, *Storyteller*
J Greenberg Consulting

Introduction

Sound is a critical element of film and video storytelling. Location sound, dialogue, narration, music, and sound effects all contribute to the impact of a production. And yet the importance of sound is often overlooked until an emergency arises, usually in the edit room. We think that can change. Cheryl and I are fervent believers in preparation being an important part of the creative process in our work in short- and long-form nonfiction. It is our hope that *Nonfiction Sound and Story for Film and Video* offers you a guide to better storytelling through sound. This book offers our perspective as two experienced content creators. We are proud to be part of a global community of nonfiction filmmakers who create millions of pieces of short- and long-form content every year for broadcast, cable, YouTube, museums and exhibitions, live events, and websites.

We'll take this opportunity to introduce ourselves and how we came to this moment of sharing our sound and story journey with you. Cheryl is a sound designer and rerecording mixer who owns a well-regarded audio studio in the Washington, D.C. area, where she does sound design and mixing for nonfiction projects designed for every distribution platform, from broadcast and mobile to immersive installations. As a double music major at Auburn University, Cheryl started out as a composition major and then discovered audio engineering as the means to marry her scores to picture. That was the moment she realized sound design was her destiny. She got her break in the machine room of a major D.C. area post-production facility, then spent four years in New York City working on national spots. She moved back to Washington, D.C. to raise a family and there opened her own audio studio in 2006. Ott House Audio is now one of the premiere audio mixing and mastering studios in the mid-Atlantic region. Cheryl has mixed projects for PBS, National Geographic, Smithsonian Channel, TV One, and the Discovery Channel, as well as many productions for Dolby Atmos® delivery. She is very much a pioneer, being the first to implement the tools for the Dolby Atmos® Near Field Home Theater Renderer. Cheryl has been on the leading edge of the 360 and VR revolution, mastering the latest audio formats from tetrahedral, binaural, and ambisonic sources. Never one to be tied to one

medium, Cheryl has also worked on interactive film and unique installations for museums across the United States.

Amy is a seasoned nonfiction producer/director who specializes in biographical and social impact storytelling. Amy is a violinist, singer, and choral director, and has been called a "professional caliber musician" by many in the performance field. She began her musical education in elementary school, where she was trained in the Carl Orff method and soon began violin lessons. She continues to play violin today, and is currently the co-concert master of the NIH Philharmonia, a highly regarded civic orchestra performing an ambitious annual five-concert season. Amy got her B.A. from Yale University, where she majored in English while continuing her music studies, performing in instrumental ensembles such as the Yale Symphony Orchestra as well as singing jazz with one of Yale's acclaimed a cappella groups. She continues to perform a cappella and also directs a children's choir at her church. Amy discovered her love of nonfiction storytelling on an early job with a broadcast production company and then learned the ropes on a variety of commercials, documentaries, and Hollywood feature films. While working as a production assistant in the location department on *JFK (1991)*, and with the art departments of *Forrest Gump (1994)*, *Nixon (1995)*, *People vs Larry Flynt (1996)*, and *Primary Colors* (1998), she delved into historical records, reinforcing her love of nonfiction subjects and archival sources, including sound. Meanwhile, she used her writing skills to break into nonfiction scriptwriting, which soon led to directing and producing work. Amy ran an award-winning production company in the Washington, D.C. area for 15 years. After the birth of her second child, she launched her current media business, DeLouise Enterprises LLC, which produces multi-platform videos and provides video production workshops and consulting. Amy continues to use her music skills in every production she directs, with a focus on the importance of layered sound storytelling, sound design, and music scoring.

In researching our project, we found that most of the books now in the market address two areas: sound design for fiction/narrative film and techniques and tools for field sound recording, primarily geared towards those interested in working as audio professionals in Hollywood or on indie narrative films. There is a gap we intend to fill with this book: for documentarians and other nonfiction producers who want to make a greater impact using sound as part of their creative storytelling palette. Our goal, quite simply, is that *Sound & Story* becomes a real-world tool for producers and

filmmakers needing a boost to their creative thinking about how sound informs story. We also offer practical strategies on how to build soundscapes, improve sound workflow from field to post, manage audio rights, and step into the world of immersive sound. We have included many stories from the field, tips at the end of every chapter to keep you focused, and interviews with experts across the industry. And we have designed some sound samples for you to hear on the website. We hope *Nonfiction Sound and Story* will become your handy pocket guide as you explore the ever-expanding universe of nonfiction storytelling and harness the power of sound in bringing your stories to life.

Acknowledgements

We couldn't have written this book without the input of many friends and colleagues, and the support of our families and colleagues. We would like to thank Bailey Allmon, who worked as Cheryl's intern at Ott House Audio before going on to her new career, and who helped us organize images and review early drafts for typos and other writing misfortunes. Cheryl would like to thank Greg Lukens for giving some of her technical chapters an early read for accuracy, and for his continued mentorship, spanning many years. And we're both so appreciative of the detailed review given by Korey Pereira, Lecturer at The University of Texas at Austin and active member of M.P.S.E (Motion Picture Sound Editors) for his input at the peer review phase, and for the careful read and feedback from audio engineer/producer Dave Dysart. We appreciate the hard work of our team at Taylor & Francis, including Editorial Assistant John Makowski, our diligent copy editor Jennifer Collins, our production manager Jeanine Furino, production editor Helen Evans, and our Editor Emma Tyce. We would also like to thank the many colleagues we interviewed, both on the record and on background, who spent time discussing with us their views of the art of sound and story. Your insights and expertise were essential to our project.

Cheryl and I have been lucky enough to give workshops all around the world, and one of the colleagues who often shares the dais with us (so to speak) is Jeff I. Greenberg, who kindly took the time to write the Preface for this book. Thank you, Jeff, not only for supporting our project but for your contributions to the production field and the people in it. We also could not have done this without support on visuals from Scott Simmons and David Fuchs. Many thanks to you for your fast turnarounds and high-quality work.

One thing we both know for sure: you can't live the crazy production life without the support of a great partner. Thanks to Amy's husband John Bader and Cheryl's husband John Ottenritter. You appreciate the importance of music and sound in our lives and are the foundation that lets us do our thing.

1

Sound Basics

Sound is essential to storytelling. Good sound propels us through a narrative, triggering certain emotions, reminding us of themes, and helping us recall information. Along with the visuals, sound creates a satisfying film experience in both fiction and nonfiction stories. When the sound isn't right, we know it. The wrong music can ruin the mood for a scene. An interview that echoes becomes distracting if we can't see a large space in the shot to justify the echo. A soundtrack with too prominent a drum track intrudes on important words in an interview. In each of these instances, the story is disrupted, rather than supported, by sound. By contrast, when sound "works," we often don't notice it. We laugh, we cry, we absorb important information—all without realizing the role that sound has played in making us respond. So, what is it about sound that makes us either jump further into the story or get pulled away from it? What are the components of sound that are essential to storytelling? In this chapter, we will demystify some of the physics of sound and explain some resulting principles and best practices that you can apply to your sound production, editing, and mix. Whether you are working as a solo storyteller or collaborating with a large production team, this basic knowledge of sound will help you improve your media making and ensure that audio is a strong part of your work.

SOUND WAVES

Let's start off with the sound wave. Sound is created by vibrations caused by pressure and release in the medium that surrounds it. These compressions and rarefactions can cause movement through air, plasma, liquid, or even solids, though typically it is air. This repetitive action of compression and rarefaction forms a pattern that is called sound waves. In the field, we record sound waves from two main sources: "sync" sound—those sounds that are synchronized with picture, including dialogue—and "wild" sounds—those audio elements we record independently of picture. We then take those sounds and convert them from the analog world in which we listen and live to the digital realm in which we produce our films. Though analog recordings can still be made, today digital recording is the norm. In post, we mix those gathered sound waves together, often weaving them with other already-recorded sounds, such as music and sound effects. During playback, the digital sound files are converted back from data to analog, which is the way the sound waves arrive at our ears. The result is a story you watch and hear, hopefully without noticing our handiwork (Figure 1.1).

What's interesting is that we often don't think of sound in physical terms. But these waves really do have a physical presence, just one we can't see. For example, low frequencies have very long sound waves. At 50 Hz, the sound wave is over 22 feet long. Imagine four refrigerators stacked on each other end to end. No wonder low frequencies can travel further. And no wonder they build up in small rooms. But we'll get to that in our production chapter. For now, just imagine all of the sound waves surrounding you and bouncing off of you in every space in which you move.

FIGURE 1.1 Graphic of compressions and rarefactions of a waveform.

FREQUENCY OR PITCH

Pitch is almost entirely determined by the frequency of a sound wave, essentially the speed at which it travels. In the International System of Units (SI), one cycle per second of frequency is called one Hertz, named after the person who discovered electromagnetic waves, Heinrich Rudolf Hertz. A sound that is 20 cycles per second is 20 Hz. One that is 4000 cycles is often referred to 4 kilohertz, or 4k. (Note that this has nothing to do with 4K footage, which has to do with pixels.) When you are making a recording, you need to know that any vibrating object creates sound. Wherever you are filming, there are many other frequencies flying around besides what you are focused on recording. They might complement the primary sound you are recording. Or they might compete with it. Understanding what kind of frequencies you are trying to isolate can help you with microphone placement. For example, since low frequencies travel further than high ones, it is easier to hear a male with a low booming voice than a small child with a higher voice (unless it's your kid, in which case you could pick that sound out of a lineup anywhere; Figure 1.2).

Every sound also has overtones, undertones, and harmonics beyond the fundamental frequency. Overtones add depth and range to the sound being recorded. When you record, you want to minimize the amount of change to all of these frequencies. This is especially true with the human voice, with its many overtones and undertones. Because the human voice has such a wide frequency range, and is very complex, you can really negatively impact the voice by manipulating frequencies too much when you are recording in the field. We will address all this later in Chapter 4 on location sound.

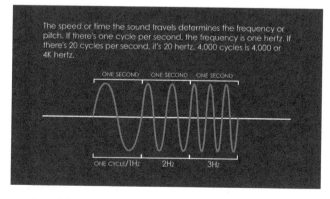

FIGURE 1.2 Graphic of sound wave over time depicting pitch.

What this also means for the video storyteller or filmmaker is that there are sounds beyond your primary audio that can interfere with your recording. Be aware of the sound around you. To do this, we recommend always using professional headphones (not earbuds) when recording sound. You will hear sounds much more clearly through headphones. You'll be able to place your microphone slightly differently for clearer primary sound, or understand before it's too late just how distracting a particular sound in the background will be to your primary audio. It's always better to rid your location of the noise—shut down that humming air conditioning unit, move the snuffling dog—rather than fix it in post. Or avoid interrupting frequencies altogether by using our sound scouting tips. But when you can't avoid competing sound waves, you do have options (which we'll address later) for minimizing or eliminating some disturbing frequencies in either production or post.

AMPLITUDE

Amplitude is the measure of energy of a sound wave. It is measured from the top to the bottom of the sound wave. The more energy or amplitude, the louder the sound and the further it travels. If you open the door to a night club on a Saturday night, chances are good that you will physically feel those powerful waves of sound washing over you. The pressure you feel and hear is measured in SPL, or Sound Pressure Level. Distance is also key in measuring SPL. For instance, a vacuum cleaner is loud at 70 SPL just a little over a yard away. A jet plane is 140 SPL at 54.5 yards away. Last summer, I measured the SPL around our community pool with my handy analog SPL meter to determine how loud our swim meets were from various distances, including the house of a person who complained these gatherings violated a local noise ordinance. Let's just say there was a lot of sound energy, but no laws were violated.

Amplitude is measured in decibels, or "dBs" for short. Sound engineers like me often think of dBs as "clicks" or small levels of adjustments: "bring that music down two dBs" or "bring that sound effects track up a click (or one dB)." By the way, like the Hertz, the decibel is another term in audio that gets its name from an important inventor. In this case, the "bel" refers to Alexander Graham Bell, who studied how sound travels, invented the telephone, and helped launch the audio engineering field with his pioneering work (Figure 1.3).

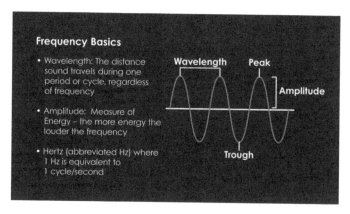

FIGURE 1.3 Sound wave showing amplitude, pointing out crest and trough.

MEASURING AUDIO

If you want to be precise, there are many ways to actually measure dBs. One of the most common is dBFS, which is the Decibel Full Scale used in digital audio systems. The dBFS is sample based and, in digital audio, has a top level of zero. In analog, there is actually sound beyond the top of the scale, or over zero. But we'll stick with digital for now. Digital audio that hits zero will distort. When recording, it's best to stick around −10 to −12 dBFS to give plenty of headroom. Final delivery levels can vary from −10 to −6 dBFS.

Another way to measure audio is Decibel True Peak (dBTP). dBTP refers to the inter-sample peaks that can be created during the conversion back from digital into analog and is a measurement used predominantly in broadcast media. However, we are seeing this specification now in online media delivery, too.

Yet another way to measure sound is LKFS or Loudness, which is K-weighted relative to Full Scale. Like SPL, it measures loudness but is an average measurement of volume over a period of time. Used heavily in broadcast to provide consistent volumes from program to program and commercials, this method is becoming the standard for mixing for all platforms. Broadcasters' specifications vary, but a target of −24 LKFS and −2 dBTP is pretty normal. We'll discuss this more in Chapter 7 on audio post-production.

SAMPLE RATE AND BIT DEPTH

During a recent house- and office-moving project, I found some old cassette tapes in a box from my father. My teenage daughter had no idea what they were, or even that sound was recorded on analog tape before the advent of digital audio; and vinyl was something cool DJs did. She has only seen me record and playback to and from a computer. This process actually converts the analog sound wave into a digital signal. Converting analog audio into digital is a process where the ADC (analog to digital converter) gathers information by sampling or taking a snapshot of the sound waves in equally spaced slices. This creates points carrying frequency and amplitude information. The information between the points is drawn in to finish the wave. The higher the sample rate the more points of data to connect the sound wave, the better the sound. Anytime there is sound recorded that goes digital, there is an ADC. Converters can be standalone, in recording interfaces or mixers, and even microphones.

Keep in mind that the sample rate and bit depth of digital audio have everything to do with soundwaves, their frequencies, and their amplitudes. The number of snapshots taken when sampling is called "sample rate." Sample rate is measured in cycles per second. To get an accurate sample of a sound, the sample rate needs to be twice the highest frequency it is trying to capture. The standard sample rate for CDs is 44.1K, and digital audio without video is based on this. The original developers of digital audio took the range of human hearing, 20 Hz to 20 kHz, when considering sample rate.

To capture 20 kHz, a minimum of 40 thousand (40K) samples are required. But we actually don't use 40K. Instead, we use 44.1K as the standard. If you want a little back story on that, here it is. The content for the first CDs was actually delivered to the mastering and duplicating plant via Sony Umatic ¾-in tapes. Yes, tapes. 44.1K allowed digital audio to be delivered for tape machines in both PAL and NTSC. Second and more importantly, the 44.1K recording standard also allowed for oversampling to buffer the digital aliasing—or degradation—that happens when frequencies above 20K are recorded. A little digital "headroom" is therefore provided for sampling. 44.1K still stands today as the standard for CD recordings, often called Red Book Audio, but it is never delivered via tape anymore. Meanwhile, 48K has developed into the standard for

digital video, both because of how digital audio is stored on digital video tapes and because it gives even more sampling headroom to prevent the ugly sound of digital aliasing.

Another consideration is bit depth, which is sometimes referred to as word length. Bit depth tells us how many bits of data there are per sample. Digital bits are zeros and ones. Bit depth determines the dynamic range of digital audio, the range from soft to loud. 8 bit audio can produce 49.93 dB of dynamic range, 16 bit can produce 98.09 dB, and 24 bit can produce 122.17 dB. Remember that the human ear can hear 120 dB in dynamic range. And here's where you as a storyteller are affected by bit depth, whether you realize it or not. If you are recording something quiet with 8 bit recording, there's only roughly 50 dB of dynamic range. This puts more of your information closer to or in what we consider to be the "noise floor." As you might guess, being in the noise floor isn't great for sound. 8 bit recordings tend to be "crunchy" because there is no dynamic range to the sounds. The sound waves' energy is literally getting stuffed into too small of a container, with no room at the top or bottom. Even though it creates larger files than a lower bit rate would, when recording or creating audio, choose 24 bit if you can.

AUDIO FILE FORMATS

There are several different types of digital file formats that capture audio. The ones we use most often in broadcast-quality production are WAV (Waveform Audio File Format) and AIFF (Audio Interchange File Format). There is a trend to use mp3 files (an MPEG compression), which are fine for voice auditions and transcriptions but should not be used in your final mix. The frequencies in the human voice are especially degraded by this file format. The reason is that the mp3s are small, so they carry less frequency information. The algorithms used to create them recognize the frequencies that are seemingly most important and disregard the rest. This really destroys the sound quality of the voice. It affects music less, but generally we like to avoid mp3s and go with WAV or AIFF files, which carry all the audio information needed to make a good mix. Of course, providing a high-resolution mp3 at 320 kbps for radio is still better than sending a WAV file, only to discover that a radio station has compressed it into a low-resolution mp3 on the air. That tinny, thin sound you hear often on the radio is either a

Skype call being recorded as part of an interview show, or a low-resolution mp3 being played back. One of the keys to successful audio workflow is to know what will happen to your files once you deliver them.

RECORDING THE HUMAN VOICE

Now that you understand something about sound waves, their amplitude and frequencies, and how we sample those elements to make a recording, let's turn to one of the most important audio components of most nonfiction film-making: the human voice. The voice is made up of an extremely wide range of frequencies. You can hear vocal sounds as low as 50 Hz for very deep voices and as high as 10K for high ones. The frequencies taper off drastically above 8K but are still present and add what we often call "sparkle" to the voice.

As a filmmaker, there are many stages along the way from production through post in which your audio, especially recordings of the human voice, may be degraded. The trick is to anticipate common issues and know how to listen for such problems as distortion and over-modulated and over-compressed audio. It's important to remember that as many tools as we have in the recording and mixing of sound, the best tools to catch ugly audio are our own ears.

One of the people you may rely on for recording the human voice is your voiceover talent. Most narrators now own their own recording equipment in their own home studios. This is fantastic for producers on tight deadlines or who want to work with talent remotely. But it can be challenging if you don't know the quality of the equipment being used, whether the sound booth is truly isolated from other sound frequencies indoors and out, and whether or not any compression is being added during the output process. Request audio files from narrators to be **recorded at** 44.1K 16 bit mono WAV or AIFF or 48K 24 bit mono WAV or AIFF files, never mp3s. I have emphasized the word "record" because if a talent records at a lower sample rate, or as an mp3, and then exports to the specifications of 44.1 16 bit WAV, you are only getting the same quality of the mp3, just with a different label. *The record sample rate is the most important* (Figure 1.4). Often music and voice is recorded at 96K or 192K to capture more frequencies in the sampling process. Don't get caught up in that argument. What matters to you as a story creator is the quality of the ADCs, the microphones used, and the recording techniques.

FIGURE 1.4 Sound being sampled.

UNDERSTANDING SOUND MIX AND DESIGN PROCESS

The mix process can hold a lot of mystery for people. A video editor once told me, "I don't know what you do, but I send the show out to mix and it's magic. It comes back a different show, all fixed and sounding great." It's gratifying to hear this kind of response to what we sound designers and mixers do every day. But it's really not magic at all. Audio post-production is a step-by-step process in which we augment your project and open up its storytelling possibilities.

Sound finishing can be broken down into the following steps:

▶ Organizing tracks

▶ Watching the show

▶ Taking notes

▶ Listening to tracks individually

▶ Sound editing and noise reduction

▶ Sound design, including adding effects, augmenting, or adding tracks

▶ Watching the show with draft mix

▶ Taking notes

▶ Final mix

▶ Approval

▶ Adjusted alternate mixes for additional platforms

▶ Outputs to final delivery specs

Organization is the first step of the audio post process. Organizing by track and clip type is necessary for most standard deliverables and ease of global application of effects and sweetening. Once organization of files is complete, sound editing can begin. The first task is making the current edits in the timeline support the story, not distract from it. Often during the video-editing process, these edits are just roughed in, so that the focus can naturally be on the story arc and the characters. In the sound-editing process, we refine and smooth out these edits, often within fractions of a frame. This process can include taking out breaths or lip-smacking so that the listener can focus on what is being said, rather than how the speaker talks. We also spend considerable time adding in room tone so when voices are edited you don't hear the background noise going on and off as those edits occur. We also "massage" soundbites so they are more fluid and more easily understood by the viewer/listener. That means we might add an "and" where two phrases are edited together or remove a series of "ums" so that it doesn't feel like the speaker was stuttering. By the way, we sometimes jokingly call this process of editing interviews "Franken-biting." Some documentary producers feel that this editing violates their sense of ethics, and there are many conversations at industry conferences and in academia about what constitutes unethical sound editing. But in a world where content is getting shorter and shorter, we have no choice but to make edits to accommodate delivery formats while doing our best to preserve the speaker's style and purpose. We'll touch more on our approach to this challenge in the chapters on preparing for mix and sound mixing (Chapters 6 and 7).

When we no longer hear the various edits we've placed into interviews or music, we start the sweetening process of noise reduction and equalization. Equalization is the manipulation of frequency to achieve a "sweeter" sound (Figure 1.5). Most often after sweetening, I'll do another version of the mix with the music and voices in order to get everything sounding good before

FIGURE 1.5 EQ Roll-Off at 80 Hz, circle showing no frequencies in that area of the spectrum.

adding in the b-roll sync sound and any additional effects or layers of produced sounds, called Foley sound. Then, it's on to the final mixing process, where there is often tweaking of all the previous steps as we mold the sound elements of the story.

THINKING AHEAD FOR MULTI-PLATFORM DELIVERY

A key element to today's successful storytelling is understanding all those possible platforms for delivery and their respective limitations and opportunities when it comes to audio playback. There are so many playback environments that it makes audio-mixing decisions very challenging. Our lives are saturated with content, from smartphones to traditional TVs, and museums to live events. Heck, there's even media content at my local gas pump. The fact is, as a storyteller you never really can control where your story will end up once you release it to the world. But you can strategize and plan for the best results over multiple platforms.

I'll give you a relevant example from the visual side of filmmaking. One colorist I work with, Robbie Carman, calls this the "Grandma's Pink TV Effect." He came up with this name after receiving a frantic call from a client

saying the color on her newly delivered show looked pink. It turns out the client was watching the program on an older television at his grandmother's house, and the color menu had not been set up properly. Similarly, your audio could sound "pink" when coming out of poor speakers, or compressed at the wrong rate, or any number of factors out of your control. The best you can do is deliver excellent audio with the playback medium in mind.

Generally, we think that in order to accommodate different delivery platforms, the best approach is to make sure you plan to create an audio mix that will work across multiple speaker types and variations in loudness. Broadcast and Over the Top (OTT) providers will give you very detailed information about how they want audio delivered. For most producers, budget and time constraints necessitate only creating one mix. Because of this, it is essential to know which playback environment is the priority. For example, if you are delivering for multiple platforms, such as broadcast and web, typically. The broadcast platform is the priority. In other cases, the priority might be a live environment presentation. I have a client who has a large annual conference of about 20,000 attendees. Though the media will also be posted online after the event ends, the top priority is the live experience at the event itself. So, in this case we work to ensure that the mix sounds great on large, big-room speakers at a high volume. We also play back the mix on smaller speakers at a softer volume to make sure nothing is lost in translation when the show goes online.

There are certain instances where you should not just release one mix and expect it to be successful, such as when independent feature documentaries are bought for OTT or broadcast. The technical specifications for each network vary so much that a revised mix is usually needed. The dynamic range of a film or feature mix can be much greater than the very small dynamic range of a broadcast mix. Often, another running time is needed as well, resulting in a change for all of the audio edits in the original mix. It is a good practice to start your production with the assumption that you may eventually need a film/theatrical mix, an OTT, or broadcast mix. This doesn't mean you need to compromise on the quality of your original delivery. We will address some ways to make the transition more efficient when we discuss the mix in Chapter 7.

A long time ago, I had a client who insisted that her 90-minute film would only be played online and in stereo. Being a self-funded documentary maker, she couldn't afford anything else. We proceeded with a mix, and everyone was happy with the results. About a year later, I received a call from that

client with the wonderful news that her project had been bought by a distributer, asking if I could turn around a mix to their specifications in a single day. You see, the audio for her project had failed the network's rigorous QC (quality control) requirements for broadcast. This didn't shock me. I took a deep breath, looked at the technical specifications and delivery requirements, and got to work. The first obstacle I noted was that a 5.1 surround mix was required. Surround is a multi-channel format where there are discreet channels feeding speakers around you, not just in front of you, as with Stereo. In addition, the levels the broadcaster required were, naturally, more consistent with broadcast specs (24 LKFS plus or minus zero) than the –6 dBFS stereo online media mix we had previously created. After bringing up the project and working for more than an hour to unsuccessfully "up-mix" the original stereo to surround sound, I realized that it would take multiple days to do the job right. I suggested we instead address the issue of the audio levels and other delivery requirements, and get permission to deliver in stereo rather than surround sound. The client received permission, and we made the deadline. All this in under eight hours. After that, I have always built any film—short or long—in a surround project, even if it ultimately wasn't finished in surround. The moral of the story is this: work to "future proof" your project as much as possible by thinking about the highest possible delivery quality for your mix.

COMMUNICATE, COLLABORATE, AND CREATE

Collaboration and communication are the key to any project's success. Fortunately, there are several tools that can help in both the communication and management of the creative process, whether your entire team is local or you are working remotely. Asana, Basecamp, and Trello are standouts in the team management arena. These tools offer the ability to manage deadlines and share ideas and assets, such as scripts or transcripts. Trello's white board approach works very well for managing the mix itself. The cards can be moved from phase to phase – keeping everyone in the loop of where the process is, where the holdups are, and what needs to be done – all at a glance. The ability to sync with calendars, such as Google and Outlook, keeps the project tracked and present on a calendar as well. Frame.io, Vimeo, and Wipster deliver amazing options for sharing ideas and give you the ability to post unique and frame-specific review notes on a rough or fine cut. With Wipster, each client can post his or her own notes on a frame, but the number of people able to post changes at the fine cut stage can be limited.

Wipster also integrates with Slack and Vimeo, and includes project status pages that work well for teams managing multiple content delivery streams. Frame.io was originally launched with some great features and is now moving towards high-security features required by larger television networks. Source Connect and Streambox work well for reviewing your show and your audio mix live with a client. These tools allow for a live, high-quality review with very little latency. The trick is to find the tools that work for you and your team. Ease of use and price is key—why waste money and time learning a complicated system?

You should now have an understanding of some of the basics of sound—how sound is created; how it moves; and how we hear, measure, and record it. We've also discussed the elements of a sound mix and how to be prepared for your audio workflow, including apps to help organize your team and help you manage the review and feedback process. In the next chapter, we will dive into the fun stuff: the opportunities for storytelling that abound with audio.

Tips on Sound Basics

▶ Sound is physical, coming at us in waves. As you develop your sound sense, remember that these waves come in varying frequencies and energy levels, and can travel different distances, depending on their length and any obstacles in their path.

▶ While sound is naturally analog, it is converted to digital during recording and then converted back to analog in playback.

▶ Always work to minimize any compressions or distortions to sound you are recording in the field or in a studio. Once those frequencies or portions of sound are lost, they can't be retrieved.

▶ Record audio at 48 kHz for the best-quality sound. Stick to −10 to −12 dBFS to give plenty of "headroom" for the range of frequencies, including undertones and overtones.

▶ Final delivery levels can vary from −10 to −6 dBFS and −2 dBTP, so, be sure you understand all the possible delivery specs for your project, including broadcast, web, display, and projection. Each one may affect how you acquire, edit, and deliver your sound.

2

Storytelling with Sound

If you are reading this book, then you believe, as we do, that sound can be more than a basic part of the story. Sound can bring characters and places alive. Sound can be subtle, too, and help the listener move with the story to a new emotional place. We will go into detail on what is involved in each of the stages of sound acquisition and mixing in later chapters. In a film course, you might hear the term diegetic sound, which means those sounds native to a scene, and non-diegetic sound, which means sound that is added to a scene. We don't use these terms much here. Our book will focus on the following four main audio elements that we believe are needed to build a strong story. Whether you record them yourself, purchase them from a library, or hire someone to create them, consider these four elements of your soundscape:

1. Sound to support human characters in your story—audio elements that reveal important aspects of who these people are; what they do; where they come from; or the environments in which they live, play, or work

2. Sound to evoke place—sound elements that help the viewer/listener understand what makes certain locations in the story unique or special

3. Sound to support or elicit emotions—music, subtle sound effects, and sync sound from your b-roll scenes

4. Sound to deliver information—generally, this is dialogue, narration, or interview segments

Go into your production with these four categories in mind, and you'll be on your way to making a compelling story with sound. It also helps greatly to be organized about the process. If you know where all your sound assets are, tag them appropriately so that you can find them later during the editing process, and then provide options to your mixer, you can succeed in using sound to go beyond the basics.

OPPORTUNITIES FOR SOUND TO TELL THE STORY

In the world of nonfiction, many of the opportunities for sound to tell the story happen organically. Some happen on location. For example, I worked on a piece last year where the filmmakers were going to be in five distinct locations, across three continents. We chatted about the process before they left, and they asked what they could do while in the field to help with sound. I suggested that the filmmakers capture wild sound unique to each location whenever they could, in longer loops to help with the sound design. What these filmmakers were doing was developing an authentic sound palette for their story. This wild sound boosted the authenticity of the piece, rather than building all of the layers from a sound effects library. Another aspect of this project's sound-gathering that made me so happy was they didn't talk through the recordings. There's nothing more disheartening than getting wild sound or room tone only to find it unusable because people whispered or made noise all the way through it. When recording room tone, be sure to gather at least 30 seconds in each interview location. If an interview is lengthy, it's wise to grab room tone in more than one portion of the recording, as the room presence is likely to change over time. Even if you only have a camera mic and a short period of time, gather wild sound or b-roll sound on tape. Though the sounds may not be strong enough to be primary audio in your film, these sounds will add to the texture of the soundscape and help you avoid the need to rebuild missing sync sound from your b-roll shots. Think about your central characters and the sounds that convey who they are and why they are in your film. Don't "downgrade" the importance of sound based on your topic. Whether you are producing a training film or a feature-length documentary, sound plays a vital role in conveying emotion and information to your audience.

Other opportunities for storytelling with sound happen in the mixing suite. Here is where you might experiment with creating a "signature sound"—a theme that recurs at key moments throughout your film to remind the viewer of a person, a message, or an emotional trigger. In the documentary film *Scattering CJ*, directed by Andrea Kalin, which Cheryl mixed, a family copes with their son's suicide. Through a Facebook campaign, his family sends the ashes to different people and places—which signifies to them his continued connection to the living. The film contains a montage of people all over the world as they scatter the ashes. From shot to shot, each person blows ashes—a somber yet also celebratory act. To connect these emotional moments, Cheryl created a signature sound by recording a rainstick. The idea was to use it each time someone blew the ashes. Whether or not it is sync sound, an audio element can signify content and provide important emotional cues to the audience. In the end, however, Cheryl and Kalin decided not to use the wooshing rainstick sound so often. While effective in many places, including several key transitions, in other places, it felt like a distraction. As a storyteller, you want to maximize the value of your soundtrack—it is half of your film, after all. How and when to use sounds is a delicate balancing act. Let's consider some of the many ways that sound can be used as a vital element in your nonfiction story.

HUMOR AND SOUND

We are both big fans of using sound for humor. Even in films on serious subjects, humorous sound can play a role. An auditory moment of humor can offer a release from a serious subject and ultimately help refocus the audience on the topic at hand. In one scene of a mini-doc I produced about combatting anti-Semitism, the main character is a comedy showrunner in Los Angeles. He describes his upbringing in a prejudiced community, his desire to become a comedy writer, and how unhappy he was to miss out on what he thought was a plum writing job on a show called "Blue Skies." Of course, no one has ever heard of this show because it did not succeed. As soon as he says, "I didn't get the job," we include a beat of silence. Then, a hard cut to the opening notes of a well-known soundtrack to a famous TV show with his name flashing across the screen in the opening credits. In voiceover, we hear the interview continue. "So, I got on a show called *Friends*, and it changed my life." This turning point in the story is emphasized by the music and the beat of silence—it is a moment of irony, one of the key elements in a comedy writer's arsenal. It serves a dual purpose of telling us something about our main character while also giving the viewer a breather from the more serious theme of prejudice. The idea for using that sound clip didn't come

to us on set. But it was an idea that emerged as we edited the interview and realized his own comedic sense of timing could help propel the story better than narration.

The music score can also offer a way to introduce humor into a sequence. I was cutting a series of interviews with children in a hospital. Each child talks about what it means to be a good leader. The goal was to create a video gift card of sorts to one of the hospital's beloved leaders receiving a major award for his work in pediatrics. The edit just wasn't working. The music felt like it was fighting with the personalities of the kids. So, I turned to some quirky, child-like musical themes with less heavy instrumentation. Voilà, the whole sequence lightened up and felt more authentic.

Another way to call attention to something that is funny in a scene is to suddenly cut the music, so that the listener pays full attention to what just happened or what was said on screen. Wall-to-wall music, by contrast, can undermine humor by becoming "wallpaper." We'll spend considerable time on soundtracks and sound effects in Chapter 9, but it's worth mentioning here that certain sounds, used in the right context—crickets, for people not understanding what was just said, or the loud ticking clock for the passage of time—will often make people laugh. While stereotypical, when used sparingly, they can make sense for a scene when you want to lighten the mood.

DRAMA AND SOUND

You can create drama with sound. Sync sound can have inherent drama. In the documentary *Let the Fire Burn*, directed by Jason Osder, about the Black Liberation organization MOVE in Philadelphia, most of the footage is archival. The sync sound in many scenes is chilling. In an attempt to get the political activists out of their commune, police firebomb a building, knowing the fire could easily spread and wipe out the entire neighborhood, which it ultimately did. One of them can be heard in the footage saying, "just let it burn." Letting this soundbite be heard—giving it space in the audio track—was crucial as Cheryl and the production team worked on the soundtrack. This quote is the sync sound from which the title of the film comes and which describes the underlying attitude the film examines—that the white police department did nothing to protect this black neighborhood from inevitable destruction. Throughout the film, the sound design is subtle. The

role of the soundtrack is to support and, in a few key places, emphasize key moments, such as when the police decide to use a helicopter to drop explosives on the complex. You hear a subtle helicopter sound that is not in the original footage and which overlaps into the next scene. The sound is barely audible in the soundtrack, and yet it is horrifying because we as viewers already know what happens next. Often drama in sound does not need to be loud. It can be as simple as a soundbite pulled into the open or a brief element to draw your attention to an action. Yet removing these sounds from the film would completely undermine its impact.

Spoken words from interviews can often have dramatic impact. In the animated film *Du Velger Selv/It's Up to You* (2013), director Kajsa Næss tells the story of the children of incarcerated parents. Their poignant interviews and young voices stand on their own. To make them feel more comfortable while discussing a difficult subject, the children were often given things to draw while talking. Throughout the film, the children's voices are real. But to protect their identities, they are depicted by animations. Sound designer Svenn Jacobsen does not interrupt these powerful testimonies. Rather, he uses the sounds of the children drawing as they talk and turns that sound of a pen making contact with paper into a signature sound for the film. The sound becomes the underpinning for unique animated transitions between sequences with the children—stop motion animation scenes of paper being cut, poked, and shaped—much the way the children are being shaped by the experiences of loss and fear when they see a parent in jail. The paper sounds are both abstract and stark—an effective way to underscore the impact on children of a parental incarceration (Figure 2.1).[1]

FIGURE 2.1 Paper sounds complement this recurring visual theme in *Du Velger Selv.*

SILENCE MATTERS

One of the common themes you will find throughout our book is the importance of silence as a sound element. That may seem like a contradiction in terms. But we hope you will come to agree with us that the absence of sound is critical to pacing, to focusing the audience's attention on something that was just said, or for changing the tempo and turning to a new location or subject. One of the ways to use silence is by preserving natural pauses in an interview, particularly in segments when someone makes a dramatic statement. Rather than editing out those silences, leave them in to punctuate the drama. In an interview I conducted with a young Palestinian man for the documentary short *Voices/Peace* (2012) about teenagers' perspectives on the Middle East conflict, some of the most poignant words in the film were this young man's wish for "a peaceful life… [extremely long pause]…a safe life." There were extended pauses in many places in his interview when he was quite thoughtful. Commonly, in an edit session one would "pull up" these pauses to avoid having the audience feel uncomfortable for the speaker and to keep up the pace of a short film. But we did the opposite. We kept several of these multiple frames of silence in the final cut of the film, for emphasis. Our job wasn't to make viewers comfortable. In fact, one could argue our job was to make viewers slightly uncomfortable and to help them view issues from the different viewpoints of the Jewish, Muslim, and Christian young people in the film. In their film *Saving Sea Turtles* (2019), filmmakers Jenny Ting and Michele Gomes interviewed many volunteers who work to rescue Kemp's Ridley sea turtles from the icy waters off Cape Cod, rehabilitate them, and send them to their proper landings in the warm waters of the Gulf Coast. At one climactic moment in the film, a volunteer who we've followed is overwhelmed as he releases a sea turtle that has been lovingly nursed back to health. He gets choked up. There is no sound, just the reality of a long pause as he collects himself. We choke up with him. This pause could have easily been eliminated. But instead, it holds an important place in the story—a turning point underscoring the human connection to the natural drama unfolding before our eyes. (I should note that Cheryl mixed this beautiful film.) With our ever-shortened attention spans and shorter media packages being consumed online, content creators may be tempted to trim every unnecessary pause in our quest for efficiency and shortened runtimes. Yet when these pauses are deleted, the words that precede them are often diminished. Fight that instinct. Listen to the words and to the silences in between. Fight for the silences.

SOUND EFFECTS

Sound effects, used judiciously, offer yet another auditory texture in your storytelling toolkit. You can use sound effects to propel characters, emphasize a particular beat of music, or trigger an emotion. There are two categories of sound effects: those that replace a missing piece of sync sound and those that are independent elements which can be layered as part of the soundscape of a film. An example of a sound effect from the second category, and one that occupies a particular emotional space, is a bell-tree. Listen to this example from Pond 5, a stock library that has a range of options.[2] The bell-tree is an instrument in the percussion family in which the player rakes across small bells. The effect is magical. This sound is often used in a composed soundtrack to emphasize innocence, simplicity, childhood, transformation, or anticipation. If you are working with stock music that doesn't contain this sound where you think it belongs—and we will cover that in our chapter on music scores—then you might decide to add a bell-tree sound effect to underscore a moment in your story arc, or provide a transitional element. Another example of a sound effect that you could layer into a film is a single ominous tone or rumble. Rather than using music, this element could signify a conflict, turning point, or dark emotion in your film. Here's another example from Pond 5 that demonstrates a tone you could sync to picture (once you acquire the proper rights—see Chapter 8) to deliver the right mood for your film.[3] More often, you might turn to sound effects to replace or augment sync sound. We both work on projects that lean heavily on archival footage. In many instances, this footage does not include sync sound. We talk quite a bit in this book about sound authenticity. And you could argue that adding a sound where it doesn't exist crosses that line and makes the scene inauthentic. It really depends on the situation. In a sequence where an interviewee was telling the story of his childhood, and describing the idyllic elements in contrast to some very tough situations he encountered, we decided to add the crack of the bat to one archival clip of a boys' baseball game. The audience knew this footage was unlikely to be family footage of the speaker himself. The idea was to take us back in time, to follow and be immersed in his story. The muted sound of the crack of the bat at the appropriate moment served to support his story. Using the same approach, when working on a story about a Holocaust survivor's son, the interviewee told the chilling tale of his father's eastern European village being burned by the Nazis. I was able to find archival footage of that very town burning (one of the creepy aspects of producing content about the Holocaust is the ample supply of Nazi-filmed horrors). But, of course, the black and white scenes

did not include sound. Cheryl was able to layer in sounds of the timbers falling to synchronize with the footage. The effect was to reinforce the memory, to bring the audience into the story. Another reason we made a decision to add some sync sound for several archival shots was to avoid a break in the soundtrack as all the other footage had sync sound. Using sound effects wisely, without over-using them, can help you deliver a better story.

PACING CHANGES

Audiences respond to pacing changes. Whether you are producing a long-form documentary or a short training film, pacing is an essential tool for effective storytelling. Pacing applies to sound as well as picture. For a fast montage sequence, you could cut to a click track or a soundtrack that offers the right mood and tempo. But then you'll need a pacing change. One way to do this is by editing a section of your film with no music track at all. Removing music signals to the audience that they should listen up and pay attention to what is about to be said or happen. Another way to change the pace is to switch to music of a different tempo or a different meter (or both). Tempo refers to the pace of the beats in a piece of music. Sixty beats per minute is supposed to approximate the rate of the human heart, so it is a moderate, steady pace for a piece that is to connect emotionally. Meter refers to how many beats are in a measure. Music is most commonly written with two, three. or four beats to the measure. (Pink Floyd famously wrote the song "Money" in 7/4, which is why we feel a bit off-kilter each time that first beat arrives after six other beats, rather than the expected seven.) You can use meter changes to alter the pacing of certain scenes in your film. If your opening montage is cut to a piece in 2/4 (two pulses per measure, with the emphasis on the first one—ONE, two, ONE, two), you could accomplish a pacing change by switching to a cut of music in 3/4 time (three hard pulses to each measure—think of a waltz—ONE, two, three, ONE, two, three). Switching meter is one way to change up the pacing and pinch your audience so that they focus on some kind of new topic or new branch of the story line.

SCRIPTING FOR SOUND

One of the things I strongly recommend to students in my workshops is to "script for sound." So often, shooting scripts, shot lists, and story boards seem primarily geared to picture. If you are developing your shooting script

and shot list, consider any sound elements that came up as you conducted pre-interviews, location scouts, and subject matter research. As you write, ask yourself if there were any sounds that could propel the story. Think about what sounds might evoke a location, without being too stereotypical, such as the sound of the combine driving past on a farm (rather than the mooing cows) or the chatter of a happy family around the dinner table. Think about what opportunities you have for adding texture to a story beyond the visual. Where will you conduct the interviews? Will that space have its own background sounds that contribute to the understanding of this person? For example, the hum of activity and stock numbers scrolling across financial monitors that are seen in the background of an interview with a Wall Street investment banker. Or the sounds of children playing outside on the playground that might be heard in a story focused on an elementary school teacher. When you interview people by phone, you may even hear sounds that you jot down for your shooting script or shot/sound list. Or someone will tell a story that involves some kind of important sound that you can note for your wild sound list, or you might recall a sampled sound you want to use during the sound design process. Your scripting and preproduction process should be full of sound ideas as well as visual ones. Even in interview-driven stories, the interview should only be one audio element, albeit an essential one. When planning our films, we can all take a page from experienced radio producer John Biewen, Audio Program Director at the Center for Documentary Studies, Duke University, and producer of the well-known podcast *Scene on Radio*. John explains: "It's not just sound for its own sake. What kind of sound can I record that will create a three-dimensional world and put these people into the world, so it's not a flat two-dimensional head? So that the listener gets the sense of being taken somewhere out in the world." Make sure you include some of your audio ideas in your shooting script or on your shot/audio acquisition list. The more ideas you consider, the more you can elevate your story using both the audio and visual elements at your disposal.

AUTHENTICITY IN SOUND

Authenticity in sound is crucial in any piece, but authenticity is essential in nonfiction storytelling. Digital media can be so easily manipulated that news and documentary can be slanted or become downright fraudulent. We like to use the clever term "Franken-bytes" to describe cobbling together several different pieces of sentences into one, which is often done when the

speaker isn't facile with language, or we are under sharp time constraints to include the soundbite in the story. But here we face a dangerous slippery slope. It is so easy to make a person say what you need them to say, rather than what they actually said. Where is the line? We both believe that intent is critical. We will listen over and over to a bite and be sure that what we are taking out is nonessential (an "um" or an "er") and does not remove context. But even an "um" or an "er" could, in some situations, be the very thing you should *not* remove because that reveals some kind of discomfort or worry—a context worth keeping in the film in some cases. So, we must be careful in nonfiction not to over-sanitize in the process of editing. Some of you are producing branded content for corporations or nonprofits. You have a message to deliver, and the on camera person is a passionate donor or the CEO. We're not going to tell you where the line should be for your work. We're just calling attention to the idea that not every sound edit is the right call. Think about context. Think about intent. Care about the contract you have with that interviewee not to undermine them while making them human.

There are similar challenges in sound design. What makes a sound "accurate?" If the original sound is masked or hard to hear, am I making it more believable by adjusting it and making it easier to hear? What about a sound that doesn't exist on the film, so we add it in sound design? Is that being inaccurate? Is precise accuracy even the right metric? Or is the right metric making a powerful story that honors the participants and their world? We're tackling some of these issues in an airplane documentary we are currently working on. It's about a plane that was first manufactured 80 years ago. There are only a couple of recorded sounds of this plane in existence, one of which we went out and recorded ourselves during a demonstration. In this case, to get through 50 minutes of material it's mandatory that we manipulate sound to simulate the sound of the plane. It needs to sound authentic, yet it's not the actual sound of the plane. Or at least, it's not the sound of the exact plane you are seeing on the screen. If sound was not simulated for this type of production, it would become a silent film.

When you have the opportunity to record sounds in the field, we recommend it. Throughout this book we will talk about the value of "wild" sound and sound layering in sound design. Everything you record on location contributes to the viewer/listener's understanding of the world they are entering. Mismatching sounds undermines that world. You wouldn't want to put

a modern car engine sound under a scene with a 1950s truck. But using a Ford F-150 sound for a Ford Explorer is not an obvious problem and can be made believable. If the shot or scene is made up of archival footage, sometimes overly clean sound is just not believable. We will discuss techniques on how to make sounds more believable in your mix session in Chapter 7. But overall, the goal is to support the story and help the audience connect with the people and places in it.

While sound libraries are getting better at tagging and describing their files, often we don't know for certain the accuracy of the description. A few years ago, we did an audio guide for one of the National Parks. It was imperative that all the sounds in the audio guide be true and indigenous. So, before even putting together any of the soundscapes, we pulled sounds from the location shoot and sound libraries, and cataloged them in a database to be approved by the park rangers. This approach worked well. Though it took a couple of rounds to get the sound palette finalized, we knew and the client knew we were fulfilling the requirement that the sounds be authentic.

Sound design can be used to support or distract from a story. For example, if you are filming a scene in what is typically a busy neighborhood, but you shoot on a day when the temperatures are frigid, and everyone stays indoors, then sound design can go a long way to build up the missing hustle and bustle. Traffic sounds, sirens, children playing, dogs barking—these sounds, subtly added to the mix, can help support the case about this thriving community. Not authentic to the shoot day, but authentic to the neighborhood and its story. By contrast, putting too many sounds in your film without supporting visuals is sure to distract today's sophisticated viewer. Making the sound authentic is a step towards pulling your audience into this moment, these characters, and this story.

"Probably the biggest mistake of an emerging filmmaker is not to understand that 90% of filmmaking is audio. That's true for when you're in the field and it's true for when you start to think about the experience that you want your audience to have — we are, above all, aural animals. A film that excites the aural world is one that actually captures the imagination."
– Nina Gilden Seavey, documentary filmmaker,
Professor, History and Media and Public Affairs at
George Washington University

Tips on Storytelling with Sound

▶ Include sound ideas in "shot" lists and shooting scripts. Consider sync sounds for b-roll, wild sound you could gather on location, sound samples or sound effects, or music styles and genres.

▶ Consider using humor, drama, and pacing to support your story.

▶ Try silence. Record it. Use it in the edit. Consider segments of story that do not require music. Don't shy away from beats of silence.

▶ Think about authenticity and what it means for the characters and locations in your story.

NOTES

1 https://vimeo.com/58988518
2 www.pond5.com/sound-effect/8716508/belltree.html
3 www.pond5.com/sound-effect/44929210/wavering-alien-drone.html

3

Preparing for Location Sound

There are several "secrets" to effective nonfiction sound acquisition in the field. As with so many essentials to good storytelling, preparation is the key. In this chapter, we will cover some of the components of location sound that contribute to a compelling story. We'll also review scouting strategies and digital tools that can help you significantly improve both the quality and the quantity of the sound assets you gather while in the field. By having better, and more, sound assets, you'll have flexibility, options, and added impact in your nonfiction storytelling.

Let's face it, decisions on locations are often made with little or no regard for sound. Picture is usually at the top of everyone's mind, from preproduction and location scouting right through setting up the shot. Even when you think you are planning well for sound; situations arise which make conducting an interview or recording sync sound challenging. This happens with large Hollywood features, so of course it also occurs in documentary and other nonfiction films, which tend to have smaller budgets and tighter schedules. Despite the challenges, when you are a nonfiction storyteller, sound tells at least half of your story. Sound offers a window into your main and supporting characters. It provides some texture to locations, which are

often characters in the film. As you prepare for location filming, think about what sounds would help to convey who those characters are and the essence of their story.

LOCATION SCOUTING FOR SOUND

Location scouting is often overlooked in nonfiction productions because of time and budget considerations. Yet this process is crucial to developing a compelling story arc. Putting yourself in the same space as your central characters gives you vital information about visuals but also sounds that can help propel the story. There may be thematic sounds that help the audience understand a character's background. Essential dialogue between two key characters may help explain a situation. And there may be other non-sync sounds from the environment where the characters live or work that can be layered into the soundtrack to help tell your story. If you don't plan now for how to gather these sounds, paying for stock or sampled sounds can add to your budget later. So, it's worth the effort.

A productive sound scout will uncover issues that will need to be addressed in the audio post-production process. Perhaps there is a construction crew operating nearby, or you are planning to film in a tall city high-rise, which often have radio frequencies (RF) magnetic interference that disrupts the signal to wireless microphones. It's important to be prepared for poor sound situations. So, on your scout you are trying to uncover situations that may result in competing frequencies for your primary sound recording.

In addition to looking and listening for problems on your scout, you'll want to consider sound storytelling *opportunities* a given setting can offer. There might be sounds that set the stage for a particular turning point in the story or can help the audience understand your on-camera subject and the world they care about. Listen for ways to move the story forward with sound. Primary audio considerations you will want to address as you scout are:

▶ Sound to support the setting as a character in the film

▶ Sound to propel the narrative arc

▶ Sound authentic to key characters

▶ Avoiding anachronistic or inauthentic sound

SOUND TO SUPPORT SETTING AS A CHARACTER

The setting is one of the most important characters in your film, and sound plays an important supporting role. Whether you are explaining an industrial production process for a training film, shooting a fundraising video for a nonprofit website, or creating a long-form documentary, your locations will serve two critical functions: putting the viewer inside the main character's world and quickly delivering important information to the viewer. Let's first address the goal of bringing the viewer into the environment where the action takes place. Your chosen settings should help a viewer feel the world of your film on a gut level. Audio is naturally a critical dimension of this world. One approach is to embrace the sync sound of that environment and bring it into the layers of your other audio elements, such as music, interviews, or narration. Another approach is to remove that sound and replace it with something that creates a stark contrast. For example, in the film *Let the Fire Burn*, about the firebombing of a neighborhood in Philadelphia as part of a police action against the organization MOVE, the soundtrack changes abruptly at 25:00 to a pastoral piano underscore. This music creates a stark contrast to the visuals shown of a heavy police action on a neighborhood.[1]

SOUND TO PROPEL THE NARRATIVE ARC

Beyond serving as one of the characters in your film, setting, when used effectively, will propel the narrative arc. For example, sound can quickly deliver short-hand information to the viewer in order to avoid unwieldy narration or titling. If, just before a shot fades up, I hear barking and whining dogs and their paws scratching, when the camera reveals our main character walking down the hallway of the animal shelter, I am not only prepared for the context of this story, I've received a hint about the turning point or narrative climax: these dogs are pining for a home. A few seconds of sound montage delivers this information with significant emotional force, rather than a title saying "At the Dog Shelter." Only by scouting the location in advance will you get a true sense of both the possibilities and the obstacles presented by this location and the many sounds—pining, anxious, joyful—made by its canine residents.

If you bring your Zoom digital audio recorder on a scout, you may be surprised what story ideas emerge when you play back the files. Listen with

your eyes closed, so you are truly *inside* this world. What themes emerge? How could you convey them through b-roll sync sound or through wild sound? What does "silence" sound like at this location? Are there any recurring sounds that might need to be recorded as "room tone" during a longer interview? Are there any activities that the main characters do as part of their lives in this world? Is there some way to build in this audio—what I call "talking while doing?" I often find that when people speak to me while they are doing something—giving a tour or demonstrating some technique or tool—they are more natural, and if we record proper amounts of room tone, this audio can be dovetailed with a sit-down interview.

If you have the luxury of delivering your production in surround or Dolby Atmos® (which we'll discuss in Chapter 10), then you can literally place the viewer at the center of the many sounds in your main character's world and even define exactly from which speaker each sound will emanate. So, on your scout you could identify a particular spot that is central and some key sounds coming from different points of the compass to convey important thematic information. But we get ahead of ourselves. At this point, you will want to consider what elements of the story—the backstory, the development, the climax or turning point, or the resolution/denouement—can be evoked through use of *sounds* in the setting.

SOUND AUTHENTIC TO KEY CHARACTERS

In nonfiction production, particularly corporate films, characters are often taken "out of context" and placed into alternative settings—studios, green screen sets, etc. In these locations, these people can lose their essence. While studio spaces are ideal for interview sound, they are devoid of other sound elements that can convey information about your characters. If you have the ability to work on location, scout for authentic sounds that transform the narrative and bring your characters to life. A busy stay-at-home dad lives in a world filled with the sounds of children, and perhaps some noisy toys. A judge may move through the overly quiet hallways of the courthouse, where all you hear are echoing footsteps on marble floors. At a rural school in Botswana, the sounds of the children chanting their lessons fills the air. These authentic sounds are the essence of storytelling. Catalogue them on your scout—whether physical or virtual—and determine which audio must be acquired as either wild or sync sound while you are on location (Figure 3.1).

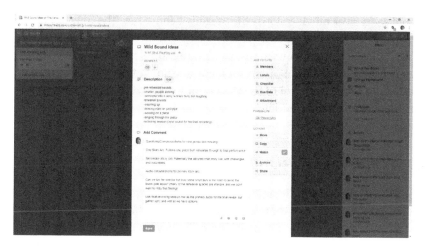

FIGURE 3.1 Trello board planning for wild sound and other audio.

Curating authentic sounds to incorporate into your film doesn't mean you disregard technical or budgetary considerations of a given location. For example, in a documentary short that I produced about teens from Israel and Palestine, we had the opportunity to film them at a conflict resolution camp in upstate New York. From a budget filmmaker perspective, the setting was ideal: not too far for our team to reach by van from our base in the Washington, D.C. area, and also an isolated setting that would allow the kids to be themselves without family or political pressures. On the other hand, it was an unnatural setting and meant that we would not be acquiring the type of day-to-day b-roll we would normally shoot to depict their lives to the viewer. We made a decision to shoot interviews and b-roll only in exterior locations, with the sounds of nature as part of the ideal setting, conveying not the worlds where the kids came from but the peaceful future they imagine when they participate in dialogue. My goal as I scouted on site the day before our shoot was to find a different spot for each teen that somehow conveyed their individual personalities and challenges facing their communities, as well as somehow depicting the impact of being away from all those pressures in a leafy, quiet camp setting far from home. For one centered, quiet Palestinian young man, we placed him beside an old stone wall. Perhaps overly symbolic, but it worked because he spoke about having to cross one of the West Bank barriers to get to school every day. Another character in the film, an Israeli young man with wisdom beyond his years, was seated in front of a path disappearing into the woods. A passionate young Palestinian woman gave us her interview seated on top of a picnic table so that we

could see a river moving slowly but steadily behind her. The only exception we made to our locations rule was for the final sing-along—a gathering in a social hall. As the only interior in the film, the social space provides a physical construct for this important moment of coming together—in essence a visual and audible symbol of the structural work that went into peacemaking during the camp experience.

AVOIDING ANACHRONISTIC SOUNDS

As a Washington, D.C. location production assistant on the Oliver Stone movie *JFK*, for which we shot many outdoor scenes, I was able to learn about location sound challenges. One of these was trying to avoid anachronistic sounds entering into exterior scenes since the film was set in the 1960s. To this day, I cringe at one of the extensive dialogue scenes we filmed on the paths and lawns by the Lincoln Memorial. The scene contains a particularly obvious roar from a modern plane engine. The shooting schedule had been reworked such that we had to film some extensive dialogue sequences between the two main characters as they walked directly under the National Airport flight path. Sometimes you can't control the shooting schedule, even on a high-budget Hollywood movie. The audio post-production folks likely did their best (this film came out in the days before digital audio tools). Even so, they couldn't totally delete that jet engine from the background of this scene.

The *JFK* film actors were experienced professionals, so they didn't get sidetracked by these anachronistic sounds. If you are working in nonfiction, consider how your non-professional "talent" might respond to distracting sounds. I once interviewed a woman in her own home who became distracted by the sound of her pug snuffling about in the distant background—she was over-sensitized to his sounds. I assured her that our directional mics were not picking up his extremely distant noises, but we ultimately had to move the dog because she just couldn't keep track of our interview conversation with this on her mind. Of course, one solution would have been to put him right in her lap and make him part of our scene. Sometimes when a sound is so obvious, or really part of the story environment, it makes sense to include it visually as well as in your recording. I've filmed in many hospitals, and the sounds of beeping equipment becomes part of the aural montage that tells us we are in this healthcare setting. When scouting, you should opt for locations that are comfortable but not distracting, welcoming

rather than intimidating, with sounds that are authentic to the primary story line in your film. Ideally, the settings are native to the key characters. If you decide to work in a studio environment, then there are strategies for making the environment more natural, which we'll address in the next chapter about sound acquisition on location.

SOUND SCOUTING TOOLS AND STRATEGIES

Even if you aren't a big budget movie maker, you will always need to balance ideal location and ideal sound. One of the best ways to do this is to physically scout all locations, both several weeks in advance of your shoot and, ideally, the day before the shoot to see if anything has changed. It is incredible how often the jack hammers move in just before you show up with your filming equipment! In an ideal world, you would hire a local location manager to do this scouting for you. I've even hired a more junior production assistant to do this important groundwork and relay back to me the things they saw and heard. You can ask for smartphone photos and recordings to get a sense of the sound at different times of day. If you are not able to hire someone to do this legwork, and can't go yourself, there are several digital tools you can use to conduct a remote location scout.

- ▶ Flickr

- ▶ Google Map street view

- ▶ OpenStreetMap

- ▶ Foursquare

- ▶ Map and lighting apps

USING VISUAL SOCIAL SHARING TOOLS TO FIND USEFUL SOUND

Flickr has always been a great tool for figuring out what is going on at a potential location. (They were recently sold to SmugMug, so we'll see what happens when they start charging for accounts.) Yes, it's a photo site, so you may think it's odd to use this as a *sound* scouting resource. Here's the

great thing about using Flickr (or Instagram): these sites contains millions of photos taken at virtually every location on earth. When you search for a location, these photos can give you a very good idea of possible sound opportunities and obstacles if you learn to "look for sound." For example, I'm about to take a trip to the United Kingdom and will be touring a region called the Cotswolds. One location I'm interested in visiting is the famous Broadway Tower. Let's say we are planning to film some b-roll and an interview there. What do I need to think about regarding sound? By looking at Flickr, I can see a number of audio situations that could arise. Some could have a positive impact on my film. Some could be detrimental to high-quality audio. The photos reveal a high tower seated amidst wide open expanses of scenic green, dotted with loads of sheep. Several photos show dark rain clouds, and one is even labeled "after the rain." It's England, after all, so it rains often there, especially in spring. So, if I'm making my list of sound elements that I'd like to be sure to pick up on this shoot, I want to add "sheep" and "soft rainfall" and possibly "breezes at the Tower" as some wild sound elements for my to-do list.

One item I can see in a few of the images of the Broadway Tower is tourists. These folks, coming in waves just as I'm about to roll, could be a major negative for my interview. For b-roll, though, they would be nice to have around. I can call ahead and see if there are particular times of day or days of the week that are most busy for visitors and try to build my shooting schedule accordingly. I can even ask if there is a time when we could reserve the tower just for our filming. And I can check our prospective shoot schedule against their list of any tour groups coming through—which would really wreak havoc on my production. And of course, there may need to be some back and forth negotiating, which will largely be affected by whom you are filming and why—if it's for the Tower's own museum, or for a documentary about English history, you may get an easier reception than if it's for a commercial production, for example. Another item I see in many tourist photos of this location is deer. A quick check on the website indicates that there is a special Deer Park on this location. The head of the deer park gives occasional tours. Again, this fact will either be exciting and some interesting sound to plan for in our film or it will cause a problem and need to be accounted for in our scheduling. All of these issues are ones that can be raised by a look at social media sites providing photographic clues to sound. Using digital tools can help you discover not only what locations look like but help you consider the audio implications and opportunities for good storytelling (Figure 3.2).

FIGURE 3.2 Flickr photo showing construction that could affect sound at the Washington Monument (photo credit: Kevin Wolf).

USING MAP APPS TO PLAN FOR LOCATION SOUND

When scouting remotely, Google Maps can be a lifesaver. Street view is especially useful for production personnel—we can figure out whether there are ramps or parking spaces or coffee shops nearby, and what entrance to use for the equipment. The team from Google has mapped places as distant as the peaks of Machu Picchu, the temples of Angkor Wat, and the Great Pyramids, to name just a few.

Open Street Map is a collaborative wiki that was started in 2004 and continues to grow. If I put in my earlier target destination, Broadway Tower, I get a nice map with the topography noted, as well as streams, various footpaths, and other items of interest, such as ponds and a café. If I decide Machu Picchu is where we want to film, things get even more interesting. I can see who has put in what information, and I can even message that person. For remote locations, or ones that even Google hasn't mapped yet, this can be an invaluable resource for a nonfiction filmmaker on the go.

Of course, Google Street View is only updated periodically, and Open Street Map is an ongoing wiki produced by volunteers, so beware when relying entirely on these tools for planning picture or sound. For example, when I checked Google to look at my own street today, it shows a car in front of my house that we got rid of three years ago and doesn't reflect my neighbor's

fabulous new house construction project that's nearing its end after almost a year. So, someone planning to get that car in the shot, or film without hammering in the background, would be disappointed. Which brings us back to the opening of this section—if you can get ears and eyes on a location, do it!

OTHER SOCIAL MEDIA LOCATION SOUND RESOURCES

Another great crowdsourcing tool that you can use for scouting the best location is Foursquare. Because it is an app that helps you locate friends who have been to the same location, you can see if you have a first-hand resource for information. Perhaps there are people that you know who live near a prospective location who can give you first-hand opinions about it or reveal any current issues, such as construction. In neighborhoods, these folks can tell you what day the garbage gets picked up or when the annual "fun run" will be inundating the neighborhood with families. Your friends can also help recommend food and coffee for your crew. An app like Foursquare can also help you think about sound that either will make or break your shoot. Using features such as "Find Nightlife" will help you rule in or out a noisy location, depending on what you are going for in your production when planning a night shoot. You also want to be sure you check any map sources for police and fire stations, which can frequently add unwanted noise to audio recording.

CROSS-REFERENCING WAZE OR GOOGLE MAPS WITH YOUR FAVORITE LIGHTING APP

You are likely using an app to help you determine the best time of day for filming. LightTrac, Sun Surveyor, Photo Pills, Sun Seeker—the list goes on and on. What I like to do is calculate great times of day for shooting particular scenes, and then re-assesss with quality sound in mind. Start with the best time of day for acquiring a particular image—let's say you are timing the shot for when the light will hit your subject just right as they walk along the river. The woman you are filming often walks along this river when she wants to think, so you are setting up the shot to look as contemplative and beautiful as possible. Now you need to plug in other variables. Of course, you will want to figure out what the location is like in terms of access at that time of day. Perhaps you need a permit that has timing requirements. Perhaps there is no parking at certain times of the day. So you can begin to

narrow down your timing. Now you can reassess your schedule based on sound. What does the location *sound* like at the optimal visual filming times of day? It may not sound as good as it looks. Using Waze or another travel app, you can enter the time of day you want to shoot and set it up as a future trip. You can tell by scrolling through the app at different times of the day to see exactly how much longer it will take to get to the location. You might see a sea of red for the clogged roadways because just as the sun is setting perfectly for your visual, a major roadway right behind where you'll be filming becomes traffic clogged. Don't panic. Now that you know, you can plan for recording what is known as "wild sound" at a different time of day in the same (or similar) location in order to properly support your story line.

Because your goal is to show how your subject is often lost in thought, and loves to look out over the water as she walks, you may have to convey the introspection of that moment with three components of sound you will acquire before or after rush hour: the sounds of footsteps on the grass by the water's edge, the sound of the water, and, perhaps, the birds tweeting and flitting in the nearby trees. You may also wish to plan for Foley sound, which are audio that we create and add to augment what would be sync sound. Sometimes these are added for effect—louder footsteps than would be natural for a scary scene. Sometimes they are added due to necessity, such as most sounds in nature documentaries. We'll discuss some Foley sound recording strategies in the next chapter, as well as how to incorporate those sounds in the chapter on mixing. For now, consider the opportunities for wild sound acquisition, and make notes that you can reference when creating both your shooting script and your schedule for the shoot day.

SCHEDULING FOR BETTER FIELD AUDIO

Adapting your schedule for sound requires a focus on several essential issues: (1) including time for wild sound, (2) building in time for b-roll sync sound sequences and background dialogue sequences, (3) ensuring you capture and tag room tone, and (4) giving interviewees time—at the proper time of day—to tell their story. Do your best to plan for optimal audio and it will pay off. Using wild sound can help you develop your locations or create thematic elements for your main characters. A substantive interview will propel your narrative, as will snippets of authentic dialogue between characters. Decent quantities of room tone at regular intervals will help you patch up any edits during post.

PLAN TO ACQUIRE "WILD SOUND"

Wild sound is non-sync sound, which can help you bolster any b-roll sync sound. Wild sounds also add authenticity to the scene, while giving it texture, since you will typically layer these audio clips into your sound design. Wild sound can also be used to create a thematic element for your story. For example, every time a particular character enters the scene, you can build a thematic sound into your textured soundtrack. Planning to capture these assets will improve your flexibility in the edit.

Every producer wants to use time efficiently on a given shoot. When building your production schedule, take advantage of any lengthy pre-lighting time to give your sound engineer time to gather wild sound. Once you start making a habit of this, you will be surprised how often you layer this sound under other sync sounds and support your storytelling. For a long-form documentary, it is common to send the sound engineer with a digital audio recorder to record some long portions—at least two-minute blocks or more—of the various key sounds that you identified in your preproduction as essential to the setting, the characters, or the story arc. Using convenient digital tools like a Zoom digital audio recorder can help. Your sound engineer can acquire a range of sounds in one part of a location while the crew is wrapping in another location; you can send someone back to pick this sound up later or on a weekend, when it's quiet, or you can stay after you shoot and get the wild sound once traffic has died down. If you are a "one-person band," operating camera and sound, you may want to add a production assistant to your team. Among their many tasks, this person can occasionally walk around with your digital audio recorder to capture key sounds. Be sure to consider wild sound acquisition as you build your production plan. If needing wild sound, you can also mention it to your audio post-production mixer. He or she may already have what you need or can go record it for you. (We'll let you in on a little secret: audio post folks love going out in the field, given the time and opportunity. A little money is nice, too!)

TIMING AN INTERVIEW

Your on-camera subjects are non-actors, doing "real life" things. On the day of your shoot, they may need to do some of these tasks on camera, surrounded by the entirely unnatural environment of equipment and crew.

You may, for example, want them to chat with family members while preparing a meal so that you can acquire some sync b-roll dialogue and interactions. On top of that, you may also need an interview from one or more people. No matter how much you prepare them for the arrival of equipment and crew, even "experts" who have worked on camera before can become intimidated or stilted. No one really believes how much equipment is involved in even the smallest and most portably outfitted productions. Your job in planning is to minimize the likelihood of someone feeling overwhelmed.

Most shoot-day schedules are focused on picture, rather than sound, but you can employ several strategies to be sure you acquire quality sound assets. If you are conducting interviews, you may want to plan for what I call my *B-roll-Interview-B-roll* strategy. I've found that while non-actors often get thrown off by having cameras and crew descend upon them, they can "warm up" to the team more slowly if they build confidence doing something that comes naturally to them. Start the shoot day with some easy b-roll, thus letting your on-camera subject get to know your crew by name. Try to build at least 30 minutes of b-roll collection into the top of your schedule each day or segment of a day with a new character. Even if this must be trimmed for "run and gun" type shoots, putting some b-roll sync sound collection at the top of your shoot will pay off in story quality. Use the opportunity to gather sync sound relevant to your main characters, while building rapport and confidence. In addition to warming up your subjects, this brief time will help them to start ignoring the camera, boom, and crew. That comfort level with the gear and the team using them will come in handy later when you are conducting the interview.

Only after this period of b-roll filming should you then consider scheduling an interview. If your on-camera subject is a very busy person, you can still collect some b-roll with sync sound of them walking down the hall to their office. I've even jumped into cabs with people who need to meet us after first being at another location. Sometimes that cab footage—of them looking out the window with their city rolling by, making a cellphone call, or practicing a speech—can be some of the best sync sound in the piece, giving important expository information about this character. (Note: Be sure they don't talk to you or that ruins the impromptu effect.) To capture this important soundscape, create your production plan such that you are always prepared to record audio on the fly from a camera-mounted microphone. (Always remembering to switch back to lav or boom sources

for interviews.) Once you've shot this preliminary footage, the person has hopefully warmed up to the crew, may even know their names, and has seen some of their gear. The interaction between subject and crew therefore becomes extremely helpful to your next scheduled piece of sound and story gathering, which may include an interview on very personal subject matter (Figure 3.3).

CALL SHEET FOR SHOOT		
Director: Amy DeLouise		
DAY TWO: WEDNESDAY OCTOBER 2		

Location AM: **Office Tower, New York City**
Crew Call: **8:30AM**
Note: Use Rear Entrance and Freight Elevator Only
Location PM: **Lower East Side,**
Note: Street cleaning parking restrictions!
Crew will stay with van, only DP rides in car with subject.
File Naming: **NYStory_Day2_10-02-19**

Time	Picture/Sync Sound	Special Notes
8:30AM	Arrival/unloading	
9:15-9:45AM	Interview Setup/Lighting	
9:45AM-10:30AM	T. Interview – corner office	AUDIO: Used WIRE LAVS for interviews at this location due to RF interference; GET ROOM TONE
10:30-11:00AM	Lighting Reset	
11:00AM-11:45AM	B. Interview – board room	AUDIO: Used WIRE LAVS for interviews at this location due to RF interference; GET ROOM TONE
11:45AM-12:15PM	T. and B. office b-roll	AUDIO: relevant, lav both and/or boom these shots.
12:30-1PM	T. and B. walking on street (grip wrap gear, meet team by freight entrance)	AUDIO: B-roll audio not relevant, wrap lavs prior to leaving building. While we shoot, record wild sound of street- cars honking, traffic, etc.
1-2PM	Crew lunch – small conference room	
2-3PM	Company move	
3-4PM	Car b-roll with M. in the "old neighborhood"	AUDIO: Lav M., set levels and drop bag in car. There will only be room for DP in vehicle. Run camera mic as backup. PICTURE: Drive around the block twice to get shots of M. talking. Then shoot out window for the third drive.
4-5PM	Wrap gear from vehicle. Shoot building exteriors and street signage for context b-roll.	Audio and grip can wrap everything to van. Camera mic.
5-6PM	Wrap	

FIGURE 3.3 Sample call sheet with audio notes.

Although you won't always have a choice, try to avoid scheduling an import-ant interview at the end of the day. Non-professionals are unaccustomed to the stress of being on camera and how to remain fresh during the kinds of punishing long days in front of the lens that actors can manage. Be con-scious of the fact that your on-camera subject lives his or her life elsewhere, not usually in front of the camera. In your pre-interview, find out whether you are working with a "morning person" or a "night owl." Generally speak-ing, the voice mechanism works better after a warm up—another reason to shoot that b-roll first and let them say a few things. If someone speaks to you too early in their own day, they could sound "froggy" as we like to say. If it's late and they've been talking all day, they can sound hoarse or dry-throated. If you wait too long for lunch, you will hear stomach grumbles that can be picked up on microphones, even from someone on the crew. Right after lunch, people get sleepy. Work hard to schedule interviews when the quality of sound won't detract from your content or cause extensive retakes.

Of course, there are always exceptions. I once had to interview a prominent heart surgeon. Our interview was scheduled for mid-afternoon. It turned out that day that he'd conducted a complex pediatric surgery for the hours prior to our interview. We took a few moments to pick up coffee for him, and he was—like most hospital professionals—able to muscle through his exhaustion to deliver an excellent interview. When scheduling interviews, always ask the person questions about their schedule to be sure you under-stand which times of day will be the most stressful for them and try to solve that as best you can with your other scheduling needs. Trying to prioritize the best time of day for picture and the best time of day for sound is always tricky. Sometimes you will have to do box dinners for the crew or provide an extra afternoon snack to fit in an important scene. Sometimes camera "wins" and you prioritize picture; you'll know that you'll need to work more with the sound in post-production. Sometimes you have to tell your Direcor of Photography (DP) "the audio in this interview is absolutely critical" which may mean she doesn't get her first choice set up location. It's a challenging balancing act, and that's part of the fun.

ALWAYS PLAN FOR ROOM TONE

When planning for a shoot, room tone may not be at the top of your list. However, you need to be sure it is mentioned somewhere on your sched-ule so that it is not forgotten. The sound of a room will change over the

course of a day, or even over the course of a few hours. Machines go on and off in the background, outdoor sounds change, etc. You want to have several different sets of uninterrupted 30-second pieces of room tone in your files for every interview. Always shoot room tone pointing the camera at the microphone. This makes it very easy to find and tag when fast-forwarding through footage. Don't assume that because everything is digital it will be easy to "grab a few frames" in between speaking. A few frames isn't enough to solve most audio problems that arise on a given project. The more room tone, the better. I like to be intentional about room tone and actually slate it (verbally). But I also like to pause after camera and sound tell me they are rolling—just a few seconds—before I call "action" or start an interview question. That way, I know I have a little extra pad of room tone.

PREPARING YOUR CREW

Technical preparation is only half the battle when prepping your crew. The other important piece is ensuring they are prepared for the emotional content and nuances of your shoot. I like to let my crew know if there are any special sensitivities of my on-camera subjects. For one film I produced about SIDS, a mother whose newborn had died of SIDS agreed to be interviewed. Our crew needed to know up front that this brave mom would be speaking about her painful loss and effectively reliving that experience on camera. I let everyone know in advance that we needed to be respectful and not be joking around as crews often do when offloading gear and getting set up. In a different situation, the crew telling stories and having a little fun might actually help make a subject feel more comfortable. In one situation with an attorney who was worried about how she would come across on camera, we had a wonderful production team who chatted with her and made sure she understood we would respect her boundaries. We also were filming some of the project in her parents' home, which was another sensitivity. I'll never forget the email we got after the shoot saying how each of us had become "one of the family." Her comfort level came through in all the b-roll footage and interview. How the crew comports themselves has a direct impact on the sound and visuals you will be able to acquire and, therefore, the quality of the storytelling.

You will want to have an advance conversation with your sound person or team to discuss whether or not you wish to see microphones, whether

there are b-roll sound needs that may require hidden microphones, and whether you are planning any primary sound acquisition that will require wireless setups. You don't want your sound person to show up without the right number of devices, batteries, and other tools you need to get the best sound for your story. For example, if you're planning to film a "walk and talk" sequence between a husband and wife, your sound tech will want to put them both on wireless mics in addition to having your boom to capture atmospheric sound. This setup will also require a multi-channel audio recorder.

To record backup audio for interviews, and to acquire additional wild sound without having to run the camera, you will also want to plan to include a digital audio recorder among your tools for the shoot. My preference is always to have a secondary digital audio recorder on set. Most models have built-in microphones which can be a useful backup on low-budget, no-mixer projects. Typically, though, we use the digital audio recorder as a secondary record system and run sound directly into it from our mics—in other words, we are running two systems simultaneously. This allows easy output of mp3 or WAV files for transcription at the end of each shoot day, so we don't have to wait until we get back to the editing room to ingest the footage in order to get our transcripts done.

For projects filming with non-actors and requiring larger teams, such as shooting multi-camera setups in a studio or on location, you may wish to plan ahead so that you can hide your crew and much of the equipment ("video village" as we like to call it) behind a large silk. This allows you to have a more intimate relationship with your key characters and keeps them from being unduly distracted by all the cables, gear, and personnel involved. This is especially important for interviews. This type of setup requires advance planning and discussion with crew so that you have rented the sufficient C-stands and silks to make it happen.

If you are not able to hide the team, it is still beneficial to remind crew in advance to avoid eye contact with the on-camera subject while the camera is rolling. It is a natural instinct for the person to look around and make eye contact with people, thus throwing off the eye-line for an interview and potentially disrupting the sound as well. The goal with all of these pre-shoot conversations and preparation is to ensure you get the most authentic, natural sound from your on-camera subjects. For all of the advance crew reminders we've discussed, you can even put a brief

list on any call sheets. Freelance crews work on loads of projects every year, so just a few notes on the sheet they look at on the day of the shoot is always helpful (as is a quick pre-shoot phone call). Your list might look something like this:

▶ record 24 bit audio at 48 kHz

▶ shooting spec is 4k UDH at 24 fps

▶ two wireless lavs plus boom

▶ record lavs on 1, boom on 2

▶ audio slate interviews (list of names provided on schedule)

▶ day 2 note: boom camera mount mic needed for a car scene

▶ please take two outputs—one into camera, one to a backup digital audio recorder

▶ special audio considerations: Interview #3 on Day 2 is very soft-spoken and has a slight speech impediment

CONDUCT PRE-INTERVIEWS

Interviews are the heart and soul of many documentary narratives. In many instances, the entire story can be woven together from interviews without ever leaning on a narrator to do the storytelling. Since spoken word is so critical to your nonfiction project, it's essential to conduct pre-interviews, to "scout" the audio that you may get during your filming. The pre-interview therefore provides three critical tools to your storytelling. First, it allows you to ask some basic logistical questions and start building a relationship with your interviewee. Second, it gives you a chance to get a sense of the person, their perspectives, and their personal style. And third, you will be able to understand how their individual story fits into the larger story arc. The pre-interview will help you to build your story and your interview questions. This doesn't mean that you can't come up with follow-up questions or delve in other directions in the interview. But it does provide you with a baseline from which to piece together your story.

One of the best ways to have a successful interview is to conduct extensive research, which includes your pre-interview. I've found it best to conduct pre-interviews no closer than a week prior to the shoot. Ideally, there are even more weeks intervening. By conducting a pre-interview as long as possible prior to filming, you can also help to avoid having your subject say "as I mentioned to you yesterday" during their filmed interview, which becomes something you have to edit out in post. In my experience, two weeks is a minimum goal, after which people no longer say that phrase. I also like having this time prior to the shoot in order to play back the pre-interview, which I record with permission. I can get a sense of the timbre of someone's voice, the way they tell their story, and the rhythm and tone. All of these qualities inform me as a director-producer. The pre-interview can also help me provide important information to my sound engineer. For example, I might learn that the person is very soft-spoken or that he has a strong regional accent. I might learn that she tends to smack her lips just before answering a question. I may not try to "solve" all of these issues in the field, but knowing about them in advance and sharing them with my sound tech helps us do a better job on location. The pre-interview also gives me vital information to help me begin to map out the possible narrative arc of the story. I jot down notes for possible visuals to help support the story and, at the same time, any audio notes or ideas. For example, someone might be retelling a harrowing story from his experience during World War II. I might get inspiration for supporting the story with the crunching of military boots trudging through the snow or the ominous rumble of tanks rolling by.

Besides factual content, a pre-interview gives you lots of other essential information, including sound elements of your story. These might include a sense of the style of music that might best support the story. It could include some key sounds which are part of this person's world that you might need to collect during your location filming as wild sound or add later as sound effects during your sound design session. This audio information helps you plan for how you will reveal each character who is central to your story.

Many people in my workshops worry that by conducting a pre-interview the subject won't have any more stories to tell. To the contrary, you will get a sense of the key elements of the story arc—the back story, any central conflict or challenge, and any change that happened as a result of that turning point in the story. You may also find some topics on which you will want to delve further once the cameras are rolling. You may learn about any concerns they might have about telling this story. You will certainly learn

about issues that they will often not tell you in an email. Most conference calling systems now allow for recording. Always let the subject know you'd like to make a recording, so you can listen better and not worry about note-taking. I get my pre-interviews transcribed, which then helps me to develop a shooting schedule and a list of audio and visual assets I will need to acquire to tell this story.

TECHNICAL PLANNING

There are some fantastic microphones on the market that make any nonfiction producer's life easier. The categories of microphones you can choose from range from wireless and wired lavaliers to boom microphones as well as camera-mountable ones, and even parabolic microphones. You'll also have a range of audio recorders and field audio mixers, which we address in the next chapter. Before you or your sound tech make decisions about what tools to bring on your nonfiction shoot, you'll need to discuss *why* you need certain audio. Reviewing your goals and needs in advance will solve a multitude of on-set problems and ensure you or your sound tech bring the right tools for the job. If you are hiring a sound tech, your pre-production planning will amaze them, and they will be even more excited to help you bring your story to life with audio. They are likely to come up with some creative ideas you might not have considered. Even if you are a "one woman band" and must operate camera and sound yourself, you'll want to consider the following questions in advance. I've added some possible answers using a hypothetical shoot focused on a hospital surgeon, just to give you a sense of how this preparation might work.

Q: Will we need to record sync sound "dialogue" between characters? If so, is there one primary character, or does each character need to have their own "lines" recorded on separate tracks?

A: We want to record the dialogue between the surgeon and the ER nurse as they walk down the hall to the operating room. The surgeon is our main character, so she will already be mic'd. The ER nurse will have to return to his duties right after shooting this scene with us, so we may have to cover the dialogue with the boom microphone and also whatever gets picked up on the surgeon's lav. Bring two lavs, but we may only be able to use one.

Q: How much time will we have to cover each scene requiring sync sound?

A: We have four b-roll scenes and two interviews to cover on day one of filming. There are 40 minutes scheduled to cover all angles of each b-roll scene after set up time. There are 60 minutes for each interview after set up time.

Q: Will there be opportunities for the sound tech to request other takes for sound? Can we create opportunities to record wild sound? If yes, what are the wild sound priorities in terms of propelling the story? Could any of these be picked up on another day or at another time?

A: During the surgery scene, we cannot ask for second takes as this is a real-time surgery we are witnessing. We could reshoot "scrubbing in" on another day. Wild sound of the various beeping monitors and equipment could also be recorded on a separate digital audio recorder while we are recording primary sync sound of the surgical procedure.

Q: Is there any thematic or essential sound that we want to include as an element in this story? Will this sound be present in the background of any interviews? Is there a way to record it separately?

A: The beeping and humming of machines in the operating room is a key part of the environment the surgeon works in every day, so this audio is important to her character. We could record it on our Zoom audio recorder on our scout day, if needed.

Q: Will interviews be done inside or outside? What are the sound qualities of those environments?

A: We plan to interview our main character, the surgeon, in one of the non-sterile operating rooms that have not yet been opened. Two supporting characters will be interviewed indoors, in their office settings. One character will be interviewed on the hospital terrace, which overlooks trees. There is sometimes noise from the medical evacuation helicopter, so we should be prepared for that interview to take longer. It would be smart to get b-roll of the helicopter landing.

Q: If interviewing indoors, should we bring extra sound blankets to muffle echoing sounds in large spaces?

A: Sound blankets will not be needed at this location.

Q: If outdoors, will we need a wind screen for the boom microphone or any lavalier microphones?

A: Yes, see note above.

Q: Do we want to have microphones hidden for any scenes? If so, what audio are we trying to record in this manner and under what circumstances?

A: No hidden mics required.

Q: What is the sound mix plan for this project? Is sound being mixed "in-house" or at a professional sound mixing facility?

A: We will have a professional sound mix and sound design session for this production.

A: We will have four interviews, a narration track, a music bed track and an effects and wild sound track.

Q: Are any sound effects planned?

A: We will record wild sound of the various equipment of the operating room hums and beeps.

A: We are planning to use a transition sound effect between certain scenes that transition between surgery and recovery rooms.

Q: What kind of music is planned for the scenes we are shooting? Will there be scenes with no music?

A: The finished piece will be 30 minutes in length. We anticipate using a custom score. There is one scene—the surgery—for which we think there should be no sound other than what is actually happening in the operating room. (For more about how to plan for your music scoring session, see Chapter 9.)

Based on the answers to these questions, you can complete building your call sheets, your schedule, and your equipment list for sound recording.

PLANNING TO BACK UP YOUR AUDIO

Remember that since this is non-fiction, there are no reshoots; you'll need to get your audio right the first time. The final step in your audio planning for location filming is to ensure that you have a backup plan for your files. Generally, I use the "3-2-1" backup system for sound and picture, with an added layer of backup for sound files. We have three copies of every card in the field, which means when we back up the files, we duplicate those files on site. Two identical copies of all the files—including all audio files—travel back to our edit system, preferably not on the same plane. One

copy gets ingested and verified. I never "blow" cards until I've verified that footage and audio, meaning that every single frame has been transferred. Yes, I know this means buying more cards. A few hundred extra dollars spent is well worth it as there are no reshoots in reality and non-fiction production. The project itself is then backed up to either a RAID drive or to LTO (digital tape backup). In addition to this 3-2-1 system, I also like to have back up audio recorded outside of the camera, for example to a Zoom audio recorder. You just never really know what is happening in camera—you can't have headphones on every second if you are directing, producing, or conducting interviews. Especially for projects where there is switching back and forth between a camera-mounted microphone and an external mic, there is always the possibility that the switch doesn't get made as the day wears on...and on and on. Back up WAV files can save the day and often do!

You've thought through your characters and location. You've built a sound acquisition strategy into your production schedule. You've thought through your equipment plan and your file backup plan. It's time to go shoot!

> **PRE-INTERVIEW TIP:** Skype and Google Hangouts work well for pre-production meetings, but you may not want to use face-to-face tools for a pre-interview. People will often tell you certain things when they can't see you. And what they reveal can become vital elements of your story. During the pre-interview, you will also learn the subject's style of speaking, and any topics to delve into further or to avoid. For more tips on interviewing, see Amy's book **The Producer's Playbook: Real People on Camera.**
> (Focal Press/Routledge)

Tips on Prepping for Location Sound

▶ When planning your shoot, always consider sound. Use digital tools like Flickr, Google Maps street view, OpenStreetMap, and Foursquare to "scout" for sound.

▶ Remember to include sound specs in your call sheets.

▶ Schedule a brief time of b-roll shooting before an interview to warm up your subject.

▶ Conduct pre-interviews at least two weeks prior to the on-camera interview, if possible, to avoid having the subject refer to your conversation. Record the pre-interview with permission, and use that content to consider audio assets to acquire that will help support the story.

▶ Have a conversation with your sound recordist in advance of your shoot day. Focus on challenges and opportunities, which will help define what tools to bring to the project and how much time will be needed to acquire usable, quality sound.

▶ Make sure you plan to back up all your audio files, and even record duplicates to an external digital recorder for important interviews.

NOTE

1 www.youtube.com/watch?v=lSPQ66mu5Y0

4

Location Sound Strategies

Stepping out onto location is exhilarating. Finally, you and your team are here, in the place you've imagined, in the location you've been planning to film in for many days, weeks or even months. It's natural, as the gear comes rolling in, to take a look around for those shots you have envisioned or storyboarded. In this chapter, we'll address how to "look for great sound"— to find those hidden opportunities. And we'll also tackle some of the inevitable challenges of location sound when filming real world subjects in non-studio locations. Let's first start with the tools for the job.

FIELD MICROPHONES MATTER

In the last chapter, we provided a list of key questions to ask so that you or your sound engineer can bring the right tools for the job. Let's take a moment to talk briefly about the different characteristics of the most critical story-telling tools: microphones. You can learn more details from books, such as *Producing Great Sound for Film and Video* by Jay Rose (Focal Press, 2015) and *Location Sound Bible: How to Record Professional Dialog for Film and TV* (Michael Weise, 2012). There are several types of microphones, which primarily fall into two categories: omnidirectional and directional. Your production kit should include both. You will, of course, need to customize

your sound tools for each project, but you will begin to find certain tools are a must-have in any situation. My preference for small documentary-style projects with one or two main characters is to have a minimum of two wireless lavalier microphones plus one directional microphone on a boom. I also like to have a secondary shotgun mic ready to be camera-mounted for car setups and other situations where you want usable sync sound but don't want the highly noticeable and space-consuming boom. This is usually because it's a sensitive situation where the boom might prevent people from speaking freely or a situation where we physically don't have room for the sound person in the shooting space. For productions with more people on camera, or with very specific reenactments of action, such as for historical projects or training videos, you may wish to have more options at the ready. When you are preparing equipment for your shoot, you will have a wide range of microphones and mixers to choose from. Even if you do not own all of the needed audio equipment (or any at all!) and will be hiring a freelance sound tech with gear, you will still want to familiarize yourself with your sound tools. Some key types of microphones and ancillary gear are listed next. Note their characteristics as you develop the sound tools you want to use for your story.

Lavalier Microphones

A typical omnidirectional microphone is a lavalier microphone. Sometimes called a "body mic" or a "lav" for short, a lavalier is placed directly onto your subject and can therefore be helpful in filtering out some external sounds. When you put this on an interview subject or performer, you know that it will pick up their voice properly, even if they move their head from side to side. Another benefit of a lavalier mic is that wind noise tends to be minimized. You can put a tiny wind sock on it, but often this is not required. A lav can be used alone or in conjunction with a directional microphone on a boom. My preference is always to use both because I like the flexibility of mixing the two types of resonances and range of frequencies that result. But for budgetary reasons or because you are a solo operator, you may only be able to use a lavalier. If that's the case, choose a good one, and be sure it has a high number of selectable frequencies and the ability to "channel switch." This allows you to use a frequency with the least amount of interference. One of my favorites is the Sennheiser AVX Wireless MKE2, which you can buy packaged with the MKE 600 Shotgun Mic for under $1,000, representing a considerable savings (Figure 4.1). The MKE2 is a sophisticated digital wireless system that is a shape-shifter, being useful both as a wireless lavalier

FIGURE 4.1 The Sennheiser AVX-MKE 2 can be camera mounted or use as a lavalier (courtesy: Sennheiser).

or a camera-mounted microphone. It's also sensitive enough to be used as a hidden microphone to capture b-roll audio, such as mounting it in between the salt and pepper shakers to capture that bit of dialogue in a diner. I've found it to be sensitive enough to pick up the voice from a second person seated next to my interviewee. This was not an ideal situation—but what is, when you are working in real-world, non-fiction conditions? My colleague and I were recording pre-interviews for a documentary, taking advantage of having a unique group of people gathered, some quite elderly, for a family reunion. We made a last-minute decision to conduct an interview with a married couple seated together, but thanks to this powerful little microphone aimed in the right direction and Cheryl's talents as a mixer, we were able to use this sound for a demo reel for this project.

At a slightly lower price point, you can get a classic wireless lavalier system from Sennheiser, the ME 2II, which is part of the Sennheiser EW112P G4 kit and can also be camera-mounted. This unit costs about $600. You will also want to keep a wired lavalier in your sound kit or be sure your sound person has one. Especially if (as we mentioned in our chapter on scouting)

you plan to be filming in an urban high-rise. These buildings are known for having RF interference. And often they also have cell towers on the roof, which also cause interference. So even if you have a microphone that automatically channel-switches, you will likely be out of luck on a clean wireless channel and need to go to your wired microphone. This happened to me when I was filming on one of the highest floors of the Chrysler Building in New York City, a place known for a high quantity of frequency interference. Thankfully, that was also known to my local sound recordist, so he was prepared with a wired mic for our interviewees.

In-Camera Microphones

Besides the lavalier, another common omnidirectional microphone is the one that may be built into your camera. This is a mic *not* to be relied on for primary sound for the very reason of its location, which is generally too far from your subject for quality sound. Another reason not to rely on a camera mic as your primary audio source is the fact that as an omnidirectional microphone, it will pick up sounds from all around the camera, not just in front of it. However, using the camera mic as a secondary source can be very helpful, such as when shooting with multiple cameras. I like to keep the camera mic on a separate channel as "reference audio" to help in the syncing process, especially when we cannot always slate every take.

Shotgun/Boom Microphones

A typical directional microphone in your production toolkit is the mic you place on your boom, commonly referred to as a "shotgun" or "boom" mic. The most common type of shotgun microphone is a cardioid, named for its heart-shaped sound pickup pattern which is most sensitive to sounds directly in front of it. Cardioids are good choices for non-fiction filmmakers because of their ability to pick up what is in front of them—the b-roll action or interview you are recording—and reject off-axis noise, such as people walking by or other background activity you cannot control. Of course, a loud noise—such as an airplane overhead or a dog barking in close vicinity— will still be picked up in your soundtrack. So, it's important to understand that cardioids do not solve all potential sound "problems" when filming. But they can be an important tool in recording what is central to your story and filtering out what is not. A hyper cardioid microphone will have a similar heart-shaped pickup pattern to a cardioid but can also capture some frequencies behind the microphone. As a result, this option can give you

FIGURE 4.2 DP and audio engineer Kathi Overton checks her boom setup before an interview begins.

a little more "ambience" and can be a good choice if you are working in a somewhat controlled sound environment, such as a home in the country or other quiet space without competing noises. A super cardioid shotgun microphone is particularly good at the "filtering" of off-axis sound and some even use phase-cancellation for an even narrower focus. As a result, a super cardioid requires extremely accurate placement and expertise and may not be the ideal choice if, for example, your subject might slightly move their head or positioning during an interview or if you are not an experienced sound operator (Figure 4.2).

Camera-Mounted Microphones

Directional microphones can also be mounted onto a camera. This setup works well for b-roll sync sound. Camera-mounted mics also work nicely in situations like cars and other small spaces, where I have often captured some of my best audio "moments" for storytelling. (There is something about asking a person to talk to you while driving—they will tell you better stories than they will sitting down for an interview!) You can find a wide range of camera-mounted microphones with varied prices, from a few hundred dollars to over a thousand dollars. More expensive isn't always better,

depending on your usage plan. An overly sensitive microphone mounted on a camera will result in unusable audio if you are bouncing around. But if you use a microphone with low sensitivity, you won't get the audio you need either. Try to find something in the middle, so that you can capture high enough quality for an occasional sound up as well as good reference audio for multi-cam work. The Sennheiser MKE 400 is a compact camera-mountable microphone at a good entry-level price-point at just over $200. Rode makes a number of tools for on-camera use, with the Video Mic Pro with Rycote Lyre Shockmount being a popular model for "run and gun" production needs. Just remember that if you need primary audio when a person is moving around, a lav will be a better choice as camera motion can take the mic off-axis pretty easily, and any bumps may also be reflected in your soundtrack. Plus, it's just darn hard to plan camera shots exclusively for the purpose of gathering the best audio from a camera-mounted microphone.

Bi-Directional Microphones

Finally, there are bi-directional mics. These can be quite useful if you are recording an interview for a podcast, for example, and want to set up a person sitting on either side of the same mic. The microphone will pick up sound equally from the front and rear of the mic. In addition to using it for a two-person interview where you are facing your subject, you can also use bi-directional mics for certain situations recording musical instruments. One of my favorite bi-directional microphones is built into the Zoom H4n recorder. I can use it for interviews in a pinch but can also feed it audio from another microphone source. For my field sound work, I typically have a sound recordist using mixer, boom, and lavalier microphones, but we often record backup audio for interviews to the Zoom (Figure 4.3).

To wrap up this section on field microphones, I'd say that for primary audio, nothing beats the quality of a boom microphone handled by a field sound expert. When placed correctly, a boom microphone provides a more natural sound than a lavalier because of its wider frequency capture range. Cheryl calls it "having more air" in the sound. This helps you to place the action of your story where it really is, as opposed to isolating just one sound from all the others in the way that a lavalier can do. Of course, that quality of a lav is quite useful when you are recording someone moving around or speaking in a noisy location, such as a car. A lav can also give you the freedom to get the audio portion of the story without having the obvious boom, which can

FIGURE 4.3 Zoom H4n audio recorder has great flexibility in the field.

sometimes intimidate people, or just be too hard to fit into a tight space that is an important scene in your story. The bottom line is that I like the flexibility of being able to combine the audio from both boom and lav when I'm back in my edit room or mix room, and I keep the Zoom on hand for back up audio of interviews and to record any wild sound as we go. These three tools are a great combination for nonfiction storytelling.

OTHER FIELD RECORDING TOOLS

Microphones for Mobile Phones

More and more documentary producers and journalists are using their smartphones to record events. And let's face it, people will watch a story at

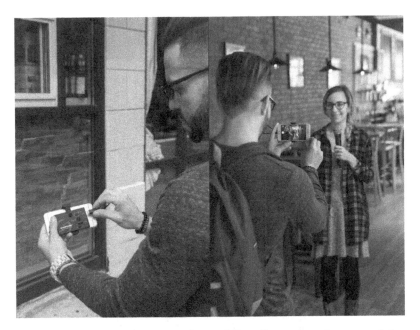

FIGURE 4.4 The Samson Go Mic Mobile allows you to record two channels of audio with your mobile phone © Samson Technologies Corp. 2019 www.samsontech.com.

a lower quality of video—of a skier headed down a mountain in a blizzard or breaking news from a conflict region—as long as they can hear good sound. Especially now that so many of these storytellers are solo operators, something lightweight, easy to use, and effective is a must-have. Samson makes a good Go Mic Mobile wireless system that you may want to consider. The kit includes a dual-channel digital wireless system with 13 hours of battery life, including a receiver that attaches directly to the back of your smartphone, tablets, digital camera, or tripod (Figure 4.4).

Parabolic Dishes

Parabolics have been on the market for a number of years and have their special applications, most often for sports. Now they are making their debut for other nonfiction filmmakers. A parabolic dish functions as an amplifer when you mount a microphone inside, allowing you to acquire sound from a specific source at a greater distance than you could record it otherwise. The down side of parabolics is that they can be large and awkward, and the resulting sound can be quite compressed. In addition, the mic must be

precisely aimed at the point from which sound emanates. But newer small and portable parabolics have entered the market recently and can allow docu-style filmmakers portability and flexibility for some interesting story applications. What if you want to record sync sound where you boom operator just can't go—as in gathering sync sound from a rock-climber ascending at great heights across a canyon from your camera position? Or what if you have multiple cameras placed for a re-enactment and need some reference audio for a distant camera, far from the main action? Then a parabolic might be of use to you. One tool that's been a recent comer in the market is the Sound Shark from Klover, a leading maker of parabolics, and you can actually mount a lavalier mic inside. Experienced sound recordist Mark Weber, CAS, told me that he and the sound team were able to use parabolics effectively to capture the on-the-field grunts and groans of the football players in *Any Given Sunday*. This gave a gritty, documentary realism to this Oliver Stone classic. As an added bonus, the sound crew appearing in the shots, which was appropriate to the typical sidelines scenes in sports coverage. Mark has also used parabolics for wildlife documentaries, including being able to cover a moose munching and breathing as if he were wearing a body mic (Figure 4.5).

FIGURE 4.5 The Sound Shark parabolic microphone captures audio for footage on the ski slope (courtesy: Klover Products Inc).

Field Headphones

Don't forget a quality set of headphones. There should be three people wearing them on location—one set on you, one set for your camera operator, and one for your sound operator. No, earbuds are not sufficient. They won't block exterior sounds and therefore can't help you determine what audio you are actually recording and what errant frequencies might be bleeding into your primary sound source. Likewise, open or semi-open back headphones will bleed audio and should be avoided. Meters are important, but they only get you so far. You need to *hear* the audio. Invest in a great set of headphones and you will not regret it. Options include Sony MDR7506s, Sony MDR 7510, and Sennheiser HD280. Considerations include comfort and how they fit over your ears and on your head. Every sound person has a favorite. The key is to use them. I read a very sad social media post about a sound tech who confessed he failed to record all the primary audio for an entire day in the field. One thing that would have helped the crew discover the problem would have been if the camera operator had worn headphones and monitored the feed going *into* the camera. Also, if the director had put on headphones and occasionally played back a take—especially any time a setup had been changed—that would have been another opportunity to discover that the audio feed was coming from the camera mic and not from the boom or lavalier setup. When I asked sound recordist and mixer Mark Weber how he made a decision about which headphones to wear, he told me this story. "I would see a commercial I had recorded playing on TV and they sounded 'brittle' to me." But then one day, he worked on a spot with a different company, and they sent him out with different headphones. "When I heard it (on TV), it sounded exactly like I remembered it. They were MDR600's—a larger, boomier headphone. As soon as I heard it, and analyzed it, I threw out my old headphones." We'll address more on headphones for mixing in Chapter 7.

Audio Recorders

You can, of course, record sound directly into camera. But there are many instances when you want to either record sound separately (as for wild sound) or just have a backup recording device for audio. There are many tools available to you for these purposes. Sound Devices 744t, 788t, 664, and 633, and the Zaxcom Nomad and Maxx are all time-tested digital audio recorders that also record timecode. If you use the Tascam DR-05 and -07 or the Zoom H4n and newer H5 and H6, you'll need to record timecode to an audio track. You'll want to know what timecode sounds like because

sometimes it can "bleed through" and interfere with your primary audio. The Zoom recorders have become ubiquitous, particularly for nonfiction filmmakers because of their versatility and affordability. The H4n remains an impressive four-channel digital recording device for under $200. The H5 and H6 have more features (and cost more) so if you are purchasing for the first time, consider whether this will be your primary or backup system. Another option is the Tascam DR100mkIII. This is a linear PCM recorder which supports 24-bit/192 kHz recording and can record WAV and mp3 files. Being able to record mp3s at the same time has a real value. First, you can quickly upload your interview files from the field, which I often do. Second, you can upload mp3s for social sharing from your shoot without using the larger, uncompressed original files (and without accidentally messing them up). Just be sure that your editor uses the WAV files to edit with and not the lower-quality mp3 files (Figure 4.6).

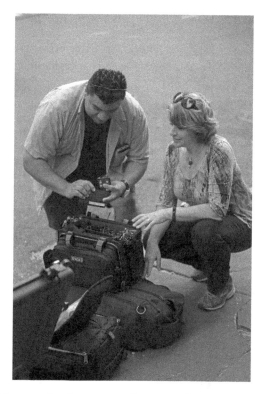

FIGURE 4.6 Always check your audio gear throughout the day, even when quickly moving between locations (photo credit: Joe DiBilasi).

Audio Field Mixers

A portable mixer remains a critical tool in any field sound kit, especially if you would like to "mix as you go" and get potentially usable mixes from many of your scenes. This allows you to focus your post on just those areas where you know you have problematic sound or want to spend more time with layering and sound design. A sound recordist uses a mixer to bring in and adjust the levels for a variety of audio sources from external microphones, camera-mounted microphone, or other audio recorders. There are a wide range of portable audio mixers on the market, with a wide range of prices depending on how many audio sources you need to bring in, among other considerations. John Biewen, host of the podcast Scene on Radio and Audio Program Director at the Center for Documentary Studies at Duke University, swears by his Sound Devices Pre-Mix 6, which he uses with a Sankin CSS 5 microphone. The Sankin is a pricey microphone at $2,300 but is extremely high quality (Figure 4.7).

Sound Devices also makes a smaller Pre-Mix 3 that provides a lightweight design and integrated USB audio streaming and can be mounted under a DSLR.

FIGURE 4.7 John Biewen records Hopi farmer David Pecusa (photo credit: Monica Nuvamsa).

Sound Blankets

Here's a tool that's not sexy but is a must-have for anyone recording sound. It has the benefit of being the least expensive tool in your kit. Perhaps for that reason, sound blankets get short shrift. Please, buy sound blankets! In fact, buy five or more. They will solve a myriad of audio issues when you are presented with challenging environments, such as especially large rooms or rooms with hard surfaces. Here's an example that happened to me quite recently. I was scheduled to conduct an interview with the CEO of an environmental organization in California. Our plan had been to do an exterior shoot, bringing the obvious nature connections into the frame around her shot. On the late fall day we arrived in Los Angeles, we discovered record-breaking temperatures over 100 degrees, plus wildfires creating a haze over the distant hills. The organization offered us their conference center, which turned out to be a large concrete box, with 25 foot ceilings and floor-to-ceiling glass on two sides. We swung into action and created a beautiful little sound cocoon in one part of the building where we could see dappled lighting through tree branches in the background of the shot. I have to admit it looked pretty nice. The CEO complimented us when she saw the shot, saying that she's been interviewed there many times and no one had thought of creating such a space where nature could peek through. We certainly used a record number of sound blankets and actually turned over a couple of long folding tables to block even more light and sound.

WHEN THE HUMAN VOICE TELLS YOUR STORY

Now that you've considered all the tools for your location kit, let's talk more specifically about one of the most essential sounds you will be recording: the human voice. For nonfiction storytellers, people speaking—whether to one another, directly to camera, or to us as interviewers—are usually required to move along the narrative. In some cases, you might even be filming reality-style pieces or training productions that involve reenactments, where some of the people will need to deliver fairly specific lines of dialogue. And yet in all of the above cases, your human subjects are not actors. They do not have the control over their voice instrument that actors do. And frankly, even if they did, you wouldn't want to make them too self-conscious about their inflections, accents, or volume levels. Proper microphone positioning will help these non-actors deliver what is often a substantial part of the audio

portion of your story. The standard placement for a lavalier microphone is in the upper section of the chest, away from anything that could interfere with sound, such as a scratchy shirt, scarf, or tie. For a smaller or higher voice, the placement may need to be slightly higher and closer to the chin. For a deeper, stronger voice, that placement may need to be slightly lower. A good rule of thumb—literally—is to have someone hold their fist with their thumb sticking up and just touching their lower lip. Wherever the bottom of the fist is will be about the right spot for your lavalier placement. (Credit to my friend Director/DP Douglas Spotted Eagle for this great microphone placement tip).

With a boom microphone, the distance from seated speaker is generally around 14 inches but closer with a smaller voice like a child's and a bit further away for a robust male voice. For both boom and lavalier positioning, you will want to listen carefully in headphones, especially if you are conducting a series of interviews in the same location. Don't assume that the boom that you've rigged on a stand won't move from its previous position. Check. It's worth the ten extra seconds. When covering a dialogue or b-roll scene with a boom, you will always have to think about whether the boom can be seen in the shot. There is constant tension between getting great sound and capturing the right visual. As a director, I try to navigate between the two and sometimes find myself in the position of "peacemaker" between the sound department and the cinematographer.

Beyond standard audio capture procedure, consider story context and workflow plan when miking for the human voice. Generally speaking, you want to deliver top-quality, clean audio that could be used as narration or "sound ups" in your film. But sometimes you will also need to consider the spatial environment and speed of post-production workflow and budget. Let's say you are shooting a walking scene with two of your key characters in a large, echoey space like a parking garage. They are chatting with one another. Your story will sound more authentic with a little bit of that boominess in the audio. You could accomplish this using traditional sound coverage from body mics and a boom microphone and mixing those in post. Or your field sound recordist could adjust the body mic positions to be a bit lower and further from the mouth than usual so the mics pick up some of the room sound. Additionally, if you are also booming the scene and your recordist knows how to use a field mixer, she could "mix on the fly" and add in a bit more of that room sound from the boom feed, so that

you don't need to go back and do a mix of this scene later, thus saving time and money in the post-production process. This is great, especially if the isolated unmixed mics are still available in case you want to make some adjustments. But realize that if you mix in the field, you will not be able to make changes in post.

Objects and other electronic signals can interfere with good sound on location. In our home base of Washington, D.C., there are a few places like the street in front of the State Department and near the White House where you will not be able to get a quality wireless mic signal because government agencies are jamming those frequencies. As we previously noted, hard surfaces can make sound bounce too much (unless you are filming sync b-roll in a large space that should sound that way). Appliances and office machines make all kinds of low frequency hums that interfere with good sound acquisition. So does the clothing that people commonly wear. Silk ties and scarves can cause a scratchy sound coming from a lavalier placed there. Some shirts with too much starch can do the same thing. Keys jingling in someone's pocket and a ringing cellphone can interfere with sound. Even phones placed on vibrate can interfere with microphone pick-up, so I always request that every phone is off, period. (This includes the crew's phones. There's nothing like interfering with your own production—so embarrassing!)

TO HIDE OR NOT TO HIDE

As a filmmaker, I'm often faced with the dilemma of whether or not to hide the microphone. My priority is always clean sound, and I believe that audiences are sophisticated, so they know my subjects are being recorded with a microphone. So, I tend to hide lavalier microphones less and less as my career goes on. You may have a different opinion, based on the kind of story you are covering, your characters, and, frankly, what they are wearing and the environment in which you are filming. For example, some interviewees may be quite uncomfortable with "dropping the mic" chord down their clothing for optimal hidden placement. Hiding the mic can also lead to problems with clothing rustling against the mic and decreasing the quality of the sound or, in some cases, making it unusable. A visible mic will generally mean a faster audio setup, which is sometimes necessary. Ultimately, you will need to make a "game day decision" at each setup. Always listen in the headphones to make your final choice in the field and on set.

TIPS FOR BETTER SOUND COVERAGE IN DIALOGUE SEQUENCES

When working with non-professionals, you will have to be strategic in your sound and shot coverage. Unlike professional actors, these "real people" will never repeat words or actions in an identical way from shot to shot. For a film with actors, you would normally cover a scene with an establishing shot. Then you would go in and get your two-shots, followed by your singles and over-the-shoulders. Reversing this process can be extremely helpful when working with non-actors, especially when the b-roll includes some form of dialogue. When filming a young couple in their kitchen, chopping vegetables, for example, my schedule called for shooting their interactions with either other first, in a loose two-shot. Next, I covered closeups—for sound and picture—of the chopping, knowing that they would tire of this quickly. Only then did we back up our camera and shoot a wide shot from a vantage point that didn't allow the viewer to see exactly what was on the chopping board, avoiding any continuity problems. By shooting tight to wide, rather than wide to tight, you can make the audio more usable in such a scene, as well as the picture. Sometimes we roll without telling our "talent," so they can act a little bit more naturally, and we might get some great audio to use. I know several directors who use this technique in interviews as well. I prefer not to lie about whether or not I've cut. What I will do is ask my DP to keep rolling after I've said, "well that's my last question" because I will often pause at that last moment of the interview and see if the person would like to share anything else. Often they do, and it ends up being great audio to use.

B-ROLL SOUND STRATEGIES

In our planning chapter, we talked about building in some "warm up b-roll" before interviews. Choose something familiar and not too complex in terms of camera coverage. Your goal is getting to know your subject but also getting quality, informal sync sound of them doing a task relevant to your primary story line. If you are filming a parent who's parenting role helps inform the narrative, hop in the car or walk behind him dropping the kids off at school. If you're interviewing a CEO, spend some time filming her checking work emails and making a few calls before you film your main interview. Or maybe she's taking her dog for a walk, showing a more personal side of her life. Whatever you choose, this warm-up can provide important sound "moments" for your story and put your subject at ease in a comfortable or familiar setting.

In terms of microphone coverage, you can of course go with a boom for this b-roll sync sound. Sometimes I prefer a small boom mounted on the camera to keep the footprint of the crew pretty tight (with my field sound engineer monitoring this mic at the mixer). In other cases, a well-placed lavalier can pick up the sound. If you are not planning to pick up speaking and are covering a scene from a wider shot framing, you might consider putting the lav in someone's pocket, or further from the center of the chest, to emulate the distance from the camera. This is a personal choice, of course. Many producers want all the sound "up front" so they can make decisions in a mix after the fact. But more and more productions are expecting on-the-fly mixing, in which case ensuring that your sound story coincides with and supports your picture story becomes even more important.

THE IMPORTANCE OF "SILENCE"

We've put the word silence in quotes for a reason. There is no true silence. Just different qualities of spaces without imposed sounds like an interview over top of them. Room tone is what we most often think of when recording silence, typically just after an interview. But getting more defined room tone, especially for long interviews, gives you more editing options since the sound of a room or space can change over the course of minutes, let alone hours. In addition to getting more intentional (and slated) 30-second segments of room tone, let your shots run a little long before cutting. That might mean nodding your head for a few more beats at the end of an answer to an interview question. Or just counting "one-Mississippi, two-Mississippi" in your head before cutting after a lovely bit of natural dialogue or sync sound. In fact, you don't even have to cut sound when camera cuts. Especially if you are using time of day timecode (which I always do), everything will stay in sync. And you'd be surprised how many wonderful little audio moments arise after camera cuts. This can help your sound storytelling immensely by giving you more tools for layering and editing in postproduction and mixing.

RECORDING WILD AND FOLEY SOUND IN THE FIELD

In nonfiction storytelling, we have so many wonderful opportunities—often missed—to bring characters to life through sound. Capturing wild sound

in the field is one of those opportunities. Miami sound mixer Mark Weber shares one of his experiences capturing wild sound: "I worked on a project down by a lake with marshland. There was all kind of wildlife—ducks, dogs, water noises—the location had such a character, so I was walking along the water and recording all these [wild sound] elements. The director said to me afterwards 'I had all this music picked, but there was such richness in the ambience that it told a better story.'" That's your goal with wild sound for nonfiction, too—helping to tell the story through the richness and nuance of location sound.

STRATEGIES FOR RECORDING LIVE MUSIC

Recording music is its own specialty. Different instruments present wavelengths at different parts of the sound spectrum. If you are recording amplified sounds, then you have additional considerations. Generally speaking, with amplified sound, I want to take a "feed" from the board—an output of the sound mix that is being created live in the moment. I also like to place microphones in a few key places in the room if there is an audience. If you aren't miking the audience that appears in your footage, it's going to sound "wrong" to the viewer for you to use only the microphones on stage. That's because these are likely cardioid mics, designed to pick up only the musicians. What you see, you want to hear. So, if you hear applause and an audience hooting and hollering, that should be part of your soundtrack, and you should make an effort to collect some of these sounds live. You could accomplish that by adding some up-firing mics (literally pointing in an angled way towards the crowd) and recording that full room sound to a separate track for future mixing. For a symphony orchestra, placing most of the mics close to the center makes the most sense. The conductor is at the center of the orchestra and therefore is effectively directing the live "mix" of sound as it heads out to the audience. Wherever she is standing is a good starting place for an initial miking position. You can then add other mics as needed for additional instruments that are not coming through in a balanced way from that position. One thing we must note: an important element of using live music in your story is rights. Even if the music is in the background of a scene—for example, coming from a stereo or from the jukebox in a bar—you may still need to get the rights for it to play in your movie. See Chapter 8 for a detailed look at what producers need to know about music and sound effects licensing.

CHALLENGING SOUND ENVIRONMENTS

Over the years, we have encountered many difficult sound environments. I get to tackle them in the field. Cheryl gets to fix them in post-production. Here are a few suggestions we have for solving or minimizing challenging sound situations.

- ▶ Working with Children: The best way to get good sound from kids is to let them have some fun and get to know your crew before you begin. I usually take them around to see all the equipment and meet everyone. This helps them avoid being distracted by those very things once we begin rolling. If they are extra curious, we might let them pretend to be an announcer or do some small production task for us, like slate the scene. Whatever it takes to help them feel comfortable and part of the team, not the subject of scrutiny.

- ▶ Filming Off-Speed: When filming off-speed footage, remember you won't be able to record sync sound. So, if you need to shoot a scene of something that is going very fast—let's say a race car or sports scene—and you decide to shoot at 60 frames per second (fps), make sure you grab that car going around the track another time at 30fps, so you can get the roar of the engine. Sometimes it's not possible to grab an emotional moment twice—such as a father and son being reunited after an anguishing separation. So, for this scene, you might shoot your primary camera at 120fps and grab a second angle with another camera at 30fps, so you can record sync sound. Or pick up some wild sound with a digital recorder. That way you know you are covered for both sound and picture.

- ▶ Sensitive Situations: In sensitive situations, such as at a hospital bedside or in a low-income neighborhood where we don't want to call attention to our equipment and our on-camera subjects, my goal is to be sure my story happens. I don't want people being afraid of the boom microphone—which for some reason seems to call attention to itself much more than cameras do. I've been known to ask a sound recordist to step back and remove a boom from directly over the scene. Even though I realize I won't get as good primary sound, I'm making a call that this scene may not

happen at all if everyone is looking up at that odd-looking thing over their heads or is suddenly acting nervous when answering my questions. Sometimes, I will just kill the boom entirely and go for a quality camera mic and perhaps a well-placed, hidden lavalier microphone. The story is everything.

▶ Windy Situations: Obviously, there are a myriad of wind protection solutions that we commonly call "wind socks" for every microphone. Use them! I'm always surprised at how often people won't pause an exterior interview when the wind kicks up but will stop it for a plane going overhead. The amount of noise introduced is probably worse with the wind. Of course, it's best to start the interview with the wind sock on if there's any chance of windy weather since it will look odd to have it suddenly appear in your shot for later takes.

▶ Extremely Loud People: If someone is yelling and likely going to stay at that high volume level, then you just have to adapt your record levels. You may have to use dampeners (some microphones have attenuation options, or you can use settings available on your mixer). Better yet, turn down the level on your transmitter if using a lav, or simply move the mic further from the speaker's face. Yes, this may disrupt filming. But if you simply turn down the level on your mixer, that may result in lower recording levels across the board and not solve the problem (often called "clipping"—where the peak of the sound level goes higher than optimal levels and can get automatically adjusted by your software). If you are a novice at audio recording, it's worth reading some of the books we have recommended, which go into more detail on gain staging and how to set your gain levels to minimize noise and distortion. Your bottom-line goal is to keep your story authentic and avoid over-modulation or distortion, both of which are time-consuming to fix in post.

SOUND ON THE RUN—TRICKS AND TOOLS

Sound gathering often gets short shrift when you are in a "run and gun" environment. There are some ways you can avoid getting stuck with poor sound.

► Keep your cables together. If you are moving fast, it's easy to lose track of your cables and your gear.

► Be sure you take time—even on the run—to check audio playback. Especially at the start of an interview. Just grab a quick test and double check. Cables do come out, and cards do get jostled when you are on the run.

► Use a lavalier microphone if you must shoot and record an interview yourself. A camera-mounted microphone is unlikely to get the ideal angle for usable interview audio, unless you are only shooting very short "man on the street" type soundbites.

► If you are shooting "b-roll" with a camera-mounted mic, remember that when you swing the camera around to get another shot, you've just lost the sound that you were picking up with the previous shot. It's easy to get focused on picture in a run-and-gun situation and forget that sync sound is happening, too. Listen to what people are saying. If you are covering a meeting or some kind of dialogue interaction, be sure to let a person you are focused on finish a sentence before you swing around to get a shot of someone else. Do "on air" zooms—gentler pulls in and out from a subject—if you want to keep the continuity of audio.

SOUND WORKFLOW IN THE FIELD: METADATA ESSENTIALS

One of the most overlooked components of sound production in the nonfiction world is file naming. It's hard to get excited about file-naming conventions, but it can affect your success from production through post-production. People often make "game day" decisions about how to name their sound files, rather than thinking through how they will be doing their post-production and whether or not those files might need to be used by multiple productions in the future. Make sure you define your file-naming protocol for the project, including how to slate audio and which tracks will be recorded to which channels, for easier identification in post-production. Don't fall into the common trap of labelling your first shot "Day 1, Take 1." Trust me, Cheryl would be millionaire if she had a dollar for every shot labeled "Take 1" that she and her team have

FIGURE 4.8 Sound report from a day of filming.

received! If you can add just one additional piece of information to your sound takes—such as Day 1 Take 1 AZ (for Arizona)—you've made your post-production process easier. In both your sound report and on your camera cards, add information about frame rate and bit rate (Figure 4.8). Both visual slating and audio slating (by speaking into the mic before the take begins with information) provide optimal information for the post-production team. If you aren't using slates—and really, why not as there are so many inexpensive slate apps for smartphones—a simple hand clap will do. This will let you or your editor know there is some important audio coming here. The clap will also provide a sync point in post-production to assist in relinking double system audio. Every piece of field information you provide will assist in file organization for less stressful audio and video editing (Figure 4.9).

As you develop your file-naming protocol for each project, think through those elements that will affect your naming, such as having multiple cameras for a single scene. Since as a rule you never want to change the name of your clips (because there may be AIFF files associated with those names, and you could lose the audio), take a few moments in your preproduction phase and come up with a file-naming protocol for your project that will work from start to finish. While all digital NLEs (non-linear editing systems) have similarities, each has some peculiarities you'll need to know for your audio workflow. In addition, be aware that because PCs and Macs

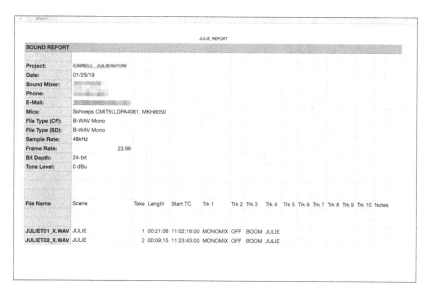

FIGURE 4.9 Clear audio metadata labels in the field make for more efficient editing.

have different protocols, certain symbols should never be used in your file-naming structure. This means it's best to use International Organization for Standardization (ISO) standards for dates with hyphens between the year, month, and day (e.g., 2020–01–14). Avoid using non-alphanumeric characters and punctuation marks. Some operating systems or drive formats will view colons or slashes as something other than a file name, so they should be avoided when creating file or folder names. I also like to include the initials of the DP since sometimes in the editing room we'll need to ask a question about how something was shot (or get a LUT for footage shot in RAW) and these folks have an incredible visual memory for details.

Be sure you establish a workflow for any interviews you are recording. On projects with a quick turnaround, you may need to export mp3 or WAV files directly from the field and upload them to your human or AI transcription service, even before your media gets ingested for editing. This is one reason I like to record backup audio on interview days to an external digital audio recorder. Ensure that you are recording timecode and track information for each interview or speaker. Important metadata you'll want to have includes speaker name, frame rate, sample rate, and bit rate. Put as much of this information as possible into the audio files themselves—most recorders will allow you to add metadata. Audio slates are also a great tool, especially

for conveying changes such as switching channels between microphones, which sometimes happens accidentally. Physical field notes that go with the data are great, too. We'll talk about this more in Chapter 6, *Preparing for Your Sound Mix*.

Location Sound Tips

▶ Consider microphones carefully before going out into the field. Generally, you will want an omnidirectional option, like a lavalier, as well as a directional option to mount on a boom. You may also want another directional mic you can mount on the camera for intimate setups and usable b-roll sound.

▶ If audience or ambient sound is part of your story, be sure you are not cutting it out entirely when you choose your field recording tools. Consider recording wild sound and plenty of "room tone" in order to add ambience back to a scene in post.

▶ Audio recorders, mixers, and headphones are all essential tools for recording quality audio in the field. Be sure to do an audio check with headphones by playing back from the recording, not simply listening to the source coming into the microphone, so, you are certain you are hearing the audio as recorded.

▶ Consider using wired lavaliers in tall buildings, which commonly have frequency interference.

▶ Whenever possible, be prepared for challenging environments and people with different microphone configurations.

▶ Make a metadata plan before you arrive on your shoot, so everyone on the team knows how to label files. Consider recording backup audio for any interviews to an external recorder, not just to the camera. This also helps with fast turnarounds on transcripts.

5

Voiceover Narration and Story

Narration sometimes gets a bad rep. We have all heard a video—possibly in the training or educational genre—where the narrator puts us to sleep. The script may be the culprit. Or the choice of reader. Or the style of the reading. Or possibly all of the above. In fairness, the narrator or copy may not be to blame. Other critical audio elements may be missing—things such as compelling interviews, provocative music, authentic sound design—and so the production leans too heavily on the narration to do all its storytelling work. In many instances, narration isn't called for at all. We both work on many productions where we intercut interviews to tell a story without relying on any "outside" voice to connect the threads. But for many nonfiction projects, narration is an important story element. Choosing the right voice for your story, and then guiding that talent through the narration process, is an art unto itself. This voice is most likely the backbone of your story, so you need to give selecting and directing a narrator the proper time and re-sources. We know that sometimes this process gets shortchanged, so we will try to shed light on a few of our experiences and best practices.

CHOOSING A NARRATOR

When you are cutting a story, you may hear a certain type of voice in your head that you feel will work best for the narration. Of course, another

approach to narration is to not have voiceover at all. Weaving the story with archival footage, sound on tape, and interviews is challenging, but a rewarding way to create a story. Not all stories lend themselves to verité though. You can try using character voices as reenactments or reading in the first person, but this can come across as gimmicky if not woven into the story well. If you decide to go the route of voiceover, it's never too early to start listening to options for the voice of your story. Thankfully, this is easy to do with many online collections of voiceover talent. Decisions about narration often center around budget, which sometimes means deciding between union and non-union talent. Voiceover professionals who are union are members of the Screen Actors Guild and the American Federation of Television and Radio Artists (SAG-AFTRA), two collective bargaining entities who joined together. The union negotiates and publishes standard fees for all acting work, including voiceovers, with fees based on distribution platform, length of recording session, and other factors. Included in the fee is a small percentage known as "P&W" (Pension & Welfare) so that these actors can have access to healthcare and retirement funds. The big difference between the union and non-union voice talent used to be experience and cost, with non-union talent costing less but generally having less experience. However, the internet has changed the landscape for voice talent. At one time, a voice professional would join the union as soon as they garnered the necessary credits because union membership could offer better access to jobs and secure pay and benefits. Today, voiceover artists do their own marketing and can still make a good living even if they are non-union. However, they have to manage their own healthcare and retirement planning. For some broadcast work, you are required to use union talent because of agreements signed by the broadcaster. To do so, you must be a union "signatory"—a party to the union agreement. If you are not, which many independent producers aren't, you can hire an intermediary talent agency who can handle the pay-mastering for you. The term pay-mastering means that for a fee, an entity you hire handles all the payments to subcontractors. (By the way, there are pay-mastering firms who handle crew payments, too.) Union members can tell you which pay-mastering firms they like to work with, so this is not a barrier to booking a session quickly.

The choice between hiring union and non-union talent is yours alone. We know people who only choose union talent because they believe in the union to provide tested and seasoned talent, while also believing in the union as a protector of the worker (for the health insurance and pension benefits mentioned). I know others who will only consider non-union talent because they

don't want what they consider to be the hassle of paperwork and strict fee structure. In the end, what's most important is that you ensure you are getting the talent you want that will deliver a strong story element for your production. Paying a little more also generally gets you good will for the occasional "pick up" or correction, once you start editing. (This privilege should not be abused. If you have more than one or two, you should pay an additional session fee for the voice actor to record them for you.) Hire the best you can afford.

Once you've decided whether to go the union or non-union route, what comes next? With literally thousands of voices to choose from, how do you make your selection? Sometimes, you know up front that you prefer a particular gender and a specific age bracket. These choices may be dictated by the target audience for the piece. One producer I work with casts for both male and female voices each time, even if the story seems to lend itself one way or the other. This gives her the option to test out choices and perhaps decide against a stereotype. That could mean, for instance, choosing a female voice rather than a male voice to narrate a "traditionally male" genre such as a military training film or a documentary on the history of motorcycles. Using a female voice with a distinctive tone could be just the right call.

When choosing a narrator, consider the dialogue in your story. If the interviews are primarily with women, consider a male voice to give the story a tonal balance, and vice versa. Voice range and tone in a narration track can offer needed contrast to both the other voices in the story and the music. If you plan to interview many young children, then you might select a lower-pitched female voice to contrast with the children's higher-pitched voices. Or, if you are planning a score that includes some heavy brass instrumentation, you might choose a big, low "Darth Vader" voice to cut through those broad wavelengths. Remember, the narrator is a character in the story, too, and should be given his or her own place and identity. Emmy-winning voice artist Melissa Leebaert explains,

> As an actor you are trained to embody a character and a role. And I need to convey the pictures I see in my head, so the listener does too. No one wants to hear you read. They want to hear you tell the story. So, whether it's a 30-second commercial or a one-hour documentary, you are telling a story.

Even if you select a voice with a subdued tonality, that choice still must support the style and content of the whole story. For example, Amy decided to hire a

FIGURE 5.1 Voiceover talent Vanessa Richardson records a narration in her home studio.

female narrator with a very calm, smooth tone for an animated production that would play in a hospital for parents with a child in the Intensive Care Unit (ICU). We can't imagine anything worse than having a child in the ICU. So this calming presence was intended to convey confidence to parents who are distressed, so they can focus on the information contained in the film about how to be the best advocates for their child during a hospital stay (Figure 5.1).

The creative decisions surrounding narration are often easier to make when your edit is taking shape. To help you with this process, ask your prospective talent to read and send you a few lines of script as part of your audition process. It is customary to request these as mp3 files, with the understanding that those are not of sufficient quality to be used in a final program. In some cases, talent will "watermark" these files so that they cannot be used in a final version without payment. (Unfortunately, some people try to use auditions to get around paying voiceover artists.) We recommend requesting a few lines from the opening or "tease" of your script, plus another section from the middle. If your end-product will be short, such as a 30-second spot, asking for a complete read as an audition is not uncommon. Requesting a custom audition not only lets you test the timbre of the voice and style of reading by a particular talent, it also lets you test the quality of the studio in which they are recording.

While once they used professional sound studios, today a majority of voiceover professionals have set up home studios from which to record. This practice reduces your costs since you don't have to pay a separate recording studio and engineer fee. Some talent will rightly add a small charge for managing the recording process since this usually requires them to spend some time doing file management and even some limited editing after your session ends. Unfortunately, the use of home studios has also resulted in some inferior recordings. When working with a narrator you haven't used in the past, or when you are not asking for a customized audition reading, you can still ask for a test recording before booking your session. We recommend it. Send this test along to your sound mixer to be sure the microphone and recording environment don't pose any problems. Don't worry, your audio engineer will be thrilled to check it out for you. Because they will be the ones dealing with problems, or potentially having to give you the bad news that parts of the recording aren't usable, good engineers would prefer to head those problems off before you are under deadline to mix. When interviewing potential voiceover talent, ask for the software, equipment, and microphones they use to get an idea of their setup. A home studio doesn't need to be elaborate. But it does need to deliver the quality you require. So, it is important to consider the studio as you conduct your audition process.

PREPARING FOR NARRATION SESSION

Once you've selected your voice talent, it's important to spend some time in advance of your recording session discussing your script with them. They are not just reading your script—they are performing it. And the more they know about it, the better the performance. It's a great idea to send your script in advance of your session so your narrator can understand your film and jot down some questions to discuss prior to your recording session. Even better, send them a link to your cut. Even if you are putting the finishing touches on it before the date of the session, seeing the cut helps your talent start to prepare mentally for their delivery.

Most voiceover professionals would like to know the answers to these key questions:

▶ Who is the audience for this video?

▶ What kind of tempo do you want for this piece?

▶ Will I be reading to picture or given certain timings I must come in at for each section?

▶ What kind of music are you using, and is it different for different sections of the film?

▶ Is there a particular tone you want to strike (or avoid)?

▶ Can you provide a pronunciation guide to any names, places or organizations? (Be sure to include how you want acronyms pronounced)

You can and should plan to play an active role during the voiceover recording session, even if your script contains some notes of direction. In fact, most voice actors want the participation of the director to help them shape the read. The process should be collaborative without being complicated. Give the voice actor some idea of what you're going for in style and approach to the story. Listen to them deliver a few lines and offer constructive feedback. Sometimes it's useful just before the start of the session to let the actor give you one set of lines a few different ways, so they can show you how they can interpret the material in nuanced ways. You'd be surprised the impact of changing pacing or tone.

Even if you choose your narrator early in your production or post-production process, use a scratch track in place of final voiceover until the cut is near completion. The script may change slightly each time you make revisions to your edit. Plus, the script usually needs to be a vetted by other producers and/or lawyers before you receive a final approval. You want to avoid the time and cost of rerecording when possible, so waiting until you have picture lock is wise.

MANAGING YOUR VOICEOVER RECORDING SESSION

If your talent is making the recording from a home studio, or from a studio not located where you are, then it is likely you will direct the recording session from the phone or a computer feed. A studio engineer should know to mute your director's line before recording, but sometimes a talent making their own recording will forget this because they

are managing a number of different details as well as preparing to per-form. Be sure the talent mutes that feed or has it totally separated from their microphone feed when recording the takes. It's really disappointing when a great take is ruined by mixing in the phone, computer noise, or voice of you, the producer. Remember, too, that the voice is an instrument. When possible, try to schedule recording sessions in the morning (in the talent's time zone), but not too early. You want enough time for the talent's vocal cords to warm up, but not have them deliver a tired read at the end of the day.

A note about including timings for your voiceover session: Timings on the script can help keep the correct pace of the edit and are essential for closely timed pieces. But talent can get obsessed with timings, which may affect their reading style. So, we suggest not putting timings on the script itself, unless you are working with a seasoned professional who special-izes in this type of work. You can keep a version of the script with tim-ings and run a stop-watch as you direct the session and then make subtle suggestions to accelerate or decelerate certain sections. A veteran audio engineer can usually tell right away if a long take will be workable for your final mix. It's a good idea to understand where your cut could have some flexibility, and where it cannot as some reads will not be precisely what you estimated. In the non-broadcast world, exact total running time is not as important, so you have the ability to go with the best read, even if it runs a bit longer than you expected. In the broadcast world, precision is required. I sometimes ask for slower reads, just to get the right approach. Often, that slow pace is really only a few seconds longer than needed and is totally usable.

As we discussed in Chapter 1, *Sound Basics*, sample rate and bit depth mat-ter for recording quality. Request that your narration recording be made at no less than 44.1kHz and 16 bit. 48kHz/24 bit is the standard for digital video. Often voice recordings are made at 96K and above. Also request that the recordings are originated as WAV or AIFF files and not mp3. Mp3s are convenient, but they derive their smaller data size by filtering out frequen-cies and range. Recordings made as mp3s do not improve suddenly when transcoded to WAV or AIFF. When recording, ask that the takes be labeled with a project code, the talent name, and the date. This will come in handy later if you need to switch to a different talent or record more lines on an-other date.

As previously mentioned, when working with voiceover talent it is important to get a sample of their recording quality prior to engaging them if you can. Many voiceover artists use a home recording studio, and while many have invested the time and money to outfit these with proper tools, such as quality microphones and sound dampening on walls, every now and then you will discover problems that will cost you time and money to fix in post. Two common issues are having other sounds bleeding into the recording or poor microphone placement. Things to listen for include outside noises, such as dogs, lawn mowers, and sirens, as well as inside sounds, such as printers and phones. When directing a voiceover through a phone patch, be sure you don't hear the phone feed mixed in. When discussing what deliverable you want for the recording, ask for as "flat" a recording as possible. Flat means there is no EQ or compression added. Even after requesting flat, when we are in the sound mix studio we'll often discover a small roll-off and compression in the narrator's voice. A roll-off at 50Hz is usually a safe way to attenuate noise, without much effect on the voice. Remember to request audio files from narrators to be *recorded at* 44.1K 16 bit mono WAV or AIFF or 48K 24 bit mono WAV or AIFF files, never mp3s. The *record sample rate* is the most important.

When directing talent, there are many techniques for getting a "good read." If there is a particular phrase or tagline that you want to use, and you're not quite sure what emphasis you will prefer, try asking for a "triple." This means the artist will say that line three time in a row, with just a small break in between each line. Triples are an excellent way to get different approaches to sentences or groups of sentences, especially for difficult sentences or ones that you want to emphasize. It's also an excellent way to get a rookie, or non-professional who must read, comfortable with the process.

It's important to get the right tone and pace for the read at the beginning of the session. Having a relaxed conversation prior to the start of the official record can go a long way to achieving your goals. However, during the session, try not to over-direct or interrupt the talent. This can cause your reader to lose their train of thought and give a poor performance. The same goes for stopping the talent too much along the way. You will prevent them from getting into a rhythm. It's better to make small check marks on your script for any sections that could use a second pass. You can return to these later, once you have gotten through a longer section of the script. Often, we call these rereads "pickups," and audio mix engineers

are accustomed to finding them at the end of the larger chunks of the recording session.

One common technique we both use at the end of our narration sessions is to go back and record the beginning of the script one more time. Often, the narrator has relaxed and become more familiar with the material and has gotten "in the zone" by this point in the session. We often find we use this version of the opening more often than the initial take. This strategy works especially well with non-professionals who may be required to become voiceover artists for certain types of non-fiction videos, such as training and educational content. Once, I asked the talent, a renowned scientist who struggled a bit in the recording session, to go back to the top and rerecord the first two pages. Much to mine and the director's surprise, she kept on reading. We let her go. She read the whole script again without stopping! That last take was the "keeper" for the whole piece.

It is not uncommon for longer documentaries to need some pick-up lines for altered text after a show has been through some reviews. If you do need to record some pick-up lines, try to have the talent use the same set-up as they did for your first recording. You can even send them a short sample of the original. Talent will sound differently on different days, even on the same microphone. While you will never get an exact match (especially if the recording studio is different), if you have the same set-up, the two reads will sound closer. When prepping to send your files off to mix, place those pick-ups on the timeline on their own track under the original track of narration. Since (hopefully) the dates are on the clips, this may seem like an extra step, but it will signal to the mixer to be extra careful about matching the audio from different recording sessions.

Tips for Narration

▶ Consider carefully the options you have for union and non-union talent. Regardless of union membership, you are likely to have fewer and better reads with a more experienced voice actor, which can reduce your editing costs.

▶ When auditioning voiceover talent, request a few sample lines to be emailed to you as mp3 files so that you can test them with the visuals of your cut. A few lines from the opening and another few from the middle of the script are helpful.

▶ When you record your voiceover narration, consider rerecording the opening few sentences once you've gotten to the end of your session. Sometimes the pace and vibe has changed along the way, and it's a good idea to be sure the open and the ending match well.

▶ Request that your narration recording be made at no less than 44.1K and 16 bit, with 48K/24 bit being the standard for digital video. Some voice recordings are even made at 96K and above. Request that the recording is originated as a WAV or AIFF, not as an mp3.

6

Preparing for Your Sound Mix

Now we turn to the post-production phase of your project (which in the business we know as "post"). Just as we emphasized the importance of planning to incorporate sound elements into your production plan, we will focus here on the value of planning ahead for your audio post sessions. The audio post-production process is critical; yet because it is usually one of the last elements of a production, it can get rushed. Complicating this further is the fact that we now work in a world of multi-platform distribution of content. Knowing how to approach the audio post-production process can save you much time and aggravation, leaving more time for the creative story design process. In this chapter we will discuss how to choose your mixer and move your project forward from the field to audio post. This includes decisions that need to be made about music and sound effects prior to the mix and how to budget for the audio post process.

CHOOSING YOUR MIXER

Finding someone to mix and sound design your project is an important task. This person's job is not just to clean up your audio tracks. You are handing off your "baby" and asking another creative to bring their ideas and their input to your story. When selecting your mixer and sound designer

for a project, one place to start is to ask other producers who they like to work with. You can do this through professional associations and online production communities. You can also look for projects that are similar to yours and check the credits. Doing a little further research can open up other options as well. When reaching out to prospective collaborators, give a short synopsis of the project and ask for samples of their work. Set up a call to narrow down your choices. Keep an open mind as you search for the right sound person for your project.

I am often on the other side of these requests and conversations and find that discussions center around budget, schedule, workflow, and creative. Budget is certainly important, but hourly rate should not be your only deciding factor. Expertise and experience with your type of content can affect your bottom line since one mixer might be able to work through your project at a considerably faster speed than another. Be prepared to give as much information on the project as possible to get an accurate estimate of hours needed and budget. Script, storyboard, or even a rough cut are all helpful to a mixer when assessing the time and budget a project will need. It's also a good idea to provide your technical specifications for delivery. Certain types of deliverables may take extra time, and a good mixer can help you economize the process.

As is the case in every aspect of video production, budget and schedule are intertwined. Think about it like finding the best airfare. If the project has a very tight turnaround and will require long days and weekends to deliver, be prepared for the sound house or mixer to give you a higher quote, as they don't have much flexibility (similar to how airfare is often more expensive when your travel dates aren't flexible). If you have the ability to slide the deadline by a few days or longer, that might lower your "fare" (much like how airfare is often lower if your dates and destination are flexible). Offering flexibility in schedule allows a mixer to take on projects that they may enjoy but may not be at their full rate.

I recently took on a documentary touching on suicide and its aftermath. Mental health and this topic meant something to me, so I took the project on at a lower rate than I normally would. Its flexible schedule allowed me to fit it in around other projects, which gave me the opportunity to say yes when I otherwise would have had to say no.

It is common sense that not all experiences, workflows, or tools will produce the same results in the same amount of time from different sound engineers.

Each sound designer knows their own tools and how fast they can work on certain types of sound challenges. In general, it's a good idea when working with anyone new to add in extra time for getting to know each other's processes.

Keep in mind when discussing rates that you usually get what you pay for. Sometimes your project may offer a perfect opportunity to try out someone new to the business at a lower rate. Giving a job to a person you never worked with or someone just breaking into the business is always a risk. But it's a calculated risk and one that can deliver rich rewards. Working with different people can often refresh the creative process and introduce new workflows, technology, and techniques. I enjoy mentoring and working with new talent for that reason. Giving a new mixer a chance to flex their burgeoning skills can make the process exhilarating and add a new perspective to productions. Of course, there are times when you have a high-stakes production that needs to be perfect. In those instances, you may want to stick with a mixer who has done this type of production many times before or with whom you have a close working relationship. For instance, you may not want to take the 80-minute feature documentary on bees in North America that you've spent the last three years filming and editing to the mixer that has only movie trailers in their portfolio. Likewise, if you are doing a highly stylized spot, the sound designer who has worked only on natural history documentaries is not the right choice. I'm not encouraging you to get too narrow in your search as audio skills do translate across many genres and styles. So, if the sound person clicks with you and your project, perhaps that overrides the exact experience match. However, in such instances, it's a good idea to build in a little extra time to compensate for the crossover in expertise.

When getting acquainted with a mixer, you should ask about tools but center the conversation on workflow and the creative process. Ask questions about how media will be received, managed, delivered, and archived. Ask if that mixer will work on your project alone or with other (often more junior) staff. Especially for longer-form projects, discuss the collaboration process and how you will handle reviews and milestones. Location doesn't have to dictate your decision. The many tools that exist for online reviews and remote collaboration open up a world of choices. That might feel overwhelming, but it allows your choice to be based on the right fit, not proximity. After considering your project, your audience, your timeline, and your budget, you alone will make the decision of who to join you in the audio mixing phase of your storytelling process. It's an exciting collaboration that requires creativity, skills, and a little mutual faith.

BUDGET AND SCHEDULING

To start your budgeting process, share a written description of your finished piece (a short paragraph) as well as your script and/or rough cut, along with any special sound ideas you might have. This will help a prospective mixer put together a realistic estimate of time and budget needed for your mix. Once you've decided on a mixer and agreed on a budget, keep in touch as your project evolves. Send along the fine cut when it's available so you can discuss what might have changed in your content or approach. This is also a good time to confirm the schedule and budget with your sound team. In addition to making sure you are on target with your schedule, being able to see and hear your fine cut helps the sound team start envisioning your mix and come up with creative ideas to solve any sound issues. When I first started freelancing, one of the hardest things for me to do was quote how long something would take and, thus, how much it would cost. I found it especially tough if I was asked to give numbers blind, without any storyboard or cut to review. Would my time estimate be considered too slow or too fast, or somehow indicate that I did not care about the job enough? It was quite stressful. Taking notes during my mix sessions and recording how long each phase of the work actually took helped me do a better job both of properly invoicing and accurately estimating bids for new projects. All this is to say that an experienced sound engineer can probably give you a solid estimate for your production. One item to remember when discussing budget with a mixer is the licensing of sound effects or samples. While most producers have a line-item for music, many fail to consider the cost of additional sound effects. Most sound design studios own collections of effects and can include these licenses in your project estimate.

Budgets for sound mixing can vary quite widely. The hourly rate of your mix studio certainly plays a role. But the key variables are the length of the end-product (TRT or Total Runtime) and the style and complexity of the production being mixed. A good rule of thumb is 30 minutes to one hour of audio post-production work for every minute of content. Of course, this is a generalization. But it's a good place to start. The next item to consider is complexity of your sound design needs. If you have produced a four-minute music video with a modest amount of editing and no narration or sound effects, that job can be completed in two to three hours. If the same length piece has a lot of b-roll with sync sound to be adjusted, plus scenes with archival footage that requires sound sweetening and sound design, then that five-minute video might take a day to mix. In the case of heavy dialogue

editing, such as a film with multiple interviews shot by different teams in different locations with a variety of microphones, the noise reduction work and meshing of tracks will likely take more than a day accomplish. A final consideration when making your budget and schedule is how drawn out you expect your review process to be. For example, if you have several executive producers who will need to review and bless each version of your film, then you can add several hours for each pass on the mix and the various discussions about those adjustments.

Longer-format show mixes range more widely in budget than short-form mixes. Interview-driven scripted reality programs often feature little sound design and have music only during the bumpers in and out of commercial breaks. These can be finished much faster than more complex shows. The speed of the mix also depends on the quality of the recording of the voices and how much editing of their dialogue is involved. An hour-long broadcast program, which typically runs 46 minutes, can take thirty to forty hours to finish, including reviews and final output. However, when on a tight schedule our studio has finished these type of shows in twelve hours, working in teams. That was possible when the sound production quality was high, the editor organized, and the audio material not overly edited. The average for scripted reality TV is about eight to twelve hours per episode, although budgeting for some episodic programming has gotten really tight. (We will discuss workflows that will help ease that crunch in Chapter 7, *Your Mix Session*.) For the best outcome, give a little breathing room in your schedule between the time you turn in a cut to a mix house and the time you expect a polished mix. Any additional time you can provide will give your mixer an opportunity to step back and truly listen to and absorb the project before launching into your mix. This allows your engineer to be more creative in problem-solving in the midst of a tight turnaround scenario.

Documentary is one of the most prevalent forms of long format for nonfiction storytelling. Depending on the depth of the sound textures, demands on sound design, and dialogue editing, a standard fifty-two minute program could easily take 60 hours in audio post. Often, this type of programming has two versions. The first is usually a longer, seamless version for digital streaming, and the second is cut down into a version for traditional broadcast, with breaks for commercials. Mixing both versions and all the deliverables for both masters adds time to the schedule and budget. The additional time for the extra deliverables can range from four to ten hours, depending on the complexity of the changes between the seamless and the ad break masters.

In the budgeting and planning stages for hour-long documentaries, 40 hours split between sound design and mix, review, and outputs seems to be the de facto number that is slugged into the budget by networks. It's not unheard of that when the story is in rough cut, or even fine cut, that the executive producers will realize the audio budget is not sufficient for the needs of the project. If, as the filmmaker, you foresee more work may be needed on certain parts of the audio storytelling than the standard budget will allow, try to get your budget adjusted as early in the process as you can. Reallocating time and funds late in the game usually short-changes some other part of the creative process.

PLANNING FOR DIFFERENT DISTRIBUTION PLATFORMS

Video content now plays on a multitude of platforms and on various screen sizes. That means audiences are hearing your soundtracks on speakers large and small, delivering sound of good and mediocre quality. Thinking ahead to the distribution and consumption of your story will help you plan and inform the sound team. As a mixer, I know that everything I touch will end up on the small screen somehow, somewhere. Even the biggest of museum pieces, 22.4 (22 speakers, 4 LFE channels) needs to be mixed down to stereo or 2.0 for distribution online. It's mission-critical for the producer to find out all the platforms the piece will live on and pass that information to their editorial and sound teams in advance of any mix. As a mixer, I need to know where and how the media will be played. This information guides how the mix session should be set up and how to approach the mix for the best results. There are also some important questions to answer regardless of playback medium. For example, it's important for me to know the demographic of the target audience. Baby boomers have some of the highest levels of hearing loss among adults. That affects how they hear certain tones and sounds. So, if I'm mixing for this age group I will make certain adjustments to be sure any voiceover or interviews can be heard above the music.

More and more often, we are mixing sound for small screen and mobile viewing. There are several considerations when you are preparing to mix these shows. The first is that we plan for what we call the "mono-compatible" mix. Have you ever watched two people share earbuds to watch a video (Figure 6.1)? Then you know what we're talking about. They are each only receiving half of the audio story. And in a true stereo mix, that might mean one person hears louder music than voices, or one person can't hear

FIGURE 6.1 Two young people share a single set of earbuds to watch a video.

narration at all. To solve this scenario, we sum to mono the mix to the center and check our mixes on small speakers and our own earbuds. Creating a beautiful mix and only listening out of high-end speakers may result in a client calling and complaining they can't hear something in the soundtrack. For the small screen, we also recommend planning your music selection accordingly. Chamber music—literally written for listening in small rooms—or acoustic instruments like guitar work well for shows that will be viewed in a more intimate, personal viewing environment like a mobile device or laptop.

For large screen delivery, which for us is often large live events or theatrical spaces and museum auditoriums, find out in advance what type of speakers will be set up in the space and how large the crowd is expected to be. We like to do a "big room mix" or even surround sound for these settings. Because these mixes can include more textured soundtracks with music and effects, you'll want to be sure you have all your elements organized and ready for the edit. You can also select more cinematic cuts of music with a wide range of instrumentation. The speakers can handle the range, and we can make it sing during post-production.

PLANNING FOR MUSIC AND SOUND EFFECTS

One of the most fun parts of the creative process occurs when planning for music and the layering of different sound elements, known as sound design. The end result is your Music and Effects track (known colloquially as the M&E track). Since music decisions can be overwhelming, with options ranging from stock music libraries to indie bands that license their cuts to original score compositions, we discuss these opportunities in Chapter 9, *Music Scores*. Here we will simply say, as you wrap up your edit and get ready for your sound mix, take the opportunity to listen—not view—your final cut. Consider your M&E track holistically. Do the musical styles and rhythms make the most sense for this story? Have you included some wild sound or effects that can propel the story or add a rhythmic, non-music element? Is there a strong and driving pace from beginning to end? Or have you created twists and turns for different story lines and characters to emerge? The goal of the M&E track is to reinforce your characters, your locations, and your story line. So, it is important to also listen for stereotypes and try to avoid them. For example, I won't use a classical music track under an interview simply because the person is over 80. Perhaps their style would be better evoked by a completely modern track. Nor would I want to choose ethnic or Bollywood-type sounds simply because the on-camera subject comes from India. What is more important than those individual components is the story you are trying to tell. Listening to the entire film without watching, hard as that may be, is great preparation for a sound mix.

As you prepare for your mix session, also consider providing those wild sounds and sync sounds we encouraged you to record in the field. You can use a sound to help introduce an idea for the audience *before* they see it on the screen. These "split edits," where sound precedes picture by a few frames, are worth it. Take good notes with timecode of any sound effects or sound ideas you want to share with your mixer. Be sure you have some pauses built into your final cut, to allow for moments of sound design to emerge out of the background.

One word of caution: editors often place sound effects in the timeline to help propel the cut forward. While this can work well, be aware that you may not have a license for these effects and they may need to be replaced by properly licensed library effects during your mix session. The licensing

could include sounds that have been sampled from other sounds, such as music. It's common to hear music samples being used as sound effects. Once, in the beginning of my career, I had to replace a clock sound sample in more than 300 versions of a national spot because the producer discovered—too late—that the sound had been sampled by the editor without permission. The music artist who owned the sound sued, costing more than a million dollars, plus the expense of one very young sound engineer replacing and remastering the 300 plus versions of the commercial. So, if you have used placeholder sound effects in your timeline, be sure to inform your sound designer that these are not licensed and must be replaced. If not all the sound effects need to be swapped out, put the "keepers" on a separate track and identify which track must be replaced in your notes to your sound team. If time allows, you could even give your sound designer time to research and select sound effects for you and your editor to listen to and experiment with prior to picture lock.

This brings up an interesting question: is it better to have a "clean" cut go to sound design with little work done on the M&E track? Or is it better to have the editor spend time weaving sound into the story? On the one hand, a sound designer may work much faster and have better tools for certain types of sound edits than your editor. On the other hand, it's important that a soundtrack not simply be added to a cut. And while most sound designers and mixers are excellent at placing and building a soundtrack around a cut, not all have the vision and confidence to suggest a change to the cut to advance the story through sound. Ideally, your editor and sound designer develop a partnership, with some interplay and suggestions going back and forth between them. We have made this work even in tight timeframes, and the projects benefit from the collaboration.

PREPARING YOUR MIX ELEMENTS

Organization is key to getting your audio from the field to edit and then into audio post. Before even starting the edit (or even production), have a discussion with the sound editor, mixer or sound supervisor on workflow. Better yet, have the location sound mixer, editor, and audio post person all have a conversation. In larger productions, the sound supervisor coordinates and wrangles all of these people and all of this information. Sometimes planning workflow is not possible before the project starts and is

left until the end when the edit is being passed along to audio post. There are standard expectations, presented here, but fine tuning the process is well worth a discussion, no matter when. Each NLE organizes clips and handles tracks in different ways. Adobe Premiere and Avid Media Composer employ tracks, though there are different options to consider. Final Cut Pro X doesn't use tracks, so it organizes sound into roles held in containers that attach to the video. Organizing the clips on tracks or roles as you go can help the edit go more smoothly and assist in an easier transition to audio post. Placing clips on tracks and into roles designated for that audio element is most helpful. Audio elements are split into narration, dialogue, music, sound effects, and b-roll, which may include sync sound footage or archival footage with or without sync sound. A typical breakdown is as follows (Figure 6.2):

Track 1 – Narration

Tracks 2–4 – Dialogue

Tracks 5–8 Sync Sound

Tracks 9–12 Music

Tracks 13–18 Sound design

FIGURE 6.2 Screenshot track layout suggestion.

ORGANIZING YOUR CLIPS

Organizing the clips onto the proper tracks is the first step in audio post. Editors often delete clips of mics that they aren't using in the timeline to keep track or clip countdown to a minimum. This is especially true for larger productions and is a common practice in features. This is understandable. The value of metadata really comes into focus in the handoff to audio post. The information embedded in the file allows the editor or sound editor to sync up original sound files with clips in their timeline. The sound mixer can now access these files during audio post in order to make final decisions about which mic tracks sound best. The "conform," as we call it, can happen either in video edit before export to audio post or in audio post. If the metadata has been carried through the production and edit process, then it's a straightforward process. An Advanced Authoring Format (AAF) is not embedded—but it is linked when exported. These files are then relinked and conformed to the edit, usually by an online editor or the sound team.

If your video editor does a lot of sound design, then have her organize the sound effects by mono and stereo sound effects, as well as by type. Keeping ambiances and like sound effects together and on similar tracks will save the sound designer or mixer quite a bit of time as they move forward with finishing the sound design and mix. In Chapter 7, we discuss sound design and explain how to break your sound elements into different chunks. Remember, if you need to swap out sound effects, place them on their own tracks so the mixer can easily identify them.

CONFORMING YOUR AUDIO

When the metadata has been compromised, performing the audio conform in video edit is necessary. If your post team needs to manually conform audio when the metadata has been compromised, this can add a significant amount of time and expense to your budget. Nesting and disabling audio clips are the biggest reasons metadata is stripped from audio clips though it is important to recognize that NLEs are constantly updating their features, and the preservation of metadata is becoming a top priority.

Often in nonfiction productions there are only two mics used—a lav and a boom (Figure 6.3). Group or keep them together on their own mono tracks in the timeline and skip the audio conform process. Bring down the gain

FIGURE 6.3 Screenshot of lav and boom in their respective channels in a timeline.

or volume on the unwanted clips instead of muting or disabling them. If in Final Cut Pro X, maintain the audio in the container. Merging, disabling, muting, or nesting clips is not suggested at this time as this needs to be re-versed before any embedded AAF or Open Media Framework (OMF) can be properly exported with all the clips.

EXPORTING YOUR AUDIO FILES FOR MIX

Audio assets are sent to the sound team through OMF or Advanced Author-ing Format (AAF) export. OMF is the original and older protocol and does not transfer as much metadata and information over. OMF also has a 2 gig limit. AAF is a newer protocol that transfers much more information and does not have a size limit. OMFs and AAFs can either be created with embed-ded audio or linked audio. The embedded audio method gathers all the audio, truncates the clip handles as directed, and places it within a single wrapped

file with the timeline information. Embedded files are much larger, but can be easier to open by some DAWs (Digital Audio Workstations). The linked audio method creates a file much like an EDL (Edit Decision List) from a video editing system, but links to the audio files. More recent NLEs actually gather and create a special folder that contains the audio files, truncated with handles if requested (Figures 6.4 and 6.5).

Recently I got a call from an editor I've known for years asking me about this very thing. He had exported a non-embedded OMF and sent both the OMF and folder with the linked media over for mix. This took considerably

FIGURE 6.4 Screenshot of unexpanded audio container in Final Cut Pro X.

FIGURE 6.5 Screenshot of expanded audio container in Final Cut Pro X.

less time than the procedure for embedded OMF or AAF, which he has been doing for the majority of his career. He asked, "Have I been doing this wrong all this time?" The answer is no. The linked media, or non-embedded OMF or AAF, used to be extremely buggy until the process included creating the audio file folder. This is relatively recent, and it has been more stable. Technology changes very quickly these days. Updates to both NLEs and DAWs happen all the time and at any point what was the way to do things can change. It is even more important now to chat with your sound team prior to preparing elements for mix. Often, I ask clients to send test OMFs or AAFs, so we can see what is working or not working.

Before creating the OMF or AAF, make sure the NLE tracks are organized. Organizing by type as suggested above will allow the mixer to get started more quickly since they do not need to organize the assets. The mixer has to organize their tracks so they can deliver to the client not just the full mix but whatever final deliverables are needed by the network, distributor, or streaming company.

PLANNING YOUR MUSIC MIX

Planning ahead for music in your post workflow makes a big impact on your finished product. Don't expect, for example, that your sound engineer will be able to stop mixing and go hunt for new music tracks when they didn't plan for this in time or budget. But if you are stumped for music in a particular section of your project, give your sound designer a heads up so they can be prepared and audition some options for you. Be sure to tell your mixer or sound designer if you are going to be delivering an original score to layback and introduce your sound post team to the composer so they, can plan the delivery of the music files. Typically, full mix and mixed stems of the composed music will be delivered to the editor who will place them on the timeline. Often, being up against a deadline or receiving revised cues, the mixer will place them in the mix. If the composer is delivering individual files, request timecode be in the file name. The timecode should refer to where the first frame of the file is placed on the timeline. Sometimes the composer delivers the cues already placed in an NLE or DAW. This is handy but make sure their system is compatible with your editor or mixer.

Music is traditionally mastered at 44.1K 16 bit, though is often recorded and outputted at higher sample rates and bit depths. Request music cues at

WHAT IS A MUSIC STEM?

Stem files of music cues are essential for a balanced audio mix for your film. A Stem is a type of audio file that allows for already-mixed elements to be delivered separately, so that when combined they constitute the full cue mix. For a music stem, these might include the lead melody track, the harmony track, the drum track, and a lead vocal track. Stems allow your mixer to balance music levels with those of other sound elements such as sync sound or voiceover. Using stems, the mixer can reduce the levels of an interfering element at a particular point in time, without lowering the level of the entire music cue. Without stems, your audio mix will be challenging, so always have these files included whether you are purchasing stock music or working with a composer.

48K 24 bit for picture. Most NLEs will playback and convert different sample rates and bit depths, but music will play at different speeds in some audio mixing programs. Convert sample rates during your video edit to maintain the highest quality and proper speed throughout the process.

Music should be placed on the timeline on music-only tracks. If you want any of the cues to be replaced during the mix, let your mixer know. As with temporary sound effects, keep temp music on its own tracks. This makes these tracks easy to recognize and swap out for final versions of music (Figure 6.6).

Music should be mixed in the native sound field that the mix will be delivered in. So, if your mix will be in surround sound, get your music cuts delivered in surround (Figure 6.7). This will offer a truer sound experience

Alaska Views 2m3 1.17.34.00.v3 - Full Mix

FIGURE 6.6 Music File Name with Cue Name, Timecode, and Version number in the name.

FIGURE 6.7 Screenshot of 5.1 surround music file with music stems stacked underneath for easy access in mix.

and eliminate some technical challenges for your mixer. However, it is extremely common for stereo music cues to be "up-mixed" to surround during a mix session. Composers often do not have the resources to mix and master in surround. Plus, budgets and schedules rarely support a music mix and master in 5.1 (or above) surround. I know I'm starting to sound like a broken record here (appropriate audio reference, right?), but it's best during your mix planning phase to discuss in advance your plan for mixing and mastering music. On a recent project, I was surprised to find out that the client expected me to create a mix for the composer as well as do my work to mix that piece of music in with the other elements of the film. The composer did not have the resources to properly mix and master the music in 5.1 surround. This was never mentioned and was not addressed in the schedule or budget. We worked through this hiccup and I was able to assist the composer. Fortunately, both the budget and schedule could accommodate this additional work.

PREPARING YOUR BACKUP PLAN

Your post-production planning should include a conversation about file backups. These days, digital formats are changing so rapidly, it is difficult to know the best way to assure your project could be "brought back to life" if you wanted to remix or remaster it. Redundancy is the best solution. Be sure your audio post house has a way to back up your project and determine if there is a time-limit on that backup or a fee for long-term backup. Use mezzanine files so your project can be brought back online easily. Ask that the mixes and split deliverables be maintained in a separate backup of the session. I have found that this ensures that the mix can be replicated, even without the mix session. This is especially true in these days of rapidly changing technology, not just with DAWs, but with audio plugins. Remember that hard drives aren't a permanent solution. Most hard drives last one to five years. DVDs last only three to seven years. LTO is still our best option whenever possible, as it lasts 30–50 years.

Tips on Prepping for Mix

▶ Shoot using time of day timecode, then provide an annotated shoot schedule to your editor. This file should be saved as a PDF with your source media, in case your mixer also wants to take a look and locate a piece of audio.

▶ Take good notes with timecode of any sound effects or wild sound you recorded, and ensure that your mixer has these files.

▶ Make sure you send entire interview source audio and transcripts, not just those clips in the timeline. Your mixer may need to replace a mumbled word or adjust an edit, using a portion of the audio not contained in your timeline.

▶ Make a list of sound concerns and their timecode in your picture-locked video, and be sure this list goes with your audio files uploaded for your mix. Examples of sound concerns might be an airplane that flew overhead during a key interview soundbite, or a transition that you think needs some kind of sound element.

▶ If you want the same sound effect placed each time throughout a timeline (for example, at section title headings), make sure they all

live on the same track to make it easy to identify them and swap them out with other options.

▶ When planning a mix for small screens and mobile devices, request a mono-compatible mix that could be understood through just one earbud. Consider lighter musical elements such as acoustic instruments.

▶ When planning a mix for big screen delivery, be sure you have all your elements lined up, including textured sound elements, music, and effects. The big screen allows you to select more cinematic scores.

▶ Discuss the backup plan for your audio media and how your project could be brought back online for future updates and revisions.

CASE STUDY IN COMMUNICATING YOUR DISTRIBUTION PLAN

Producers don't have a crystal ball. But usually a producer or film-maker knows by the mix stage what audience they are targeting and what opportunities they are exploring. This is all good information to share with your mixer, even as it changes and evolves. A few years ago, I was preparing to start a theatrical mix for a feature doc about the artist Duchamp. The filmmaker mentioned that he was in talks with a European distributor. After further discussion, we realized that the primary target audience for the film would be art museums and art aficionados, with film festivals and theatrical screenings having min-imal play. We agreed to focus on meeting the potential distributor's technical and deliverable specifications. The required mixes were 5.1 surround and stereo, and followed by more traditional broadcast stan-dards, and after that, a theatrical mix. Knowing that the art museums and artist groups were most likely to screen the film in stereo we de-cided to make the stereo mix "king." That meant planning for mixing in stereo, with some cross-checks to be sure the soundtrack worked in surround sound. Right before mix was scheduled to start, the deal went through, but for a shorter version of the film. The filmmaker

delivered two versions—one that was 53 minutes and one that was 90 minutes. Usually, I prefer to sound design and mix the longer version first because it is easier and more efficient to lift content out than add it back in. But because the short version was due first on a tight turnaround, we flipped our priorities and handled the short version first. Later we finished the longer version plus the theatrical surround mix, with a stereo version for web delivery. Knowing the twists and turns that were happening on the distribution deal-making side of this project helped me to plan and clear an efficient path for multiple mixes while making all the deadlines for broadcast and theatrical release.

7

Your Mix Session

Audio Finishing is one of the final steps of a project; knowing what to expect can take the stress out of the process so you can have fun! In this chapter, I'll give you my insights into the sound design and mix process, so you can understand additional possibilities for the role of sound in your story. We'll cover tips and tools for collaborating with your sound design and mixer, as well as introduce sound editing and design techniques for working with voice, effects, and music. We will also discuss monitors, the use of headphones, and listening techniques for a better mix. To understand the evolution of a mix, let's review the basic steps of audio finishing, which can often go in this order, but that's not a hard and fast rule:

▶ Organizing tracks/Prep of OMF/AAF

▶ Watching the show down/Spotting session

▶ Providing notes

▶ Sound editing and noise reduction—narration, dialogue, and sync sound

▶ Sound design, such as adding effects, augmenting or adding tracks

▶ Watching the show with a draft mix

▶ More notes

▶ Final mix

▶ Approval

▶ Adjusted alternate mixes for additional platforms

▶ Outputs to final delivery specs

COMMUNICATE, COLLABORATE, AND CREATE

Collaboration and communication is key to any project's success. Fortunately, there are several tools that can help with both communication and management of the creative process that work if your entire team is local or if there are team members that work remotely. Asana, Basecamp, and Trello are some of the best platforms in the team management arena. Monday.com is a newer platform that combines attributes from all three. These tools offer the ability to share ideas, deadlines, and assets, such as scripts or transcripts. Cheryl has found Trello's white board tool works very well for managing the mix. The cards can be moved from phase to phase—keeping everyone in the loop of where the process is, what the hold ups are, and what needs to be done—all with a glance. The ability to sync with calendars, such as Google and Outlook, keeps the project tracked and present on a calendar as well (Figure 7.1).

Frame.io, Vimeo, and Wipster deliver amazing options for sharing ideas and give you the ability to post unique and frame-specific review notes on a rough or fine cut. (For a deep dive into tools for sharing edits, Jonny Elwyn does a great job in comparing Wipster and Frame.io a useful article on his website. See our Online Resources for a link). Amy likes to use Wipster because each client can post his or her own notes on a frame, but she also is able to limit the number of people able to post changes at the fine cut stage. Wipster also integrates with Slack and Vimeo and includes project status pages that work well for teams managing multiple content delivery streams. Cheryl likes Frame.io because it is fully integrated into DaVinci Resolve, can manage assets as well as the review process, and has

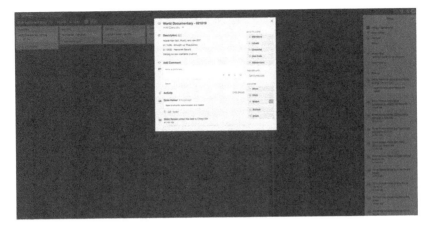

FIGURE 7.1 Screenshot of a Trello board for mix.

FIGURE 7.2 Screenshot of audio review notes using Frame.io.

high security features required by most media outlets. Source Connect and Streambox work well if you think you will need to review your show and your audio mix live with a client. These platforms allow for a live, high-quality review with very little latency, though Streambox offers better resolution for video playback. The trick is to find the tools that work for you and your team. Ease of use and price are key—why waste money and time learning a complicated system if it's not needed for your project? (Figure 7.2).

THE SPOTTING SESSION

A spotting session is a terrific starting point for kicking off the audio post process of your production. This is the time when you and your sound designer, supervising sound editor, or re-recording/dubbing mixer sit down and watch the project together. Whenever possible, the spotting session should happen at the mixer's studio; if that's not possible, an acoustically treated room with professional speakers calibrated to either broadcast or theatrical spec should be used. Ideally the mixer "watches down" the material prior to the spotting session. If not, plan to watch it twice through. Once without talking, the next time stopping at various points to discuss any issues. Taking the time before the spotting session to watch the material saves on time by eliminating that first pass together. If pressed for time in the spotting session, have bullet points ready and discuss as you stop and start. No matter the length of the piece, communicating in this way at the beginning of the post sound process will head you in the right direction. Even if you think the piece is straightforward and don't have time to watch it through together, shoot off a short note or give a call to your mixer to talk through the key aspects of audio. Your colleague will appreciate that jump-start into the project and thought process.

One of the main topics of a spotting session is problem audio. But you also want to discuss approaches to scenes, sound design ideas, and thoughts about transitions. Though most people prefer to do this in the same room, a spotting session can happen through a call or video conference. Ideally, you should schedule your spotting session after the sound team has received all of your elements and had time to prepare and organize them. This allows the sound team to understand the elements and start getting the lay of your project before diving in. Notes with time code reference can be very helpful to reviewing your cut together. One easy way to share these with you sound team is in a shared Google Sheet or with a Trello Board. Think of those notes as the road map to the sound design and mix.

If prep time is not possible, we sometimes are forced to review video with reference audio. But having the elements in hand makes this session more productive and allows your sound designer to respond creatively to your project. Experienced mixer Benny Mouthan explains, "When I'm sitting there in the spotting session and we're talking about it...that is when my best reactions from my belly happen, and that's usually the way I need to

go." L.A.-based rerecording mixer Karol Urban likes to go to the edit suite for the spotting session:

> "I want to watch it where they're cutting it and where they've sat and stared at it for weeks and weeks and weeks and weeks and weeks. Because they're going to have listened to things a billion times in that space and that space is going to have colored the sound in their minds."

In addition to getting a sense of the space where the sound was first developed, this process allows Karol to check out the timeline with the editor and director and go over a plan for preparing the audio elements being sent to her studio. My approach is a little different. I like to spot my sessions in a mix environment. It gives the entire team a chance to hear their project in a way they may have never heard before, in a more critical listening environment and away from editorial distractions. Whatever you decide, plan on including a spotting session in your mix process.

PROVIDING FEEDBACK ("NOTES")

Notes are the heart of any creative project as it evolves. Notes can also be quite personal—one team member hears a particular cue one way, someone else hears that cue entirely differently. Most producers and editors do not stay in the mix suite for the entire session. More and more, the mix is entirely remote with directors coming in for check-ins and final review for longer projects. For spots and shorter vignettes, the review process is more often remote as turnarounds are tight. While I sometimes miss the collaboration and instant feedback in the room, in many cases working alone has allowed me to explore different approaches and achieve new results that might differ from what the director initially imagined.

Not working onsite with the producers and editors gives us some unexpected opportunities. For example, in *Scattering CJ*, a feature documentary about a family healing from the suicide of their son, the director had specific ideas about sound design during the part where the parents recount that fateful day. During the spotting session, we discussed heavy sound design to create imagery, and there was music driving the scene. My team and I kept adding sounds and creating some vivid imagery. But it felt wrong. We tried taking

out the music entirely and letting the sound design live on its own. Still, it felt inappropriate and somewhat manipulative. Slowly, we stripped the sound design back to almost nothing and it worked. The power of the words stood on their own. Overworked sound design and music can sometimes distract from a story's impact. We felt the starkness of the sound design allowed the story to stand on its own. But knowing that the director was expecting very full sound design and music, we posted three versions of that scene for her to review while we moved on to other scenes. Version A—as expected with sound design and music; Version B—no music, just sound design; and Version C—very little to no sound design and no music. By posting options, the director was able to give us feedback notes based on her honest reactions, not shaded by anyone else's comments in the mixing suite. Though surprised by Version C, she concluded that this was the right approach. By collaborating in this way, we were able to come up with the right strategy for an emotionally difficult scene. Without hearing it the three different ways, and experiencing the creative journey in the three options, the director may have still wanted the full design and music because she hadn't experienced an alternative. Because she could hear the three approaches, the director could choose what worked for the scene. It does take more time, but was well worth the time and effort. For the final mix, we did end up using an ambient music track extremely low in the mix so that it was more felt then heard.

Though posting scenes for feedback is a good solution for collaboration on the go, getting feedback roughly halfway or two-thirds of the way through the edit-sound-design-mix process is a good idea. Often, decisions are made for individual scenes, and it's good to step back and see if those decisions are working as a whole. However, posting and getting feedback is time-consuming for both the sound team and the directors so you want to post significant chunks of material at one time.

Collaboration

Filmmaker Nina Gilden Seavey like to leave her sound person alone to create, but knows that magic happens when there's collaboration.

"I think a lot of times emerging filmmakers and students think of sound as being kind of like a rudimentary chore that they have to get through. They don't see it as a world of creativity that enhances the experience of the audience in the entire world that you're creating in the film."

Sound Rerecording mixer Karol Urban offers this insight into how she knows that a collaboration is working:

> *"I really like figuring out the person that I'm working for and figuring out their vision, and in doing that, you always learn a different way to work. My favorite way to work is when I identify what it is that they're looking for, and there's a click. Does that make sense?"*

Like the initial spotting session, the mid-review is time well spent. Playing through the piece in its entirety as a work-in-progress gives everyone a chance to "gut check" decisions that have been made. Are they working? Should we try another approach? Does the story feel "whole" with this sound design, or are we distracting from it? Especially when budget or deadline is tight, a mid-mix review helps guide the mixer to make decisions for the piece and manage the remaining time properly.

LIVE REMOTE REVIEWS

There are ways to review "live" instead of posting and sharing feedback after reviewing the cut independently. We can share a desktop and send audio through the computer via Skype or another desktop conferencing program. However, because sometimes you will get latency issues (picture will lag after sound) and the audio is not high resolution, this is not optimal for decision-making and creative collaboration. Streambox offers hardware and software solutions that allow for real-time review with 4K and 7.1 surround. Soon, the hardware option of Streambox will allow for Dolby Vision and Dolby Atmos®. The latency is almost nonexistent. The audio and picture are married together out of the DAW and streamed live at high resolution. On the other end, the reviewer can listen back in stereo through a browser. Surround and Dolby Atmos® reviews require a hardware solution to playback via Streambox.

The challenge—as in any remote review—is how the reviewer is receiving their audio. For color, we can calibrate our monitors. But for audio, there is so much more to consider. Speakers have different capabilities and calibrations. The room where you are listening can itself color and shape the sound. There has been great progress on auto-calibrating speaker systems and tuning for room acoustics, which has improved sound quality for both consumers in their living rooms and professionals working on the project. Until recently, there hasn't been much control over playback outside of the mix suite. As this

technology spreads, more mix reviews will happen in living room settings by directors and editors with their calibrated setups, either with live streaming review sessions or playback of posted mixes married to picture. This works for the small screen and near field mixes, but in-person reviews on the sound stage or larger mix suite for theatrical mixes will still be needed. There are so many different ways to communicate and collaborate as you review your mix. There's really only one rule: the best way is the way that works!

MONITORING YOUR MIX: HEADPHONES, SPEAKERS, AND PLAYBACK

Getting ready to make decisions in sound requires proper monitoring. There are a few things to look out for when choosing speakers or headphones. All headphones and speakers are not created equal. Headphones that you use to listen to your favorite music are not necessarily the headphones to review and critically listen to a mix. However, know your headphones. Look at the frequency impulse response and know how the sound is being reproduced, so that any coloring of the sound from the headphones is known. One item to consider is frequency response. Most headphones and speakers can play-back frequencies from 20 to 20K Hz. That is standard and required. Broader frequency ranges do not mean better sound quality; just because playback is of higher or lower frequencies doesn't mean it sounds good or is not coloring the sound. Another thing to watch out for is if the speaker or headphone is as "flat" as possible. "Flat" means that there's little to no addition or attenuation in frequency. These kinds of speakers and headphones are not enhanced for the casual listening experience, but are ideal for the most accurate reproduc-tion of the sound. See Figure 7.3 to see what sound information is coming into your ears when a headphone has a non-flat response.

FIGURE 7.3 A non-flat frequency response.

Speakers and headphones can sometimes color the sound by boosting certain frequencies and attenuating others. It is critical to make sure the playback device is flat. Even some sound cards, especially in laptops, tend to "enhance" the sound. This is to make the experience more pleasing for general use but can wreak havoc for critical listening.

Using open back headphones, such as the Beyerdynamic DT990, or a semi-open model, such as the Beyerdynamic DT880, can also help. Two other open back headphones to check out are the Audio-Technica's ATH R70x or AKG K240 series. Because they are open, and the air can move freely in and out of the headphones, you get a sense of air and spaciousness that is often lost in closed headphones. In addition, their light weight and soft pads make them comfortable to use for long periods of time. However, keep in mind that sounds leak in *and out* of open backed headphones and may not be good for noisy or busy environments. For critical listening and final mix decisions, closed back headphones, such as the Focal Spirit Professionals (or any of the Focal Professional Headphones), are a solid choice. Cheryl often switches between the DT880s and the Spirits when having to work in headphone settings. There are so many headphone choices. The trick is finding the pair or pairs that work for you at a price-point that is affordable for you. Comfort, sound image, and accuracy are the most important factors

Studio monitors, or speakers, have the same sound image and accuracy requirements and just like headphones, there are many to choose from. The size of your room and if you need a surround system or not are additional considerations. There are so many different monitors for different size rooms and purposes. The key to success in selecting the correct monitor is research at the time of purchase.

Years ago, when I built my first room, I noticed that my mixes were not translating out of the mix suite as well as I would have liked. The monitors in the room sounded so good all the time and masked the not so good sounding elements. This is great for general listening but not for critical sound decisions. I chose three brands of nearfield monitors and did a blind shoot out of all three. All three had very flat impulse responses, were powered speakers (so no amplifiers had to be added into the chain) with enough power for the room, and were matched with subwoofers for surround applications and bass management. After the shootout, where mixes were compared with off air masters and studio mixes, and daily mix sessions occurred, the least expensive monitors were the most comfortable to mix on all day and created

mixes that translated best to air. The key is to find a set of speakers that translate audio as accurately as possible.

I also feed my mixes to a consumer TV and another set of small speakers. My go-to small speakers for stereo playback are Avantone Power Cubes. If you can make the mix sound good on those small, less than ideal speakers, then the mix will translate better for the smaller screens and in most playback environments. The larger speakers are for hearing the spectrum of frequencies, critical decisions, and mix for bigger rooms and screens. The key is getting the mix to sound good on all three types of speakers: consumer, small, and large. This will help when the mix needs to translate to multiple platforms. More on that later in this chapter, in the section entitled Finalizing Your Mix.

Remember that headphones are just one tool, not your only tool for listening to playback. It is an epidemic these days that editors, sound designers, and even mixers are expected to make critical aural decisions on headphones every day, and even all day. Mixing entirely on headphones is not Cheryl's preferred mode of mixing as she likes to push the air with the sound and feel the mix. However, more and more editors and mixers alike are required to mix in open work environments where headphone mixing is the only way. Fortunately, tools that simulate acoustics and space are becoming more available and affordable.

Still, exclusive headphone use while mixing is not recommended and not good for the longevity of your ears. Unfortunately, it's a trend that is not going away. The only way to save your hearing, whether in headphones or with speakers, is to listen mostly at lower levels when not making final mix decisions. Your ears just cannot take production-level sound all day. You will need to switch to full mix levels when you need to make good decisions on the final mix. We will discuss playback strategies in mixing later in this chapter.

Another consideration when monitoring your mix is the room itself that you are listening in. Your environment could be noisy with ambient noise, such as the HVAC and hum from lights. The room could cause reflections and build-up of bass and other frequencies that all effect what you are hearing and thus how you are reacting and processing the sound. Though expensive, there are even professional speakers that can tune themselves to the room they are placed in. Environmental noise is one reason many people in remote situations choose to review mixes on headphones. However, there

are several resources for acoustic treatments and tuning the room. There is a trend in audio that contends that since the space most people consume audio is not ideal, the environment of the mix suite can follow suit. Quite the opposite is true. It confirms the need for acoustically solid rooms with calibrated speakers. There are so many environments, playback devices, streaming and transmission sites, headphones, sound bars, and ears out there—the only way to get a translatable mix is to work in an environment that allows you to be free of any doubts in what you are hearing.

Most audio specialists understand this and build the best environment they can to work in. Also, once their ears are trained, they can work around most issues and different environments to create the best mix possible before releasing it to the great unknown.

THE SOUND EDIT

The sound edit is where we lay the foundation of nonfiction storytelling, focusing on voice and sound on tape. Our goal is to fix mistakes—take out that throat-clearing, remove the missed frame of an overlapping audio clip—and create a seamless audio story. Personal approaches may vary, but for me, an audio edit often starts with the solo playback of each track or group of tracks. I want to hear each individual part of the story line, and see what they separately bring, before I think of them together as a whole. Once I've listened to each track, then I start to clean edits, reduce noise, and "sweeten" (adding equalization [EQ] and compression) each track, starting with the narration and moving through the dialogue and natural sound or sound on tape. Any time there is a gap between edits, I will go searching for room tone to patch them and keep the sound consistent (Figure 7.4).

FIGURE 7.4 An audio patch between soundbites using room tone.

In the edit process it's good to globally level out each component (voices, music, sync) to be the same. The main goal is to make the sound support the story by not having the edits pull you away. Rough edits, noise, lack of patching in room or wild sound can all equal unwanted distractions away from the story. The goal of the editing phase of the post sound process is to smooth these out. This "level" out pass should adhere to any technical specifications that need to be delivered, knowing that there are many more passes on your mix as sound design is added.

Another component of this smoothing process is taking out any extra noise. But deleting noise may not always be the answer. That's why I prefer to call it noise management, rather than what it's usually called, noise reduction. Here's a great example of why: I (Cheryl) worked on a film (*Let The Fire Burn*) that was edited entirely from found, archival footage. Every shot was noisy. Noise became part of the sound palette. By patching noise throughout to cover edits and adding noise into the cleaner scenes, this low-grade sound became part of the story and helped bring the viewer back in time to experience the story as it was told. It also gave listeners a more seamless soundtrack assembled from various archival sources. Each project has its own challenges and needs, and you or your sound mixer may have to adapt your approach for a particular story.

SWEETENING AND INITIAL MIX PASS

Most often sweetening, the adding of EQ, compression, and other audio effects actually starts during the sound edit, during that first levelling of audio clips to make them match better across the film. Some even start the sound design at this point. Benny Mouthon takes this top-to-bottom approach: "I just clean the voices first and then I just do everything from the get go. I just hit play. I have all the tracks open, everything's there." After many years, I started doing a mix pass with music, natural or sync sound, narration, and dialogue before adding in sound design. I find that it's important to at least test a mix as I start managing the sweetening. Working on a sound mix is similar to adding ingredients from a recipe—except you are always deviating from the recipe by small amounts. I like to start with music and voice and, using those, create a good balance across the board. Then, in subsequent passes, I add in the other elements. Working in this way allows me to add sound design at the appropriate level to the foundational mix. Doing a preliminary mix pass prior to doing sound design also makes final mix decisions go

faster because I can hear where the problem areas may be (such as a voice that is too soft to come out over the music track). Often, sound design opportunities are also more obvious when we do an initial mix.

SOUND DESIGN

Sound design is where things get interesting. This is where we augment the basic sounds of the story and add in some other elements—sound effects, transitional elements, Foley sound, and additional wild sound. And it is not a one-pass process. Rather, we work on sound design many times as we refine the audio story. Most likely, during picture editorial, your sound design has already started even if specific effects or music are place holders and will be swapped out later. Sometimes the sound design is created by the sound team concurrently with the picture edit; other times it's done before, during the production phase. This often happens in large-scale fiction feature films. There are no rules of when to add in sound design—it depends on the creative flow. I often add or subtract sound design even late in the mix process. If the mix isn't gelling, it's often because the sound design isn't working for a scene.

When sound designing, I often shut my eyes and listen to just the sound, especially the story being vocalized. This triggers auditory imagery not dependent on the visuals to accompany and support the story. After jotting down ideas from this process, I then watch the picture without any voices to pinpoint where sound should be added to complete the picture. This is not only to support picture but also support what could be heard, even though it may not be seen. These techniques help me develop the story in sound. For instance, in a visual where there are train tracks and no train, the sound of a train could be heard in the distance. Or if it's a neighborhood at night, a dog may be barking three streets over. If in the narrative they are describing a battle in war or a riot in history, then sounds recreating that may be mixed in over archival pictures or even present day footage so we can hear the history. Another method is to create a soundscape as the speaker recounts the story on screen.

On many nonfiction projects, the sound designer is also the mixer or the picture editor. Often the sound *team* is *one* person. Each project can take a different approach. Most nonfiction stories are told with more limited budgets, so the teams tend to be small. I like to work with at least one other

person on longer projects. Splitting up the editorial and sound design gives the person handling the final mix at the end of the project more energy and objectivity for the final mix and sound design passes.

Sound design can be broken down into understandable chunks: Foley, ambiances or background effects, hard effects, and cinematic effects. Natural sound or sound on tape/sync sound is often considered part of the sound design. I keep these natural sounds or sync sound on separate tracks so that they can easily identified from the rest of the sound design if the producer needs to know what is being used in the show (this is most often for licensing purposes). Sometimes technical specifications also require these elements be separate from the added sound design in the final deliverables.

USING FOLEY SOUND

Foley is the art of acting out or creating sound live, mostly to picture, and it's very much its own art form. People who perform the Foley are called Foley Artists. The term comes from renowned sound effects artist Jack Foley, who is considered the Father of Foley. His many credits include *The Phantom of the Opera (1925) and Spartacus (1960)*. In the traditional sense, Foley is performed on a Foley stage, with a room full of props. Foley pits are created from different surfaces, with different materials easily accessible to be able to create sounds and textures (Figure 7.5).

FIGURE 7.5 Using many sound sources for nuanced storytelling.

Many people in nonfiction storytelling don't have the resources for traditional Foley. However, nonfiction filmmakers usually have access to a boom microphone. With a boom mic, a keen imagination, some quiet and patience, do-it-yourself Foley is within reach. For instance, our team at my audio studio used sand, corn meal, and some brushes to emulate polar bear cubs walking and playing on ice for a nature documentary. The whole process was recorded to picture. Then we adjusted some of the sounds for precise placement, sweetened, and mixed. The entire process took only about an hour for a ten-minute section of the film (Figure 7.6).

Foley, especially footsteps/walking can also be created through using a midi keyboard and software, such as Kontakt. The Foley libraries that are readily available today make the assembly of realistic sound effects that you can map to a keyboard for easy triggering and placement to picture. There are a plethora of samples for certain shoe and surface types, as well as the varying rustle of clothing, key chains, and even body movements that are available and mappable.

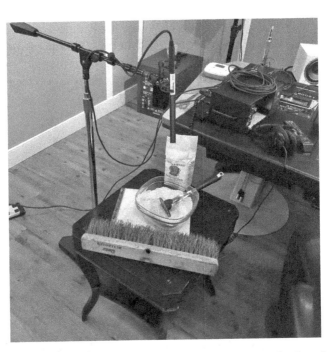

FIGURE 7.6 Cheryl's recording set-up for Foley sound of polar bear paws on ice using sand in a bucket.

For some, using a keyboard to place effects does take some getting used to, but is a game changer. Between the time saved in placing sounds, especially footsteps, and the range of samples available it's well worth the learning curve. There are also plenty of Foley sound libraries that you can use to cut in Foley manually if a keyboard is not available (Figure 7.7).

The goal of all of this Foley work is not to fill your production with extraneous sounds. It is to judiciously choose those places where adding layers of audio can help propel the story, provide context for characters, and help bring the audience into a location. As you listen to your "radio story" when you begin the sound design process, listen for those holes and gaps that might be augmented and supported with some added Foley sound.

FIGURE 7.7 Kontakt Software using the Foley Collection with samples of women's high heels on tile.

DESIGNING SOUND FOR ARCHIVAL FOOTAGE

When adding sound design to archival footage that has no sound, don't create audio that is too "clean" or it won't match picture. By using EQ and adding noise and even distortion, you can emulate sound that matches the historic quality of the picture.

AMBIANCE AND HARD EFFECTS

Ambiances help to create the world, the space in which the story lives. Ambiances can be as simple as wind for a desert scene and as complex as rebuilding every sound you would hear at a busy airport. Ambiances are often called soundscapes, but that's a little misleading. Soundscapes may contain more discrete sounds as well, not just wind or rain, for instance, but anything that could be found in an environment that is heard but not seen. In that way, hard effects are a part of the soundscape but are not considered ambiances. Something to keep in mind is that not all ambiances are created with one effect. Usually layers of sound effects and natural sound are blended to help lay the foundation and texture of the soundscape, with hard effects giving the listener something discrete to hold onto. That being said, don't just add to add and have layers—that can turn the ambiance, the world for your story, into mush. Be focused and selective in your sound design choices and critically listen to the sound scape you are creating.

A musical tone, a droning sound, can create a certain ambiance. The key is to have whatever drone or tone complement your music score. Low-frequency drones or tones can add substance to a section, especially when absolute silence is not working. When layered into sound design, low-frequency effects can add tension and depth.

Hard effects are those effects that are placed to action on the screen or support action on screen but can be heard. These are usually mono or stereo, placed in the sound field, and panned to follow the movement on screen or direct you to movement on screen Examples of hard effects are a car door slam, a tree falling, an explosion, and a car driving by. Foley are often hard effects, but Foley is always created sound and mostly recorded to picture. Recording voices for background "walla" (see Glossary) in a scene is Foley or ADR (Automatic Dialog Replacement) but is not considered a hard effect because it is not specifically tied to any movement on screen.

TRANSITIONAL EFFECTS

Cinematic effects is a general term that I coined for those sounds that help create transitions or match video effects or graphics. They can be synthetic in sound, like a traditional whoosh, or more granular, like a created or pulled sound that is in the content anyway. For instance, once I pulled sounds from a film and created transition and impact effects from the actual soundtrack of the film for the trailer. My goal was to only use sound that was in the film for the trailer. The car driving by became whooshes, the gun shot became impacts, and the voices from the film were weaved into the music to create texture. Even I was astonished how well it worked. Musical accents such as cymbals, drums, and triangles, have long been used to accompany graphic or video effects. If chosen wisely to match the music, these sound effects integrate into the score and are subliminal to the listener.

Often, I like to blend sounds that are a direct pull from a story for cinematic effects. One way to play with this idea is to use hard effects in the show and blend them with whooshes and hits to create a distinctive signature sound for a particular moment or action.

If you are tight for time on sound design, look for opportunities to create what Cheryl calls the "Red Umbrella" moments to sprinkle into the mix. These moments usually occur between voices, in video transitions, and on animations. For example, a "Red Umbrella" moment could be a transition effect between scenes or a title effect. Cheryl calls these "Red Umbrella" moments because they grab attention and then let it go. Be careful when using these: when an effect pops out between a voice it can be distracting if there's too little space. It's a decision to be made based on content. This is a good way to grab someone's attention in promos and spots.

FINALIZING YOUR MIX

Once sound design is completed, you're ready to finalize your mix. Before starting the final review, decide how the review process will go. Will you start and stop to tweak and address notes or play the content in its entirety? There are no rules about this; each project and people involved can dictate how to review. If there are a lot of decisions to be made, resolving them along the way can help keep the listener focused on the task at

hand, instead of thinking about previous material. If not much needs to be decided, it makes sense to review in longer sections or complete pieces as it gives a better sense of the material as a whole and decisions can be made in context. If time permits, allow a few days or weeks for breathing room before delivering the final, finished product. Listening to it away from the timeline gives renewed perspective on the content. At the very least, wait a night before delivering the mix to listen with fresh ears and eyes. The sound design is constantly refined as the mix progresses. In the final stages, constant tweaking of the sound track is going on. Mixes can often be treated as layers, meaning one or another element is put "over" another in discrete layers and not mixed together. It is called a "mix" not a layer. This is most often true with narration and interview. The voices are often put on "top of a mix" to make sure the listener can hear the narrative content. This is frequently done at the request of producers if their demographic is older or if the final cut will be played in a very "boomy" environment. There are many ways to make the voices cut through and be present in the mix. Pure volume is one, and presence is another. Presence can be achieved through EQ and compression. Initial EQ settings can be found by sweeping the frequencies, and boosting and attenuating those frequencies to enhance the voice. Compression and EQ are skills that require practice and time to really understand. Tweaking one or the other and adjusting gain and volume all effect how the audio presents in the mix. Tables 7.1 and 7.2 provide some guidelines that may help you get started. By no means are these firm rules or a "set it and forget it" setting. These are only suggestions.

TABLE 7.1 Basic EQ Settings for Voice

	Boost plus 2–3 dB/gentle Q	Detract 2–3 dB/gentle Q	Boost 3–4 dB	Boost 2–3 dB
Lower Voice/Male	65–85 Hz	650–950 Hz	1800–2500	3200–4500
Higher Voice/Female	85–110 Hz	800–1000 Hz	2100–2800	3500–4800

TABLE 7.2 Gentle Dynamic Range Compression Settings for Voice

Threshold	Ratio	Attack	Hold or Release	Make-Up Gain
–20	2:1	Fast	Long or Slow	2–4 dB

Remember, if your audio is not reaching the threshold the compressor will not be triggered. Plus, if the ratio is set to 1:1 then no compression will occur.

Placement of narration is key, too. Often just nudging the voice not on screen a few frames one way or the other can take it off the effect or music hit that is masking the voice. Many times, I place very slight reverb to fatten up a thin voice. Once the dialogue levels have been set, discussions about mix can center around whether to let the music be louder than the sound design or vice versa. I think this helps the mixer understand how the producer is hearing the story and their auditory priorities, but remember it's called a mix for a reason: it's a mix, not a layer. The blending of all the elements is required, and at different places in the story some elements may be more prominent. Just like with narration, the manipulation of a mix occurs through many different techniques, including equalization, compression, and placement of elements, not just volume control. The difference between a good mix and a great mix is often just one or two decibels and a few tweaks.

When making final mix tweaks, make sure the mix sounds good on as many speakers as you have. I always play back mixes on large, small, and then consumer TV speakers. That way I can hear how the mix translates to each one. The playback volume of content does matter in how the audio is perceived by the consumer. Professional mixers know how to calibrate their systems for different playback scenarios. Many viewers and even some screening venues do not. This is another reason to be informed about the playback platforms and environments. Playing the content very softly on small speakers gives a better sense of what material is less present or being lost in the mix. This will help you avoid the tragic mistake of losing something in the mix. Likewise, monitoring content louder than normal gives perspective on what your mix will sound like on the verge of distorting and overbearingly loud.

TIPS FOR MIXING AUDIO IN YOUR VIDEO EDITING SUITE

Though we have described audio finishing from the eyes of a sound designer and mixer, often the editor is put in the position of finishing the audio. Cheryl really urges editors to mentally switch hats and become the mixer and resist urges to tweak the cut, color, and graphics while focusing on audio finishing. When you see an issue with picture while you're mixing, pretend you

are away from the edit suite and make a note to address it later. Use the best possible speakers or headphones that you can afford, as opposed to earbuds. One advantage of being your own audio mixer is that you can tweak the cut to support audio decisions more easily and improve the story from an audio vantage point. But one downside is that you will be tempted to constantly tweak the picture, which can hold you back from finishing the mix. Make sure when you finish mixing, that listen to your mix on a variety of platforms, and out of a variety of different types of speakers, just as we would do in a sound studio. You don't want any ugly surprises. Take advantage of the many tools and plug-ins that are available for do-it-yourself mixers. I especially like the RX tools from iZotope, the AVID Pro-L for mastering, and the Fab-Filter EQ's and Compressors for sweetening.

Common Audio Deliverables

Most distributors have a list of audio deliverable specifications. If no specifications are given, I suggest delivering stereo full mix at −6 dBfs. This gives a good level for most consumer speakers and is safe for when it is consumed as mono (through one earbud!). Even when stems are not requested, delivering these files either with first frame of audio (FFOA) or a "2 pop"—one frame of 1k audio exactly two seconds before program start—is standard.

Typical Assets to be Delivered for Network, OTT, and Theatrical

Looking back to Chapter 6 *Preparing for Your Sound Mix*, you may understand why organizing the elements is so important. Especially if mixing in the box in the NLE. Delivering all these kinds of assets is difficult, maybe even impossible, to do without an organized timeline. If you aren't sure what elements are which, and they need to be delivered, perhaps it's time to call on a more senior sound specialist who can help you navigate your deliverables.

Standard Deliverables for Corporate and other Short Form Stereo Mixes (currently delivering at −6 dBFS):

Stereo Full Mix

Stereo or Mono Narration (VO)

Stereo or Mono Dialogue

Stereo or Mono Sync or Nat Sound

Stereo Music

Stereo SFX

Standard Deliverable Specs for Long Format Mixes:

Broadcast Levels are often −24 LKFS plus or minus 2 and −10 dBTP

OTT Levels are often lower at −27 LKFS plus or minus 1 and −2 dBTP

Standard Deliverables for Surround Mixes (deliver with a 2 pop or First Frame of Program):

5.1 Full Mix

5.1 MDE - Mix Minus Narration

5.1 M&E – Music and Sound Effects Mix

Stereo Full Mix

Stereo MDE

Stereo M&E

Mono Narration

Mono Dialogue

Mono Translations (if used)

Stereo Sync

Stereo Sound Effects

Stereo Music

Tips for Sound Mix and Design

▶ When choosing headphones for a mix, look for ones with a quality frequency response and no attenuation (adjustment) to frequency, so you are getting an accurate sense of the mix.

▶ Before starting a mix review, decide how the process will move on and if you want to watch the entire piece first or start and stop with notes.

▶ Playing the content very softly on small speakers gives a better sense of what material is less present or being lost in the mix.

▶ If you are tight for time on sound design, look for opportunities to create what Cheryl calls the "Red Umbrella" moments to sprinkle into the mix. These moments usually occur between voices, in video transitions and on animations.

▶ When adding sound design to archival footage that has no sound, don't create audio that is too "clean" or it won't match picture. By using EQ and adding noise and even distortion you can emulate sound that matches the historic quality of the picture.

▶ Use tools like Wipster, Frame.io, Source Connect, and Streambox to share cuts with your team if you must work remotely.

8

What You Need to Know About Music Copyright and Licensing

Before we get into this topic, we need to emphasize that we're not attorneys. We can only share what we know from our years of experience working with music rights for nonfiction storytelling. This chapter is not legal advice. We strongly recommend you speak to a legal professional regarding your specific production. Okay, now that we've provided that important disclaimer, on with the show!

A BRIEF HISTORY OF MUSIC RIGHTS IN THE UNITED STATES

As a storyteller, you might find it useful to know a bit about the story of music rights in the United States from the perspective of the songwriter. First, you should know that a musical work is considered copyrighted from the very moment music and lyrics have been set down on paper, recorded, or stored on a computer. No registration is necessary to protect ownership. As a songwriter, you can also register your work with the US Copyright Office. It's a pretty simple matter. Instructions on how to register, which can be done electronically for a small fee, can be found online (see our Resources for the link). This is the same link for registering your script,

podcast, script treatment, or screenplay. It's important for you as a film-maker to know that the copyright in the composition is distinct from the copyright in the sound recording, also known as the "master." We'll get to that in a moment.

In addition to copyright, there is the matter of publication. Performing a work of music doesn't constitute publishing it. To publish it, you don't need to go through a professional publishing house. Sharing it through your YouTube or Vimeo channel is considered an act of publication. However, many of the music rights processes which we have today stem from the "old days" of a work being published and distributed to the public on paper. Some of the earliest days of music publishing began in the 19th century, when the industry really began to flourish. A few blocks of New York City's 28th Street, between 5th Avenue and Broadway, became known as Tin Pan Alley. This area became a creative vortex filled with some of the most prolific music composers and publishers in the history of American song. The name supposedly came from the sound of the cheap, upright pianos these writers used to crank out their music. Songwriters like Stephen Foster ("My Old Kentucky Home," "Camptown Races," "Oh! Susanna," and others) churned out more than 70 songs and lyrics in less than 40 years in the early to mid-1800s. Other musicians soon followed, such as the even more prolific Harry Warren ("Lullaby of Broadway", "You'll Never Know," and "On the Atchison, Topeka and the Santa Fe"), the child of Italian immigrants whose birth name was Salvatore Antonio Guaragna. Warren composed more than 800 songs, was one of the first composers to write for film, and won three Oscars. Despite being prolific, these composers didn't make much money. That's because the publishing industry kept a firm grip on the rights to most of their songs and therefore managed to keep most of the royalties. (One common maneuver was to have one of the publishers' names added as a co-composer, so that the publishing house could keep more money.) Eventually, the American Society of Composers, Authors and Publishers (ASCAP) was formed in 1914 to formalize the process of royalties and payments and to try to give some standardized rights protections to composers as well as publishers.

Why all this back story? Often, content creators treat music as something to use for the soundtrack of a video without considering the fact that another creator invented it and another entity published it. Thus, we now turn to how to accomplish compensating those parties while staying on budget for your project.

TYPES OF MUSIC RIGHTS

When creating your story, you are most likely to think about the need for music. However, you may also need rights for music that you picked up in recording the natural sound of a scene—such as audio playing on a radio in a car where you are filming a scene or the music selected by a dance troupe for their performance that you are filming. You may also wish to license sound effects and Foley sounds. Many filmmakers also use a narrator and will need a talent release to use this voice in the soundtrack. Let's start with a summary of all of the different kinds of rights that you'll need to understand in order to create your soundtrack. These can include:

- ▶ Mechanical License

- ▶ Synchronization Rights

- ▶ Master Recording Rights

- ▶ Digital Download License

Additional considerations are:

- ▶ Performance Rights – live stage and recorded

- ▶ Exclusive and Non-Exclusive Licenses

- ▶ Estate Releases

- ▶ Talent Releases

Don't panic. This stuff isn't as hard as it looks. Here's a handy flow chart to help you understand and make these decisions (Figure 8.1).

COST OF MUSIC LICENSES

Just as there is a range of artists, so too is there a range of costs for licenses. The least expensive licenses are for stock music, since those tracks can be sold more than once by the company that owns them. I've seen rates as low as $50 per track for non-broadcast use and $350 per track for broadcast use.

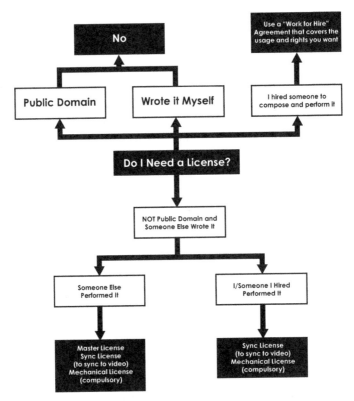

FIGURE 8.1 Follow the flowcharts to help you answer the question "Do I Need a License?"

That use can be unlimited, but that means the track is married to that particular video, not to other videos you have created or other versions of the original video. Be forewarned that many cheaper sound libraries don't provide great mixes. Some of them may sound pretty tinny in your soundtrack. Licensing a well-known song can cost several thousand dollars in fees per year for the various licenses, plus the cost of an agent to handle securing of them. But the impact of a well-known song could make or break your story. So, you will need to research your options at the start. You may want to create a hybrid soundtrack, where you use some custom sounds or music tracks and some stock sounds and songs. Many filmmakers also turn to new and emerging artists who are eager for the visibility of having their name in the credits and featured in film promos. The options and opportunities are wide open, so create a realistic licensing budget, but also get creative with your thinking.

FAIR USE

Before we go further, let's talk about the "elephant in the room": fair use. Referenced in Section 107 of the U.S. Copyright Act (found on the U.S. Copyright Office website), fair use is "a legal doctrine that promotes freedom of expression by permitting the unlicensed use of copyright-protected works in certain circumstances." The key concept to remember here is that fair use is an exception to another party's copyright—it is not a right in and of itself. Because fair use is considered to be a "doctrine" and is guided by case law rather than a specific set of legislative rules, grey areas abound. For example, one of the criteria of the doctrine is "transformative use." Many filmmakers could argue that simply by being part of a film and not an artist's recording, an audio work may have been transformed. There are other criteria as well, including how much of the work you use and the impact on the market value of the original work. Almost every nonfiction storyteller will claim fair use at one point or another in their creative careers. And often, it does apply. Just as often, it doesn't. Fair use is not about whether or not you are charging people to see your film. If you record a Beyoncé song in your living room, the recording and unlicensed performance (not the sale thereof) are the infringing acts. Fair use is not something you can automatically claim because your content was created for or by a nonprofit. It is not automatic because you are only using five seconds of a song. Fair use has traditionally been strongly supported by the courts when applied to uses that are in educational institutions (such as a film class) or when a work is quoted in a journalism or scholarly work. There is also a long tradition of fair use for satirical works. It's less clear about everything else. Even if you believe you have an ironclad fair use exception, you may be dragged into expensive litigation by the owner of that intellectual property to prove your case in court.

There's a big conversation going on now in the nonfiction field, primarily among documentary filmmakers and film programs, about which usages could and should be deemed fair use. The discussion centers around the freedom to tackle difficult and important issues for civic discourse without being hampered by the automatic withholding of rights by license-holders. And it's true that large license-holders tend to say "no" to small filmmakers, mostly because they don't want to be bothered with the paperwork in exchange for small fees. Another issue I've come across more often lately is finding an audio clip of a speech or a sequence that I know is free government footage on a stock footage website and yet

the website is charging for it. With clips from government archives, it's worth hunting them down directly from the federal agency, presidential library, or other collection involved rather than going through the stock aggregators. On these fronts, nonfiction creatives must stake a claim in order to do the important work of storytelling in a free society. To learn more about documentary best practices, and some guidelines on fair use, we refer you to the excellent information on fair use best practices developed by the Center for Media and Social Impact at American University.

One way you could determine if your project meets fair use guidelines is to use the checklist from Cornell University on copyright (see the Resources section of this book). As you will see, there are issues that favor a determination of fair use, and those that do not. Nothing is clear cut. And a few of the items on the checklist are in tension with one another (transforming the work leans towards a yes for fair use, but if the work you want to use is creative—such as a piece of music—then fair use is not favored). Another criteria that disfavors fair use is that there is another "reasonably available licensing mechanism for obtaining permission to use the copyrighted work." And the fact is, for almost all circumstances these mechanisms do exist. We'll tackle these in just a moment.

When we are working on our respective projects, Cheryl and I lean towards assuming that a significant percentage of archival and preexisting content does *not* fall under fair use, and our attorneys agree with us. We also believe that copyright holders (including us) should be compensated for their works appearing in, or being heard in, other works. We have both seen the term fair use thrown around when in reality it is more likely that a producer just doesn't want to spend the time researching to whom licensing fees are owed or an organization forgot to budget for licensing fees. So, as you begin to collect music cues, sound effects, and archival materials for your production, make sure you work through the rights issues for the material you use. That might lead you to find a few different options for a single sound cue, just in case. We remind you again that we are not providing legal advice. You should always check with an attorney who specializes in intellectual property rights and can review your specific project and usage plan. Bottom line: if you are going to claim fair use, speak to your attorney—and/or the attorney(s) for the organization for whom you are producing the content—in order to make your own risk assessment.

LOCATING MUSIC COPYRIGHT HOLDER AND PUBLISHER

Your first step when wanting to use a previously published piece of music as a component in the score of your film is to locate who owns the copyright and determine who is the publisher. They are not typically the same person or entity. Copyright of the composition is often owned by the artist, but managed by music publishing companies. Sound recording rights are often managed by record labels. The best place to start your search would be a Performing Rights Organization (PRO). The biggest by far is ASCAP (remember, that group founded in 1914 to protect music rights holders), followed by Broadcast Music, Inc. (BMI), and then SESAC. Each organization represents different copyright holders, including songwriters, composers, and publishers. And each PRO licenses only the copyrighted works of its own respective copyright holders. So, you have to find out which one represents the songwriter, composer, or publisher whose license you need. SESAC-represented music includes quite a bit created for media projects like films, TV shows, and commercials. So, if any such content is contained in your film, you will need to seek out a SESAC license. Links to these PROs are in our Resources section, and you can conduct searches based on song title through their respective websites.

LICENSE DEFINITIONS TO KNOW AS A CONTENT CREATOR

Compulsory License

Thanks to a provision known as a Compulsory License, our copyright system allows you an automatic granting of a license as long as you pay the license-holder for using their material. This is how bands can get permission to record "covers" of other peoples' compositions, provided they pay a fee for each song recorded. So as long as a band pays that royalty (or you do, as the filmmaker recording a cover song for your film), the license is automatic.

Mechanical License

Before the aforementioned cover band can release that copyrighted song on a CD, as a digital download, or via a streaming medium, they need not

just the Compulsory License but also another license called a Mechanical License. As a filmmaker, you need to know that this Mechanical License does not include your right to put that recording into your film and then make and distribute copies of your film containing the song. For that, you will need a Master Use License, described below.

Master Use License

The master recording refers to the song publication—literally the means by which a song goes out to the public. Typically, this master recording is owned by a record label, though more and more artists are now holding onto their own publishing rights. When you purchase a Master Use License, you are receiving permission to use the master recording in your visual production. If you plan to use the song as part of your soundtrack, you will also need a Synchronization License in order to synchronize the music with the visuals in your film.

Synchronization License

Popularly known as a "Sync" License, this agreement allows you, the licensee, the right to literally synchronize the recording of a particular song or stock music track to the visuals in your film. Sync Licenses can be just a few hundred dollars. Or they can be thousands. In my experience, the fee range depends on a number of variables, such as how popular the song or artist has become, the type of production you are creating—commercial, corporate, documentary, etc.—and how you will be using the material in that work. (See Important Questions to Answer Before You License below.)

IMPORTANT QUESTIONS TO ANSWER BEFORE YOU LICENSE

Once you've figured out how to track down the rights-holder(s) of music you want to use in your film, you will need to be sure you have the answers to these questions, which will likely be asked at several steps of the licensing process.

1. Who is the artist or band who performs the song?

2. Who is the publisher?

3. What type of media distribution do you want to use the song for? For example, film festival, cable TV, internet, theatrical, commercial, or "any and all media." Are there restrictions on physical distribution vs. online distribution? Dollar amount limitations of physical product?

4. What is the term of use? Try to think as broadly as you can. It will cost more to license for a longer period of time, but it will also cost you in time if you have to go back and track down rights again later, because the usage will be longer.

5. What are the "territories" of usage? Again, think broadly. If your film is being distributed by your local public TV station in Nebraska, but is likely to be picked up by PBS and distributed more widely, start with "North America" as your minimum territory.

6. What is the length of the clip being used? Typically, it's harder to get permission to use an entire song than just a clip.

7. How is the song being used? In other words, is it the background music for your final titles, or is there a clip of a music video on screen in one of your scenes?

8. What fees are you prepared to offer? You'd be surprised, most licenses are negotiable. You will need to have a number in mind. Typically, there will be a fee for the master recording license and another fee for the publisher. Remember that there can be more than one publisher.

AVOIDING DIGITAL MILLENNIUM COPYRIGHT ACT (DMCA) TAKEDOWNS

A common problem for media makers is having their media temporarily removed from a distribution platform for licensing violations, which is something you want to avoid. Digital Millennium Copyright Act (DMCA) is a US law that protects content creators from having their work shared on the internet without proper licensing. As a content creator, you want this law to exist, because it means that you can protect your content with embedded code and be sure someone else isn't profiting from it without

your permission or profit. One of the common reasons a video gets flagged is that music playing in the background inside a scene has not been properly licensed, even when the score and other elements have been (see below for more details). Since DMCA takedowns are an automated process, your video could be flagged even if you *do* have all the proper licenses. So, keep digital copies of all your licenses. Generally, I recommend keeping copies not just in your computer files for the project, but also inside the editing project folder where all the footage lives in a folder cleverly labelled "Licenses." That way, you can provide proof of proper license when required, and any editor working with the footage in the future will know the parameters of the license if they are cutting a new version of the video.

LIVE PERFORMANCES IN YOUR VIDEO

One of the tricky areas of music licensing presents itself when you are filming a performance that itself contains music. There is no "one size fits all," so let's run through two common scenarios. In our first scenario, you are filming at an awards event. As each awardee comes on stage, several seconds of a popular song is played. Let's say one person gets Bill Conti's iconic theme "Gotta Fly Now" from the film *Rocky* (1976) and another gets the Katy Perry song "Roar." You are filming these awards to create a film about the organization, and your video will be played on the organization's YouTube channel after the event. The event organizers will need to pay a license fee for using copyrighted music at their event. Both BMI and ASCAP charge a sliding scale depending on whether or not an entrance fee is charged, whether the music used is played in a live performance with a band versus recorded music, and how many attendees are at your event. The fee is not dependent on whether or not the organization is a charity (for more details, see our resource links on festivals policy for BMI and ASCAP). However, those fees only cover the live moments at your event when those pieces of music are played. They do not give you the sync license to play back this same music in the video recording of your event. So, you will still need a sync license for the content. If you don't, you may get a DCMA takedown notice.

In our second scenario, you are producing a documentary film about a musician who travels the world giving performances in trauma-filled regions. In one scene, the musician performs a cover song of a piece by a

renowned artist. This is a pivotal scene in your film, and you intercut shots of the musician and the faces of the audience, enthralled and transported by her emotional performance. Do you need to get a mechanical and sync license for the song? As I'm not an attorney, I can't tell you whether or not you would have a strong case that both her performance and your filmic representation have transformed the original work into something new worthy of being deemed fair use. However, if you seek a major distributor for this film, you will likely be asked to back up your claim of fair use, as well as provide all other copies of releases plus a copy of your Errors and Omissions insurance, which is based on your claims. (We'll cover E&O in a moment.) The bottom line is you need to go into the process with knowledge and a plan.

LICENSING STOCK MUSIC AND SOUND EFFECTS

One of the best things about using a stock library, among the many options of sounds and songs, is the fact that the licensing component will be very straight forward. When you select a song you want to use for your production, you will pay for it and receive a license. This license will cover the Master License and Sync License for using the song to picture. You will typically have options for the type of license you are receiving based on distribution. For example, with the license shown in Figure 8.2 you can use this music cut for online video, social media video, a video for a website, a corporate presentation, a slideshow, and videos on YouTube, as well as on a free app or game for Android or iPhone. You would need a different license if you want to use this cut of music in a theatrical release film or a commercial advertisement. As you might expect, the fees are higher for those uses. But I have found that stock houses are open to negotiations, based on your expected distribution, the length of the license, etc.—all of those questions you asked yourself and answered (on pages 134–135) prior to getting started. One thing to remember about working with stock music is that if you are working in an organization that produces many different video projects in a given year, you can save money by purchasing an annual blanket license to use music from that stock house. To maintain your license, you will need to report all of the music cues you have used (usually on a quarterly basis), including the usage type, such as web or live event distribution. This can be a significant cost savings over paying cue by cue for the music and gives you access to a wide range of musical styles and genres (Figure 8.2).

FIGURE 8.2 Excerpt from a standard non-broadcast music license.

LICENSING MUSIC FROM A COMPOSER

Many people think licensing music from a composer is cost-prohibitive. On the contrary, I often find that the amount of time it saves me hunting down six different types of music for the various twists and turns in the story, and then editing and mixing them seamlessly, is well worth it. Plus, many composers will work with you on a Work-for-Hire basis, and let you do a "buy out" of the piece of music for a flat fee. You should be up front about your anticipated distribution. If it is small, or for a non-profit, most composers will work with you on their fee. I have also made arrangements with composers that they not reuse the same theme for a period of time—let's say two years—but after that they can rework that music bed for another client. That also allows the composer to work with me on price. The best part about working with a composer is getting just the right moments, moods, and, most importantly, transitions in your score. Music majors at local colleges and universities are great sources for Work-for-Hire composition. We'll delve more into the process in Chapter 9, *Music Scores*.

RIGHTS OF PUBLICITY APPLIES TO VOICES

The Right of Publicity is something you and I have if we live in the United States, the European Union, Canada, and several other countries. This right applies to every person in that country, whether a known celebrity or not. The right of publicity means we control the use of our likeness—including

our voice—and that someone else can't commercially benefit from it without our permission. These rights continue to exist even after we are dead (the timeframe can vary from jurisdiction to jurisdiction). Journalistic works are generally exempt from having to be concerned about the right of publicity of people in their content via a fair use exception, though sometimes this has been challenged in the courts. Here's where the right of publicity applies to us as filmmakers with respect to sound: don't use a famous person's voice—or something that sounds like it—in your production if you are not prepared to get permission. An example would be the case of Tom Waits v. Frito Lay, Inc. I won't get into the details, but suffice it to say that someone imitating his famous voice in the soundtrack of a commercial was not okay with him, and he sued and won (a link is provided in our Resources section). Bette Midler also brought a case and won. Bottom line, think twice before using a "sound-alike" voiceover artist and asking them to imitate a famous voice.

TALENT RELEASES

A talent release is an agreement that gives you as the content creator the proper permission to distribute your film that includes the voice, image and/or performance of "talent." Generally, you will use such a form for unpaid on-camera interviews as well as paid actors. When you use a voiceover talent, you should also get a release. If you are using union talent, the release will already be a part of the signatory agreement. If you are not a union signatory—and many independent producers are not—then you can use a signatory agency to book and pay your union voiceover talent. They can help you with any questions about releases. If you are using non-union talent, or need a release for someone you are interviewing, I think it's worth the time to have an attorney craft at least your first one. Then you can create derivative versions for other projects. The internet is filled with standard talent releases, which are great to look at for a guide, but you want to be sure you are covered for the specific use you want for your production. Be careful if you go this route—the road to perdition is paved with producers who used forms they "found" online. You want to be sure you have the ability to make edits to the voice, or even alter it (which might mean EQ-ing the voice during your mix). You want the maximum flexibility as a creative, and you also don't want to have to hunt down all the people involved in your film several years after the fact, when suddenly you win that much-hoped-for distribution.

USING AN AGENT OR HANDLING RIGHTS YOURSELF

Clearing rights yourself isn't as complex as it may seem. But the decision of whether or not to handle it yourself is not always a matter of saving money. For example, many times I will choose to work with an agent because I know they have worked with a particular artist before, or a song that is getting a lot of requests for use in videos. If I know that they have a relationship with the artist and publisher involved, then I know they might have a better shot than I do at getting the license and will save me or my client significant amounts of time and money. Agents who can handle licensing for you—and many if not most are not attorneys—will charge you an initial fee for the negotiation, and then another fee for securing the licenses if you decide to move forward. I have paid fees as low as $700 for the initial negotiation work. It really depends on what you are asking, how hard they feel it will be to do the negotiation, and whether they already have relationships with those agents and publishers.

I have also cleared rights myself and would not discourage you from doing so, too. Because my films are primarily for nonprofit organizations and causes, I will often go to the artist directly to gauge their willingness to have their song used in our soundtrack. Having the artist say "yes" goes a long way when negotiating with the publisher. In many cases, having this support can keep you from having the door shut in your face, figuratively speaking, by one of the large rights-holding entities. And in fairness to them, their attorneys and licensing folks are probably paid quite a bit of money, so it's hard for them to justify small negotiations for nonfiction shorts and documentaries with limited release. One thing I've found is that an artist's interest can also help clear the rights for less than the standard rate. I was able to clear use of the Men Without Hats song "Safety Dance" for an educational safety video by first contacting the original artist and then getting his referral to their agent. I was similarly able to clear a version of Bobby Picket's famous "The Monster Mash," for which we wrote new lyrics with the hope that we could use them in an animated sequence for a children's educational program. I reached out to Pickett himself, through an intermediary who knew his agent, and he was so taken with our idea that he offered to record our version (and did). Because we were recording our own new version of the song, we paid an attorney to negotiate a sync license and a mechanical license for the original song. By the way, if you decide to produce a cover song, you can handle the license

through CD Baby's handy service (see our Resources collection). But you will still need to get the sync license for using it in a video, which they do not offer at this time since their focus is albums. The bottom line is this: artists understand other artists, and are often willing to lend their support for good causes. I believe the key is twofold: (1) offer them some remuneration, which they are entitled to receive for their copyrighted works. This shows your respect for the work and the artist. And (2) make sure the usage is consistent with the person and brand of the artist. They are more likely to say yes if you are pitching a cause or content that is relevant and would reflect well on them.

ERRORS AND OMISSIONS INSURANCE

When you have licensed or fair use elements in your production—images or audio—and want to get public distribution for your film, that's when Errors and Omissions Insurance (E&O) comes into play. Most networks and major distributors will require that you have it in order for your film to get a distribution deal. E&O insurance is essentially malpractice insurance for filmmakers. Unfortunately, you as the content creator are expected to cover the cost, which can be several thousand dollars. Keep all those licenses and talent releases we've talked about handy, because you will need them when making your application. From these documents, you will need to create a detailed film log so that the insurer understands where you have secured right, and where you may be relying on fair use exceptions. For her documentary *The Art of Dungeons & Dragons*, co-Director/co-Producer Kelley Slagle explains this detailed process was one of the hardest things she had to do in the years-long process of making the film.

> "We had to create an exhaustive film log, where for every cut in the film we were required to note the timecode, detail what was in the shot and audio track, confirm we had all releases, licenses, and contracts for who and what was on the screen, and whether we relied on any fair use exceptions. There were also trademark and copyright searches done by an attorney, and a fair use opinion letter from our attorney expressing his opinion that any unlicensed IP fit under a fair use exception. It took us nearly 60 hours between three producers to get everything together for the [insurance] broker, and another couple of hours to complete the application process."

WHO CAN HELP ME LICENSE?

An intellectual property attorney who specializes in film productions can be quite helpful as you navigate licensing. You may believe that legal fees will be too expensive for your budget, but after-the-fact problems and reedits to cut out problematic material would be much more expensive. There are also a rising number of solo and small practice attorneys willing to work for reduced or flat fees with documentary filmmakers if they can verify the scope of the project up front. If you don't want to use an attorney, you can use a music clearing agent. These folks are experienced negotiators and often have worked with major artists and commonly licensed songs, so they have a good sense of what rates can be negotiated. Some examples of clearing agents are included in our Resources section. There are also companies that pitch themselves as "audio agencies." These include companies like Jungle Punks who can help you create an original score or license one that you need. Or you could try a hybrid like Rumble Fish that both manages rights for music creators and helps distributors and filmmakers get tracks and licenses, often from indie artists who want exposure. And of course, you can do the work yourself. But we'd still recommend running everything past an attorney if your film is going into wide release.

FINAL TIPS ON MUSIC LICENSING BUDGETS

Sound is integral to all nonfiction stories. The music tracks and sound effects are often some of the first things I plan for, not a last-minute component added in at the end. This also helps with budgeting. Some strategies I use to keep my budgets as low as possible are: (1) do flat buyouts with composers, (2) negotiate a license renewal that is the same as the initial license for the next year or two (rather than an automatic increase), (3) reach out to artists directly if you are planning nonprofit use; while they do not generally manage their own rights, their support may help you get a better rate from the publisher, and (4) do your own initial legwork to save on legal fees; find out who owns the copyright and who owns the publishing rights, and be clear about how you will be using the piece of music.

Tips on Music Licensing

▶ Consider who owns the rights to a piece of music before you fall in love with it in your soundtrack.

▶ If you want to license a cut from a popular band or composer, determine up front if you are willing to cover the budget for the right licenses. If you have a small budget, be sure you are willing to put in the time and effort to try to negotiate a lower than standard fee, and understand you may not succeed.

▶ You can definitely negotiate licenses on your own, but in many cases it is best—and more efficient—to hire an experienced licensing agent and/or intellectual property attorney to assist you with this process.

▶ Not everything falls under fair use. Become knowledgeable about the parameters of claiming fair use, and be prepared to offer an attorney opinion letter outlining the basis of your claim

▶ For most documentary distribution, and some other types of nonfiction productions where you are conveying factual information about areas such as medical procedures or pharmaceuticals, your production will need to be covered under E&O insurance. Be sure you know the process and keep track of all of your licenses.

▶ If you license music on a regular basis, for a company or nonprofit that produces many videos a year, consider buying a blanket license from a stock music library rather than paying for each cue.

9

Music Scores

Music offers our most powerful storytelling tool. If you have beautiful, compelling pictures and the wrong score, you can turn off your audience. If you have less than perfect images but a compelling score, they can still become hooked. Think about how many times you have shared content on the internet where the shot is quite basic—perhaps a cell phone camera trained on someone speaking, cut to an uplifting or otherwise engaging music score? Consider, for example, the unlikely political campaign of Beto O'Rourke, who fought for (and lost) a Senate seat in Texas, but nonetheless garnered national attention for a future Presidential run. One of his top outreach tools was social media. His response to the issue of players "taking a knee" during the American national anthem went viral. I would argue that video connected with people in part because it was married to an emotionally uplifting music score.[1] That is not to say the content is undeserving. Quite the opposite. Nonfiction content is often important, timely, and issue-driven. So, supporting it with well-chosen music can make the difference between good content and great filmmaking. In this chapter, I will outline some of the strategies for scoring, as well as how to manage the workflow and the budget. Whatever you do, don't sell your project short by not considering music early in your preproduction process. The style, tempo, and approach you develop to music can influence your shooting strategy as well as your editing process. Cheryl and I are both trained in Western instruments (Cheryl

plays clarinet and is a fabulous jazz pianist; I'm an *a cappella* singer and also a violinist who plays regularly with a symphony orchestra). So, we will give you some guidelines in this chapter based on our musical backgrounds and expertise. But the world is wide open to you, and there are millions upon millions of wonderful compositions and songwriters you can collaborate with to find the right sounds and styles for your stories.

ELEMENTS OF A STRONG MUSIC SCORE

If you are looking for scoring rules, you won't find them here. Selecting music can be quite personal. But we do feel there are several characteristics of a strong music score. These are (1) Authenticity, (2) Purpose, and (3) Impact. We will start with authenticity, a subject about which Cheryl and I are passionate when it comes to sound and story. Just as we would not want to use a sound effect that doesn't fit the period or the image on the screen, we also avoid musical sounds and styles that are not authentic to what is happening visually. For example, when working with a composer, I might already have in mind a particular instrumentation that I feel will work as a score element, to introduce a character, a story line, or a recurring theme. Or, I might feel we need to stay away from a particular instrumentation that feels too stereotypical. When I told the story of Holocaust survivor Eli Weisel, composer Todd Hahn and I decided to stay away from a violin theme, as we felt that was just too evocative of the famed theme of "Schindler's List." But he did write an award-winning score which opened with a haunting cello theme supported with faint vocal echoes in the deep background, to introduce this very personal story. Because we were using Weisel's own voice from speeches as the narration to the piece, and his voice is in a higher register, having a deeper registered instrument worked well in this opening. However, when designing your music score, whether using a variety of stock tracks or working with a composer, be sure that the music authentically fits the world of the film and the characters in it. Find themes or styles appropriate to a particular character, or an important moment in the rising story arc. Play the themes separately from the images and see if they still evoke the locations, characters, and story. To me, this is the sign of an authentic score. One that really *belongs* as an authentic part of the film.

Authenticity is tied to the purpose of a piece of music. Why is this particular style or rhythm needed at this moment in the story? Could a different cut of music fit better? Why or why not? I try to ask myself these questions

each time I am working to find the right cut—either as a temp track or final cut in my film. Sometimes, when asking yourself questions about the purpose of music in a particular story segment, you will discover there is NO purpose to having music there! Perhaps there should simply be silence or natural sync sound. Perhaps there is a rhythmic element that is happening visually—like someone tapping a pen on a table—which can become the score for the scene. Always ask yourself the purpose of a piece of music in a scene. What role does it play in explaining a character or situation? One role it might play is to change direction. I'm especially fond of breaking up a long stretch of soul-searching drama with something lighter—a piece to change the subject and mood. As you work with a composer or make selections from a stock library, consider how contrasts in tempo, style, and emotional weight can serve your story and its characters. Composer Damion Wolfe explains,

> "If you just put a smattering of emotional music throughout, no one will really come away remembering it. Be careful about dumbing down the music, or [making it] so generic that it actually distracts from telling your story. This is one of the reasons to bring on a composer. You can create your own sonic hook—a theme, or even something short like a three-note motif—something that comes back to the listener."

Finally, we call your attention to impact. What impact does a particular instrument sound or melodic line have on the audience? Does it remind them of a recurring theme or character? Does it make them nervous? Anxious? Excited? Music connects with us in such a visceral and emotional way. Try playing different pieces with the same stretch of film and see how the impact changes. The flip side of this equation is lack of impact. If the music feels like "wallpaper" then it probably is! Find something better. The bottom line is that every story deserves its own musical story that supports it.

CHOOSING YOUR INSTRUMENTATION

Each instrument brings a unique sound to a story. You can take advantage of some of the inherent qualities of certain instruments as you listen to stock music or work with a composer. Composers who write custom scores, and those writing for stock houses, can call on a range of musical traditions and instruments from around the world. Some of your options include piano,

guitars, Western symphonic and band instruments, Eastern sitars and san-toors, Middle Eastern ouds, African wind and rhythm instruments, South American flutes, etc.—the list is endless. And, of course, the oldest instrument of all, the human voice. If you are considering using Western symphonic instruments and aren't familiar with all of the sounds they can make, you're not alone. You may just know what you like or don't like. That's fine, but you might want to learn the names and specific sound qualities of the major instrument groups in order to help you search for what you need in a stock library or to communicate more clearly with your composer.

Instrumentation affects story, as certain instruments evoke emotional responses. Probably one of the more famous uses of instruments to tell a story in western music can be found in Sergei Prokofiev's famous "Peter and the Wolf." You might even listen to a recording as a way to hear the unique storytelling qualities of each of the sections of the orchestra—winds, brass, strings, and timpani. In this work, the oboe, with its somewhat plaintive but also slightly comical sound, evokes the waddling duck. The flute, which can lightly flutter up and down scales, represents the bird. The deeper, contemplative sound of the clarinet, often associated with the human voice, is used to tell the story of the cat. A walking line of the deeply-voiced bassoon provides the role of Grandpa. The French Horns, often called upon in scores for major heroic moments, play their famous theme for the wolf. The loud percussion instruments provide the sounds of the hunters. The strings, with their varied range and collective strength, give us the various melodies as Peter makes his way through the forest. You can truly visualize the story as each instrument makes its entrance and exit in this masterful work. Ultimately, when I'm listening to a possible cut of music for a film, or considering various instrumentations or styles, I try to watch my cut with the voice tracks volumes turned down, or even off, and hear what music my mind imagines. Each character or scene introduced usually brings its own musical ideas. And then I can test those ideas and see if they support the emotional essence of the story on the screen. (See our Resources section for some websites that can help you navigate different musical styles and elements.)

Many stock libraries include music from various countries. The problem I often have is that these cuts tend to use overly traditional instruments, and so they can undermine a contemporary story line if not used judiciously. One popular category in stock libraries is "World Music," which can blend multiple origins, instruments, and styles. Again, this can work against your story. If it sounds too generic, or the instrumentation is completely wrong

for the country your narrative is focused on, then it can fight the narrative. One solution is to record music as "wild sound" while you are travelling. You will want to be sure you know who the musicians are, in case you need to secure rights that do not fall within the fair use doctrine. (For more on Fair Use, see Chapter 8, *Music Licensing*). One handy thing about working with stock libraries is that, with some direction from you, many will help you pull selections to audition.

USING RHYTHM IN YOUR SCORE

Rhythm is essential to storytelling. Your editing has a certain pace depending on what is happening in the story arc. A slow, deliberate section taking place in a quiet, small town might contrast with a fast-paced montage to introduce a new urban location to which the main character has moved. These pacing changes often require rhythmic elements in the score. But rhythm and percussive elements are sometimes overlooked because of a concern that these sounds will "fight" with narration or dialogue. (More on how to solve that in Chapter 7, *Your Mix Session*). But we would encourage you not to shy away from percussive elements, which aren't always drums. Two instruments that have percussive elements are the piano and the acoustic guitar. Guitars must be strummed, and the body of the instrument can be tapped, giving a sense of motion to the score. There are several different types of guitars, each of which offers a different storytelling style. I'm a fan of the 12-string guitar, which has a richer sound than the traditional 6-string. You will commonly hear a 12-string guitar in folk music, but it can also be used for a more folk-pop sound. I'm fond of using this instrument for a story that requires some simplicity and honesty in its music score.

The piano brings a percussive element to a score, because the strings are literally struck by hammers. Pianos have 88 keys, which give them a range of just over seven octaves. A piano can be part of a score, adding depth, or it can be used alone as a solo instrument. One of my all-time favorite examples of using percussive elements to drive nonfiction story is in the short animated film *The Girl Effect* (2001), a movement launched by Nike Foundation to end global poverty by intervening in the lives of adolescent girls. The ticking clock motif in the animation is propelled by a base note repeated in the left hand of the piano, and amplified by staccato bow strokes by the celli. This is one of the few animated shorts that makes me and my workshop attendees cry every single time we play it, and I believe this impact is largely

due to the score by Elias Arts founder/composer Jonathan Elias and composer/recording engineer Nate Morgan. Give it a listen and see if you agree.[2]

MUSIC AS AN ELEMENT OF SURPRISE

Tempo changes are some of the best ways to keep the audience engaged with your film. Just as you may want to change the tempo of edits depending on the emotional content of the scenes, so you might also change tempo with music. Another way to build in an element of surprise or a break from the past segment is to change the key. This can be a real issue if you are using stock music. Because stock music is composed by so many different artists, and their tuning is not precisely the same, I've even come across tracks that are a half-tone off. This means you really can't play them back to back. Sometimes it feels right to stay in the same key, while segueing to a new piece of music with a different tempo or style. Most of the time, though, when transitioning to a new segment, I want a key change as well, to provide a cue to the listener/viewer that we are in a new place in the story now. One of the things to look for in a good music library is the ability to search by musical key. This is one of the aspects of the Audio Network library that I like so much—being able to identify the key of the piece, so I can consider an interesting key change from one cut to the next. And also, so that I can avoid a transition that will be boring—like three cuts in a row in the same key—or one that would clash, like a half step change.

MUSIC AS CONNECTIVE TISSUE

Sometimes music is the "glue" that can help smooth abrupt transitions between scenes, or help to connect scenes that belong together thematically. A great example is the documentary *Moving Stories* directed by Rob Fruchtman and produced by Cornelia Ravenal, Mikael Södersten, and Wendy Sax, which I was lucky enough to catch at the Chesapeake Film Festival. The film follows different dance teachers as they coach at-risk students in four different countries. The climax of the film consists of the final dance performances of these students, who just a few short weeks ago were not dancers. It is a transformational moment. Each group of kids and their instructors dance choreography they have been practicing for only a week. Each dances to a distinct piece of music. The producers decided that rather than hear all the different tracks of music to which the performers are dancing, and

intercutting them, that the scene required a unity that could only come from one piece of music as a score. Producer and co-editor Mikael Södersten spoke with me about the process of coming to that decision.

> "Our director and I both worked on editing the film. Coming from a cinema verité tradition, Rob was used to using diagetic music, which is part of the world of the scene. So when it came to the climactic performance sequence, he edited sequentially, using the music that was playing when each performance was shot, because he wanted it to be truthful to where each happened. But coming from the world of fiction filmmaking, Cornelia and I felt we needed a unifying principal. We also saw the opportunity to elevate the audience's experience. We see it all the time in narrative – like Hitchcock's orchestral score in *The Man Who Knew Too Much* and in *American Graffiti*, where all the music comes out of these teenagers' cars but is applied thematically so that it comments their relationships and heightens the emotional impact. So, what could we do? We agreed with Rob that we didn't want to impose non-diagetic music onto the performances. We felt the music needed to come from inside the world. So, we used *Channels and Winds* by Ravi Shankar and Philip Glass, the piece the Indian girls danced to, for all four. Then Cornelia and I re-cut the footage, choosing and interweaving images that built to a climax as the music did."

This piece begins the sequence as diagetic music and ends up as the score of the remaining sequence, carrying the scenes to their climactic ending. The result is magical, powerful, exhilarating.

WORKFLOW FOR CREATING A MUSIC TRACK

Let's back up to preproduction. Generally, very early in my process—as early as when I'm conducting pre-interviews for a doc-style piece—I am already getting ideas for music. Perhaps the music is inspired by a particular location. While I try not to be too literal (we see a cowboy, so we hear cowboy music; we see someone from India, so we hear what we think of as Indian music), I do try to make the music feel like it fits the people and places we are getting to know on screen. Often, I am jotting down possible music style notes in my shooting script. Certainly, by the editing script, I have ideas written down. I might even reference some stock music tracks, or have started collecting them in a folder so I can be listening to them as I review

the cut. If we know we are going with stock music rather than scoring, then certainly by the second rough cut I have made selections and am testing them out, and perhaps we are even cutting to them in certain scenes. The flavor of the film is strongly influenced by music for me so I want to start shaping that component of the storytelling as early in the process as I can. So just a quick road map for this workflow:

► Preproduction

- Budget for music

- Begin auditioning tracks for temp tracks or actual tracks

- Speak with a composer about deadlines, budget, and stylistic approaches

- Consider music that is relevant to characters and locations

► Production

- As you film and conduct interviews, consider how you could accomplish different pacing later in your edit. Can second camera coverage help?

- Shoot b-roll sequences with enough latitude that you could linger on a shot and change the pacing when editing to music.

- Shoot sequences that will allow you the flexibility to create a montage to a score—for example, if you have shot many scenes with dialogue or interviews, be sure that you have plenty of shots that can establish locations, personalities, or simply change the pacing once you are editing. This means ensuring your shot list and scene coverage plan includes a variety of lengths of shots and different lens techniques—rack focus, whip pan, static, etc.

- A sequence of static shots can also hold more meaning when cut to music, establishing, for example, the emotional connection a central character has to place.

▶ Postproduction

- Audition more tracks, now that you have most if not all of your footage shot and have a sense of the different styles and pacing you might need.

- Use temp tracks for your rough cut or start working with your composer to audition some samples as you begin editing.

- Fine cut should include most if not all tracks, if you are going the route of stock music; when working with a composer, these can be used as temp tracks.

- Before delivery of final cut, make sure all licenses are secured; keep copies of licenses in multiple places—including inside the project folder on your NLE.

SCORING TO CUT vs. CUTTING TO SCORE

One of the great joys of filmmaking for me is to work on the music score. The process often involves a "chicken or the egg" question: do we lay down a track first and let it provide our pacing, or do we cut first and then add a score? Almost always the answer is "both." What I mean by that is, for some scenes, in order to achieve the proper pacing, we've got to get a track of music in there that feels right. Fast montages or very slowly paced scenes often need to be edited with a soundtrack playing. That doesn't mean we can't change our minds. But often the score drives the energy and cutting style of those sequences. For other scenes, we may wait until we have a rough cut that I can "watch down" several times before I get a sense of what style of music might work. The scenes have their own rhythm and generally invite a particular approach to the music.

Of course, there are many stories in the feature film industry of how certain temp tracks actually ended up in the finished movie. I can understand how that happens. Those scenes go through dozens of recuts and tweaks. People reviewing them get used to the temp track. Then the score gets done and it feels "wrong"—like it doesn't belong with the film. This might be why director James Gunn decided to have composer Tyler Bates go ahead and create the major themes for *Guardians of the Galaxy* in advance. In fact,

in his KCRW podcast interview with Elvis Mitchell, he talks about how he was inspired by Sergio Leone's *Once Upon a Time in the West* (1968), for which scores were written by Ennio Morricone early in the filmmaking process to help establish a pace and style for the camera shots. Gunn and Bates worked together on the big themes and also selected the pop songs in advance so that they could play them on set and similarly set the pace and vibe of the scenes. (To hear the podcast interview with James Gunn, go to our Resources section.)

While in a nonfiction piece you are not going to play your music on set, you can also use a similar strategy of thinking through the musical styles and pacing in advance of your edit. You can even work with your composer early in the process to test out some thematic material or try a particular instrumentation as you develop your edit. (More on working with a composer in a moment.) The goal is this: don't add music like wallpaper after the room is built. Music is integral to the filmmaking process. It is an essential element of your storytelling and should feel like it belongs with those scenes and characters.

One of the common usages for both stock music and custom music is what I call "copycat scores." A particular song is popular, so you want to replicate that sound and style. I get it. And occasionally I do it. But mostly I avoid it. Bottom line is that a sound that is popular at this very moment is likely to be out of fashion by the time your video gets posted. I find it fascinating that many of the popular mini-biographies now flooding social media are cut to more classical-sounding scores. Perhaps because the producers realize these are more timeless.

WORKING WITH A COMPOSER

If I'm working with a composer, I try to bring them into the process as early as possible—often while I'm still scripting or planning the shoots. I might send some track ideas at this stage. I might send links to pieces I really like, or identify styles I feel are currently being overused and want to avoid. If I have the time in the editing process, my preference is to send a draft edit to the composer early on, so he or she can get a sense of the approach and try out some thematic ideas (Figure 9.1). Of course, sometimes the temp tracks we send lead us in the wrong direction. The composer I work with regularly will often surprise me with a different approach to a scene. This is why that

FIGURE 9.1 Todd Hahn composes a score to picture.

collaboration is so important in the music scoring process of filmmaking. Composer Todd Hahn is one of the leading scoring artists in the country. Here is his take on the process of scoring:

> "The bottom line is the visuals drive the music—you are making a musical metaphor for what you're seeing. The visuals and the dialogue are working the analytical part of your brain. The music's job is to be a catalyst for your emotional response. With a really compelling visual, the music writes itself; it's just kind of obvious what the music should be, and the composer has more options."

Of course, sometimes speed is of the essence, and there is not much time for back and forth with the cut. In these instances—such as delivering a commercial spot or show promo by a deadline—you will have to deliver "picture locked" scenes to your composer. That means you have received all final notes and approvals, and there won't be any timing changes to the visuals. Be careful to include exactly as much black at the open and close as you will have in the final show. The final fade is particularly important and is often overlooked. Then you get your music back and it doesn't feel like it rings out properly—because you didn't provide any pad for that to happen.

A common problem with post-scoring a film with no time for tweaks is that filmmakers often forget to leave enough silence between scenes for musical transitions. If your composer has written a theme in 4/4 time, for example, and there are only three beats between the end of one scene and the start of the next, that requires a measure with irregular meter. Most good composers work with these issues all the time and manage to make the score seamless. But it's a good idea if you are working for the first time with a composer to build in more "air" to your edit. It's much easier to tighten a transition later than to open one up. And remember, the score doesn't need to be—and probably shouldn't be—wall to wall music. There should be natural spaces where natural b-roll sound and voices can emerge. And even places with no music score at all. The story drives these choices during the final sound mix, which we address in Chapter 7.

STRATEGIES FOR SELECTING STOCK MUSIC

There are more and more stock music libraries emerging every day. Some have quite wonderful pieces of music you can use, and certainly a wide range of styles. Some have unique features. For example, Audio Network gives you the key and the meter of each piece, which I find very helpful as a musician. APM Music offers filters for archival and vintage tracks, which can be handy for certain projects. Killer Tracks has thousands of sound effects in addition to musical themes. Premium Beat has low prices and useful industry articles on its blog. Here are some strategies for finding what you need:

1. Make use of filters. Most good music libraries allow you to search using a number of filters. These can include tempo, style, length of cut, and whether or not sound effects or vocals are present. You can narrow down and save the types of pieces you like and start building a collection that works best for your piece.

2. Don't look at price alone. Some of the low-budget libraries don't offer particularly good mixes of the music tracks. As a result, your end product can sound tinny, instruments can get "cut off," and the tracks lack depth.

3. Listen with good headphones. Your computer speakers aren't the best option when choosing final tracks. You may miss some interesting—or problematic—instrumentation or vocals in the mix. Listen to the entire cut. I recently chose a cut I really liked, only to discover an error—two

clashing notes—in the middle of the rising arc of the piece right at a critical point in our story.

4. Check all the versions. Many stock tracks will offer different instrumentations, versions with and without vocals, versions with and without heavy drum tracks.

5. Is there a story arc? Music needs to tell a story in order to support your visual storytelling. Marrying stock music to the twists and turns of your narrative can be a challenge requiring multiple tracks. So, it's helpful to find some cuts where there is a climax and resolution or some twists and turns and not the same repetitive theme.

6. Search by composer names. Stock music is written by real, live musicians! If there is a piece you like, but it isn't quite right, chances are good that something else composed by the same artist may meet your needs.

7. Endings matter. I am a great believer that one cut of music should end, and not just cross-fade to the next, which is just lazy musical storytelling. And I can't tell you how many times I like a track, but the ending fizzles out. So, I've gotten into the habit of checking the endings first before I fall in love with a track.

8. Check the license agreement. Make sure that if you are planning a long life or many variations for your project, you want to be sure you are covered. "Royalty free" doesn't mean free, it just means you won't pay a royalty each time your video is watched or downloaded. But if you are delivering different versions for different platforms, you are likely to need multiple licenses.

BUDGETING FOR MUSIC

The range of fees and pricing models for music can feel overwhelming, and as broad as the range of musical styles. Generally speaking, non-broadcast rates are lower than broadcast. For non-broadcast or non-commercially distributed works, a stock cut can cost as little as $25 and go up to $350 per cut. Broadcast rates are often double that. Of course, if you need 10 or 15 cuts for a long film, then you may do better negotiating a flat rate or a custom score deal with a composer. Custom scores can range from $2,500

for a 3–5 minute short to $5,000 to $17,000 for a one-hour documentary. Some of the fee range comes from the level of experience of the composer and how much back and forth they expect for versions and tweaks. Many composers are now working out what I would call a "hybrid" deal, which can reduce the up-front costs of a project, but allows them to make money on the back end. The composer gets a flat fee for the work. In addition, the composer retains the mechanical rights so that he or she earns a royalty each time the film airs. The network or distribution company retains the publishing rights, so they also receive a small royalty each time the film airs. In addition, the network can retain a copy of the composition for its internal library, and their producers can use it—or parts of it—for other shows. When these uses occur, the composer also gets a small royalty. These royalties can add up over time and multiple airings, so this deal makes the custom scoring process affordable for the producers and profitable for the composer.

If you or your organization generate a large quantity of content every year, say for your YouTube channel, then you will have more options in terms of flat pricing, whether with a composer or with a stock library. For example, many libraries offer an annual fee to customers who produce a large amount of content. (You will still have to send in quarterly usage reports, so that they know what is being covered under your blanket license.) Some libraries, like Epidemic Sound, are offering monthly subscriptions for as little as $15/month for YouTube creators, and a higher but still very reasonable monthly rates for corporate content creators. It's worth checking out all the options a library has to offer. Some are stronger in one genre of music than another. Some offer better mixes or more options for different versions, stems, and stingers. If you end up spending a lot of time editing and tweaking cuts, you may have lost some of the savings you thought you had in a lower initial cost.

Whether you work with a composer or a stock library, I would encourage you to call and discuss your projects in advance with these folks. I have found everyone on the music side of our storytelling industry to be ready and willing to work with content creators to bring their projects to life.

Tips for Music Scores

▶ Consider authenticity, purpose, and impact when selecting stock music or working with a composer to create your music score.

▶ When working with a composer, bring them early versions of your cut so they can begin thinking about musical ideas.

▶ Consider instrumentation, world regions, and culturally appropriate musical references as you consider the role of music in your story.

▶ Add rhythmic elements. These can be drums and percussion instruments or those instruments with percussive elements, such as piano.

▶ Consider tempo, meter, and key changes as ways to ensure music tracks don't get boring.

▶ Listen with quality headphones and speakers to ensure the mix of any stock music will work for your delivery platform.

▶ When considering a stock music cut, check for alternate versions and listen to endings of songs to be sure they don't just fizzle out.

▶ Consider any music that lives inside the film. Could there be a role for this music as part of the score?

NOTES

1 https://twitter.com/nowthisnews/status/1032017750829531142
2 www.youtube.com/watch?time_continue=3&v=1e8xgF0JtVg

10

Spatial Audio

Emerging Technologies in Immersive Sound

It is an exciting time for immersive technologies! And thankfully, audio has finally become part of the revolution. Breakthroughs in the recording, mixing, and playback of spatial audio have given creators new tools and workflows, allowing immersive sound to take its rightful place alongside immersive visuals. With these technological changes come opportunities in nonfiction storytelling, with a range of applications, such as news stories, documentaries—both short and long form—museum exhibits, live immersive experiences, and training applications. Immersive nonfiction storytelling has taken advantage of being able to place the viewer into a situation, with its accompanying emotional responses, and to bring us films that educate and inspire. Before we continue, let's define a few terms (see our Glossary for more details). Spatial audio can refer to a wide range of sound, from stereo to the various types of multichannel surround sound to binaural and ambisonic sound. We will focus on binaural and ambisonic, as they are able to deliver the type of soundscape that brings the viewer into a fully immersive experience. The unique qualities of immersive experiences can affect sound. In platforms such as 360 and those viewed with web browsers, the viewer can look in all directions in the scene, but can't really move through the scene. The audio and video is therefore limited to what we call three degrees of Freedom (X, Y, Z). The newest iteration of immersive experience, Six Degrees of Freedom (SDOF VR), uses X, Y, and Z axes as well as movements along those axes, such as moving

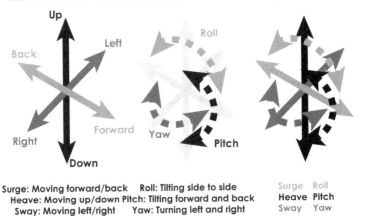

FIGURE 10.1 Three degrees of freedom versus six degrees of freedom.

forward or backward, left and right, up and down (Figure 10.1). So, when ex-periencing this one has unlimited viewing and listening perspectives. But that makes the audio recording, rendering, and playback particularly challenging. In terms of current mixing platforms, my studio is using Dolby Atmos®, so I will spend the most time describing working on this platform. But many of its qualities, and the production assets needed and the workflow, apply to other immersive mixing tools used to create sound imaging (how the sound is placed and played back spatially). The optimal location for our ears when listening to sound with regard to imaging is what sound engineers commonly call the "sweet spot." (You can find more details on Sound Imaging and De-grees of Freedom in the glossary.) Our goal with this chapter is to provide you with both the big picture on where immersive is headed, and some practical storytelling tips for the tools and strategies you will need to become success-ful in building the audio story for three-dimensional experiences.

Though some of the science used in the creation of immersive audio is not new, the blending of previous audio groundwork in ambisonic and binaural audio with new recording, listening, and mixing tools makes immersive sound cutting edge once again. One caution: while there are multiple methods of tell-ing your story, the story should drive the method you choose. So, as we begin this chapter, we want to emphasize what we see as two primary challenges for content creators in this space. The first is shiny object syndrome. We both at-tend industry conferences where the excitement about a particular new piece of tech seems to become more important than the content it was designed to help create. Our goal is to provide you with a broad overview of the state

of immersive audio today, rather than point you towards specific tools. The second challenge is workflow. Due to the rapid influx of new tools that seem to change almost overnight, producers are finding that their workflows may change mid-project. So again, we will try to give you a basic overview on workflows, but not lock ourselves into recommending one particular methodology. As the expression goes, we are all "changing the tires while driving." Let's take a look at what is emerging in spatial audio and how it affects you as a filmmaker.

WHAT IS OLD IS NEW AGAIN: AMBISONIC AND BINAURAL AUDIO

There are two primary types of audio we deal with when creating immersive experiences: binaural and ambisonic. Binaural audio, also known as 3D audio, has a long history. In many ways, binaural audio leans on stereophonic inventions of the late 19th century, most notably one by Clemente Ader, who built upon the telephony invention of Alexander Graham Bell to create an 80-channel spatial telephone that was exhibited in Paris in 1881. The resulting device, known as the théâtrophone, was widely used to listen to musical performances throughout Europe. Amazingly, this early binaural device also allowed the non-attendees to listen off-site (Figure 10.2). Perhaps this is the first case of streamed content? When amplification and speakers started to be phased in, in the 1930s, the thrill of these devices waned.

FIGURE 10.2 Clemente Ader's 19th-century invention, the théâtrophone.

Throughout the 20th century there have been attempts to revive binaural content. But because binaural content requires specialized microphones for production and headsets for delivery, interest remained low. In some ways, the visual and audio delivery system remains the biggest challenge of wide-spread use of immersive content. We are now constantly on our phones, with earbuds providing instant access to audio content; having to pull out special headgear has led to adoption resistance in the public at large. What will radically transform immersive audio is the introduction of artificial in-telligence (AI) into the equation, as XR audio expert Adam Levinson ex-plains: "Machine learning and signal processing will transform audio for XR—devices will understand through the cloud your spatial positioning, where you go, what you do, and what you should be hearing."

While we await that transformation, let's delve into how binaural audio is currently recorded. A binaural audio recording setup uses two microphones placed to replicate the distance between our ears and therefore how we per-ceive sound as it travels from the source to the ear (Figure 10.3). A binaural

FIGURE 10.3 Neumann KU 100 binaural "head" microphone (courtesy: Sennheiser).

recording device helps to process the world around us that shapes the sound, such as room shape, reflections, and even our own bodies. All of these elements can filter, shape, and color the sound. The nature of the two channel recording requires playback on headphones for full effect. Live music, podcasts, and games can all become immersive experiences with binaural sound.

Ambisonic audio was developed in the 1970s by Michael Gerzon and the British National Research Development Corporation. It is now getting much wider use as more tools are developed for gathering, implementing, and playback of spatial audio. Ambisonic audio is not like other surround formats because it's not associated with direct channels or speakers, but rather the full 360 spherical sound field, including the W, X, Y, and Z axes. To deliver an immersive experience, the audio information coming via these axes is as follows:

W: Omni information

X: Left to right directional information

Y: Front to back directional information

Z: Height—Up and down directional information

To record ambisonic audio, a sound engineer will use tetrahedral microphones. Tetrahedral microphones employ four cardioid microphone capsules positioned in an array to capture the 360 degrees around the microphone. Some intrepid content creators have not waited for affordable tetrahedral microphones and have actually built their own setups. One such sound engineer is NPR's Josh Rogosin, who put together four omnidirectional mics in order to begin exploring 360 video. But manufacturers are finally catching up. New options include Sennheiser's Ambeo VR microphone, the TetraMic from Core Sound, and the ZYLIA ZM-1 3rd order ambisonics microphone which can be used alone for 360 audio or with a group of ZM-1's using the company's VR/AR Dev Kit for 6 DoF sound. If you own the Zoom H2n, the firmware can now be updated to handle ambisonic audio. That means you can use the H2n as a spatial audio microphone. Zoom also just released the H3-VR, an affordable ambisonic recorder/mic combo. In reality, you may end up combining a group of microphones—some with ambisonic capabilities and some without—so that you can achieve the combination of location-specific ambience and audio sources you need to create an immersive sound experience (Figures 10.4 and 10.5).

FIGURE 10.4 Recording ambient sound for an immersive project using the Sennheiser Tetrahedral mic, a Zoom H4n, and a Rode shotgun mic.

FIGURE 10.5 The Sennheiser Ambeo 3D VR microphone (courtesy: Sennheiser).

Ambisonic audio is extremely flexible and can be formatted into many speaker and channel arrays. For example, our audio studio recently used Flux by Spat, a software tool that models various speaker and room simulations. Spat also allows a traditional Digital Audio Workstation (DAW) to spatialize the audio using a Dante sound card as an interface. Starting inside a traditional Pro Tools 7.1 session, we are able to use Flux to place the

audio exactly where it needed to go for a recent museum project projecting onto a 50 foot dome. This particular Spat audio setup was 16 speakers in a 360-degree sound field.

When we are mixing 7.1 surround sound, we may pan the audio to jump from speaker to speaker to achieve sound image. By contrast, ambisonic audio moves seamlessly within the audio sound field and is not tethered to a particular speaker. In this way, it is object-based audio. Sonically, ambisonic audio is "clean," meaning it does not have any phasing issues. These qualities make ambisonic audio a good pairing for Virtual Reality (VR), Artificial Reality (AR), and Mixed Reality (MR) experiences. The sound fills the sound field, and any panning or rotation within the recording is reproduced exactly, because the localization is so precise.

There are four categories of Ambisonic recording and playback, depending on what they accomplish sonically. First Order Ambisonics use four channels to recreate the 360 sphere and is very localized, with a very small sweet spot. Higher Order Ambisonics (HOA), recreates an even more detailed and localized capture, allowing for better sound quality and imaging. Second Order Ambisonics have nine channels, and Third Order Ambisonics have 16 (Figure 10.6). Sixth Order Ambisonics use 49 of the channels.

FIGURE 10.6 The ZYLIA portable recording studio can record an entire 360-degree music scene with just one ambisonic microphone (courtesy: ZYLIA).

Channels in this case refer to polar patterns that can be created. That's why HOA have more detail and exact placement—there is more information to manipulate.

Breaking Creative Barriers with Ambisonic Sound

"We've been in the era of "pre-Pong" [the 1980's video game] when it comes to spatial audio, and there is so much more that we can do. The early experiments were done with tracking—left, right, and quadrants—and having sound track with you as you turn your head. Maybe allowing for a sense of something flying overhead. But that's just panning. It's not really spatial. And a few cute enhancements can assist in our sensory perception now, like adding sub-pac (vibrations). But what, really, is spatial sound? What do we think of? It is to feel proximity to the source of sound. To really give that sound design the power it ought to have is what we're after. Do our footsteps echo behind us? How perceptually accurate can we be when we replicate that? Ambisonics are like a pointillist painting: we can put sound 45 inches from your right eye if we want to. And that's pretty fun stuff."
-Nancy Bennett, Chief Creative Officer, Two Bit Circus

There are a few downsides to ambisonic audio. The primary one is that with certain types of ambisonics, sound is so localized that the "sweet spot," the optimal listening position or space, is very small. Higher Order Ambisonics have a larger sweet spot, making imaging easier to accomplish. More care has to happen on set to place a tetrahedral microphone in the right spot to capture the sound. It is important to think about the point of view (POV) of the end user and what the focus of that POV is. Also, if using non-tetrahedral microphones be sure to position them as you normally would, if possible. Usually, the biggest challenge in gathering sound for VR or 360 video is that there is no place to hide the microphone. Try to place the microphones on the stitch line (ideally in the area directly under the camera), so it's a little easier to mask later in editorial. When mixed and rendered, the audio may seem out of phase or out of focus. Gear can be expensive and the files tend to be large. The good news is more platforms have adopted ambisonics, providing better and more affordable tools for content creators. An example is Google's spatial audio software tool called Resonance Audio that works across mobile and desktop platforms.

Let's turn our attention to what happens once spatial audio is captured. How does it become a recording you can work with in your mix? Audio captured by tetrahedral microphones are raw ambisonic recordings and are

"A" format audio. "A" Format Audio is not usable in NLEs or DAWs in the traditional sense. They first must be decoded into "B" format audio to be used and heard. There are two types of "B" format depending on the decoder used. There are standard decoder plug-ins, like Harpex, but usually the microphone comes with an A to B converter.

It is very important when decoding to make sure to keep the information in the proper order to replicate the sound recorded. The order of the W, X, Y, and Z axes is different in the two different types of "B" format audio. Furse-Malham or FuMa is an older protocol that is supported by a variety of plug-ins and other ambisonic processing tools. AmbiX is a more modern standard and has been widely adopted by YouTube and Facebook. FuMa and AmbiX follow different orders; not following the correct order in post is what leads to the most problems in mixing ambisonic audio.

FuMa follows this order:

W: Omni information (or the sphere) at constant volume and phase

X: Left to right directional information

Y: Front to back directional information

Z: Height—Up and down directional information

Ambix follows this order:

W: Omni information (or the sphere) at constant volume and phase

Y: Front to back directional information

Z: Height—Up and down directional information

X: Left to right directional information

AUDIO DIFFERENCES BETWEEN 2D, SURROUND, AND IMMERSIVE PLATFORMS

Let's take a moment to define how the sound experience differs from 2D to immersive. Mono sound is single-channel. Traditional two-channel stereo

provides sound information coming out of one or the other channel, or has sound information spread between them. 360 audio is spatial but passive, meaning that the sound moves around you, but you do not move around inside the sound environment. 360 video soundtracks tend to be either stereo or binaural. Traditional 5.1 surround sound requires channels that correlate to speakers: Left, Right, Center, Low Frequency Effects (LFE) Left Surround, and Right Surround. 7.1 is similar, but adds rear speakers as well as side surround speakers into the mix. With VR sound, you have six degrees of freedom, and therefore can move around "inside" the space. That means sounds change as you move. This requires a special headset to consume this audio content. VR audio combines traditional stereo, mono, binaural, and higher level ambisonics.

AUDIO DELIVERY FORMATS FOR IMMERSIVE EXPERIENCES

Immersive sound differs from traditional 2D audio because it employs the Z-axis or height. In an immersive audio experience, you can hear not just around you but also above you, and even below your head. Traditional surround formats, such as 5.1 and 7.1, employ speakers arranged around the sweet spot, but this does not include height. Immersive sound formats are currently either object-based or channel-based. Channel-based means audio is output through channels and is spread over the speaker array as panned; it is a more traditional approach. Object-based means that when we are building a mix, we can render it to a three-dimensional space made up of objects—as many as 128 in Dolby Atmos® and an unlimited number in DTS:X. When the film is played, these objects then adapt in real time to whatever speaker array exists in the viewing space. Most object-based audio mixes have surround sound beds (5.1, 7.1, etc.) as their foundation. Then additional elements are added using the object-based tools. Object-based audio is exciting because the format is more translatable than channel-based immersive sound systems, since the mix is adapted to the speaker array and room. When encoded, the mix carries the information of the mix suite and translates it to the end environment (Figure 10.7).

Introduced in January 2012 with the George Lucas film *Red Tails*, Barco's Aurora 3D was the very first immersive sound technology. It is a channel-based format relying on speakers placed high up on the walls along with a ceiling speaker. It is a valid format in commercial theatres around the world

FIGURE 10.7 Object-based audio is rendered into three-dimensional space.

and has a larger presence in Asia and Europe than in the United States. Barco Aurora 3D has recently made inroads with its headphone technology for recreating immersive sound formats, but is just now making inroads into the home theatre market.

Dolby Atmos® was introduced shortly after Aurora 3D, in June 2012, with the Pixar film *Brave*. It has quickly taken the lead in immersive sound (disclosure: I (Cheryl) mix Dolby Atmos® projects). Dolby Atmos® is an object-based immersive sound format that has strongholds in both commercial and home theatre settings. Content mixed in Dolby Atmos® is now streaming through platforms such as iTunes, Netflix, Hulu, and Amazon Prime, with more outlets announced regularly. Immersive audio will assume a stronger role as gaming and interactive content creators push for headphones that reproduce spatial audio. This move into reproduction for interactives is a huge step into non-linear entertainment and storytelling.

DTS:X is another object-based immersive sound mixing standard that arrived in movie theaters in 2012, and was available to private consumers soon after via AV receivers and Blu-rays. Late to the immersive sound game, it is

slowly gaining ground and is available on most home receivers, but fewer titles are encoded with the technology.

As the industry moves towards standardizing its formats so that equipment manufacturers can standardize their own gear, a new immersive format has emerged: MPEG-H from Froenhoffer. MPEG-H is object-based. It was first released in 2014 and was accepted in Korea as its broadcast standard in 2017. MPEG-H is starting to spread to Europe and was recently used for the broadcast of the 2018 French Open. CES 2019 brought announcements from SONY that it will use MPEG-H as the immersive sound codec for its 360 Reality Audio system for immersive mixing and playback for music. The exciting part of MPEG-H is that it is an open system for both interactives and immersive sound. It is designed to go from broadcast systems and streaming platforms to home theatres, tablets, and even VR devices. It can be played over speakers or headphones. The goal is to present MPEG-H as the future by having it be open to developers and easier to license. It is intended to allow consumers to use audio presets to control the mix, even to the point of manipulating dialogue levels. This is a big selling point, especially to networks and streaming companies who want the consumer to have the best experience. Of course, as a mixer this scares me. We work to achieve a specific mix that pulls you into the story, and in many cases, you could argue we are creating the story with our mix. So, having the audience make changes to this mix is a bit frightening. On the flip side, it would prevent many issues in playback platforms that we currently have little control over, allowing the consumer to control their listening levels geared to their systems and taste. I am sure this will be a very hot topic among content creators moving forward.

DOLBY ATMOS®

Dolby Atmos® is an object-based sound technology platform, developed by Dolby Laboratories for the creation, delivery, and playback of immersive audio content. It is employed primarily in cinemas, streaming, home theatre, and gaming. I first experienced it in 2013 at the *Sound on Film Conference* in Los Angeles, and what struck me immediately as a sound designer was the opportunity to deliver story content through more than the X and Y axes. The opportunities for storytelling literally made me giddy. I could place, move, and effect any sound in the sound field, including height, and it would translate from room to room and location to location, with metadata

attached for proper playback. This would provide for extremely localized playback, no matter the size or movement of the object. Another intriguing area for me was a change in my workflow. For example, instead of creating a large sound by spreading it over multiple speaker channels, I would be able to adjust the size and precise placement of a sound into the full sound field of the frame. You can see right away the possibilities for this technology when it comes to immersive storytelling.

On that same trip to Los Angeles, I had an opportunity to visit an audio post house where they were adapting surround sound mixes to Dolby Atmos®. I saw the process in action, with tools I use every day. It made me a believer. This was not what we call "vapor ware," but actual working software I could use to create new content. However, I was curious about the plan to get the technology beyond the commercial cinemas and into homes. As a mixer of primarily nonfiction, I felt this was critical to allowing broader content to be accessed by the home viewer. After mentioning this, I was ushered into a room where I listened to mockups of home theatre setups for Dolby Atmos®. Today, almost every receiver sold for home use has immersive sound decoders installed. Affordable sound bars and home speakers can emulate the mix via manipulations in reflections off ceilings and walls. There are even room-tuning tools included in some packages that allow the speakers to "read the room" and adjust the sound mix for that particular space. One of the more exasperating aspects of mixing traditional 5.1 or 7.1 surround for home theatre is that you never knew how the system is actually set up. More often than not, the surround speakers are on the floor with no idea of correct placement. Now that immersive sound has driven easier and better consumer setups, all mixes have a better chance of being heard in the intended manner.

The first project I mixed in Dolby Atmos® was a test for a network looking to start streaming with this new format. The film recreated the first act of a production about air crashes. The mix took me a long time, as I worked through learning the technology and tools to deliver the sound as I heard it in my head. Looking back, I was translating my vision from surround into immersive. Now, mixing is just the opposite for me. The most exciting moment of that mix was panning the first jet from behind me over my head and having it crash lower front right. I have been waiting my whole career to have that control. The excitement continued as I put voices in the overhead speakers like intercoms on a plane and moved on to create the true chaos of what a plane crash would be like think fire, explosions, impacts,

and screams. It was so real to me that I now have difficulty flying. Satisfaction came later as the Executive Producer (EP), who has spent her whole career in nonfiction storytelling, was blown away by the experience and as excited by the possibilities as I was.

The first project I *wanted* to mix in Dolby Atmos® was a museum project that had a 180-degree life-sized screen with 16 speakers in a small gallery theatre, with two overhead speakers and one Low Frequency Effects (LFE) speaker. I had done large museum installations before and knew this director would want seamless movement of audio around all the speakers that was exactly placed to the images. After looking at a fine cut, I saw that it included a recreation of the battle of Yorktown. I realized an audio panner with height and 360 spatial capabilities was a must.

After doing some research I realized there were tools available, they just weren't yet in Pro Tools, the DAW I use every day. Even the Facebook 360 tools were not available yet. I was surprised by this because I had seen Dolby Atmos® in action almost two years prior in LA. I reached out to my contact at Dolby about acquiring the panning tool. The technology I had seen in LA was already had been implemented in commercial cinemas and the tools I needed were close to being released. Both Dolby and I moved quickly to implement the new tools for the project, but I had to complete the project in an unfamiliar DAW. Though the mix turned out great and the 4D Theatre has won awards, I came out of that experience determined to implement Dolby Atmos® in my own studio using Pro Tools. What transpired led me to build the first near field (home thetare) Dolby Atmos® mixing suite on the East Coast.

As a result, I have a few tips if you decide to work in the Dolby Atmos® format. As frequently discussed in this book, one of the biggest challenges any film maker and mixer has is translating their mix from platform to platform and location to location. If you are having your film mixed in Dolby Atmos®, be sure to listen back through the Rendering and Mastering Unit (RMU) to the derived mixes and tweak to achieve the surround and stereo mixes desired. Just like comparing surround and stereo mixes in traditional channel-based mixing, this will help you deliver the mix you want. In Dolby Atmos®, other sound mixes, such as the 5.1 and 7.1, can be derived automatically from the time the audio is encoded, so there is no need to mix or deliver the audio more than once. Though true, we have had to tweak and output different mixes to satisfy different technical specifications as requested, similar to doing both theatrical and broadcast mixes (Figure 10.8).

FIGURE 10.8 Cheryl working on a Dolby Atmos® mix (photo credit: Ian Shive).

GATHERING FIELD ASSETS FOR SPATIAL MIXING

Immersive productions differ from those made for stereo and surround sound in their audio production workflow, primarily because of the need to populate the Z axis with audio. This is the axis that affects the height of the sound in a spherical environment. Just like in any other projects, preproduction planning for the gathering of sound assets in the field is important. When you are in the field, make ambisonic recordings of natural and sync sound (not interviews). The decoded recordings translate extremely well into Dolby Atmos® because they contain the Z axis and carry over spatial sound image. Multiple omni microphones, placed to complement and overlap each other, are also helpful when approaching the mix stage, especially because these can provide needed ambiance elements. For example, when working on an environmental title for the Smithsonian, the location team found that sync sound of some of the animals was not easily recordable. So, my team went out with a tetrahedral microphone (ambisonic), a zoom h4n (quad), and a boom mic (mono). We then brought in the assets and worked in the Dolby Atmos® mixing suite so we wouldn't have to work the whole day with head gear on. The tetrahedral microphone provided a spatial

reproduction of Rock Creek Park that was lush and fully 360. What was also caught in the recording was a sports car as it drove by.

The quad and mono recordings added layers and textures to the 360 base of the ambisonic recording. We just chose to try out the tetrahedral microphone and used the h4N as our backup, instead of using an omni. The playback of the decoded ambisonic recording of the car in Dolby Atmos® was spectacular. The car could be *felt* as it zoomed around and revved its engine. This is the future of sound acquisition and mixing—making the listener/viewer fully sense the environment of the story.

Of course, there will be situations when omni or ambisonic recordings are not available. In this instance, it will take your sound designer and mixer some thought and time to create 360 sound elements from 2D assets. Similar to the current challenge of creating 5.1 or 7.1 surround out of mono and stereo assets, it is possible to achieve good results. Just remember to add additional time to your schedule to build these elements. As immersive sound becomes more mainstream, more and more tools and techniques will be developed to support the massaging of 2D assets for 3D productions.

Musical assets have similar challenges in immersive sound. Stereo full mix music can be manipulated and used when mixing for immersive sound, but it's not ideal. The stems from a stereo music mix are helpful in any mix configuration, but are essential when building music in Dolby Atmos®. If time and budget allow for an original score, plan on mixing in surround (unless Dolby Atmos® mixing is available) and providing stems. Music stems allow the mixer to spatialize the music throughout the 7.1 bed and make objects out of individual instruments. If your music score or other music content for your production is being recorded live, use additional microphones to help create dimensionality to your score. Two to four up-firing mics or omni-directional mics placed above the musicians can provide natural height information. Omni mics hung and placed around the performers can also gather the information needed for an immersive sound mix. Try to place omni mics and some tight cardioids in the middle, on the sides, and at the conductor's and listeners' positions. As we have discussed in previous chapters, there is nothing worse than a wonderful live performance that seems like no audience was present. The same is true for immersive productions. So, if you are recording a live event or performance, be sure to mic the audience in the same fashion outlined above to capture reactions from multiple vantage points in the space.

Filmmakers should approach immersive sound opportunities from the be-ginning as they are capturing sound. Capturing as clean sound as possible should be a given no matter what, but it matters even more in immersive environments. That's because the immersive mixing process makes each sound more localized. When you start to mix, you will really notice poor audio quality. This is especially true for VR/AR/MR as the encoding and rendering process can make poor audio stand out even more.

For more linear storytelling in the immersive realm—for example, a documentary-style approach to a natural landscape—capturing sound with clean elements in mind is essential. Using tetrahedral and Mid-Side micro-phone setups goes a long way to creating the sound field in mix. Mid-Side microphone set-ups use two microphones. The mid microphone captures direct signals, while the side microphone captures ambient signals. If spe-cialized microphone set-ups cannot be used, consider using an array of mics placed strategically for the scene. Much can be done in post without these sources, with a more traditional approach to production and standard as-sets, such as mono and stereo sources. The magic can happen in post when the sound designer or mixer imagines the spatialized space and creates it. When planning for an immersive mix it is even more important to commu-nicate and see where the mixer can make a difference, even for lower budget projects. If music is being composed, provide stems so the mixer can create the immersive music mix. Mono sound effects are easier to manipulate as objects, though stereo effects can be used as well.

YOUR IMMERSIVE MIX

New tools and plug-ins for 360 and immersive mixing are being introduced every day. As sound designers, we use mainly the same tools to sweeten audio in immersive as we do in traditional sound formats. EQ, compres-sion, reverb, and sound design can all cross over very easily into immersive formats. More specific tools include those for panning, up-mixing, room modelling, and convolution reverb. For the most part, you will still work in your DAW of choice, such as Pro Tools, Nuendo, and Reaper. For 360, Tools for VR and Facebook 360 are fantastic and free. In their 360Pan Suite, Audio Ease also has some very useful 360 tools for VR mixing, including panner, render, and rotation tools. Harpex software is used extensively for microphone conversions and modelling speaker arrays, and Spat Flux has an excellent spatial modelling tool and ambisonic panner. Reverbs tend

to still be in the traditional audio space, with very little in the immersive object-based space. AudioEase has one of the only systems that supports Dolby Atmos® with its "Indoor" reverb feature. Altiverb, also by AudioEase, is also widely used because of its quality and ease of use, although it does not employ height. Nugen's Halo is a popular choice for up-mixing music and ambiances to Dolby Atmos® because it does employ overhead sources. Up-mixing is the process of converting audio into higher imaging formats. For example, mono audio can be up mixed to stereo or even 5.1. Most often stereo elements are up mixed to 5.1 or 7.1 surround formats. With immersive audio formats, up-mixers add in the overheads for the Z axis. However, be cautious of possible phase issues when using an up-mixer. The manipulation of the sound to create a broader sound image comes at a cost. Signals can be spread so that they overlap or partially overlap each other, cancelling out audio information. This results in a tiny hollow sound. When possible, I choose to build music beds and ambiances natively instead of using up-mixers.

When mixing in immersive sound, people seem to stay very close to their roots and not stray too much from what they know works. This is not a bad approach. However, I've learned to test out a different approach or technique in small chunks, instead of investing in a work flow or idea over a longer period of time. For instance, in placing dialogue as objects in a mix I played with different placements for the voice as an object and not just center-anchored as we are accustomed to hearing. This worked very well in certain scenes, such as those with movement, intimate scenes, or very loud vocal scenes that included yelling. I mixed a few scenes like this and then rendered out the final mixes; I listened back in Dolby Atmos®, 7.1, 5.1, and Stereo. There were no translation issues, which was great. If there had been any, it would have been early enough in the process that we could have solved those problems. Experimenting and testing as you go is essential.

When planning schedule and budget for immersive sound mixing, the creative should not take more time for this type of mix than it would for a traditional one. As in any creative collaborative environment, add time if there are ideas you want to explore or different approaches to story that you want to try out. The really cool part about Dolby Atmos® is that all the mixes and deliverables can be derived from one render. Time needs to be added to screen the derived mixes to make sure they are as expected. This workflow is similar to listening to the stereo down-mix of the 5.1 surround in a traditional surround work flow. Time must also be added to make all of

the PCM audio deliverables. Feature films will almost always individually mix the different formats being delivered based on the original immersive or 7.1 mix. It is not uncommon for immersive sound mixes to be expensive.

Because it's newer technology, the rate tends to be elevated. However, the trend for nonfiction is to add time at the end of the process at the surround mix rate to screen all of the derived mixes and to make sure everything is translating correctly, rather than just elevate the mix fee across the board. Plan on adding one to two days for every 50 minutes of run time for an independent production. This includes the time needed to make all the deliverables, including the print masters.

We tend to take the marrying of video and audio for granted in non-immersive formats, so in the world of immersive, it can be a surprise when this process isn't always so easy. Platforms and tools are constantly changing, but currently there is not an easily accessible tool to marry immersive sound with HDR, HDR-10, and Dolby Vision®. At over six figures, it is just too expensive. But the industry is responding to the need for affordable tools. For example, Blackmagic Design's Fairlight audio features in the latest version of DaVinci Resolve now include advanced spatial audio formats. If you are not able to use such spatial audio mixing tools, then you will need to send your final mix and color master to another studio with these capabilities to create your final master.

There are some mistakes you can avoid when mixing for immersive. One common mistake is going too far with a sound. Think of a new driver handling a car. When faced with a curve in the road, they often jerk the steering wheel too much, overcompensating, when all that is needed is a small adjustment. The same is true for immersive mixing. Small adjustments in a mix can make a huge impact in spatial sound. We tend to think we have to use every object (128) and the more movement the better. Yes—adding these sounds is thrilling! But quiet scenes, with small amounts of ambience and a few objects, often have the most impact. There's something very intimate about pulling in the music a tad closer, almost like a blanket, and drawing the tones ever so slightly closer as an object. Or creating a scene where the listener can feel the atmosphere around them in the darkness of the night. These are the magical moments you can create in an immersive mix.

There are some additional problems to avoid when working in immersive. Before you start, it is even more critical than with a traditional stereo mix

to have a concrete deliverables list, so that the rendering system can be set up correctly. Think ahead to your derived mixes and listen back constantly through the Dolby Atmos® RMU. Be aware of what you are supposed to be hearing and what you are actually hearing. This is true in any mix situation. When setting up your session, make sure to build the beds and objects in numerical order. This strategy makes it easier to move sessions from system to system.

NONFICTION APPLICATIONS FOR IMMERSIVE SOUND

Some of the most innovative uses of spatial sound are happening now in the nonfiction space. A great example of this work has been created by immersive sound designer Ana Monte Assis. In her shared creative studio space in Germany, this Brazilian audio engineer built original sounds for an immersive training project about the human heart for Stanford Virtual Heart. This VR experience created by Lighthaus and Oculus Rift was designed to help medical students and families understand common congenital heart defects. For the project, Ana and her partner David DeBoy had to analyze the frequencies of the human heart as heard through the body wall as if through a stethoscope. They were not able to use actual heart recordings, because these recordings were either too corrupted or too "clean." Instead, using tools from iZotope RX, they developed original sounds, and then added spatial elements specific to each type of defect. Another creative space getting involved in 360 and VR is the music industry. Nancy Bennett recently directed the award-winning "One at a Time" music video for Alex Aiono & T-Pain, winning the Lumiere VR Award. Corporations are jumping onto the immersive train for educational applications. Walmart purchased more than 17,000 Oculus Go headsets for internal customer service training in a joint project with STRIVR. Sound is of course an essential tool when creating such realistic scenarios and when working towards an emotional response from the participant. VR Producer Anneliene van den Boom and the team at WeMakeVR in Amsterdam has been doing just that with a series of 360 educational experiences, including one for students about bicycle safety called *Beat the Street*. (If you've never been to Amsterdam, it's worth understanding that thousands of people bike to and from school and work every day on the streets of this city.) Shooting with Nokia OZO in order to simulate the feeling of biking, Executive Producer Avinash Changa put together a frame on a small scooter (Figure 10.9). According to van den Boom "The OZO is small and light and allowed for lengthy takes and easy battery

FIGURE 10.9 Filming a bicycle safety VR project (courtesy: WeMakeVR).

swaps. (Today, other options would be the Obsidian or Insta360 Pro II.) For audio, the team relied on a mix of microphones, including lavaliers on all the kids doing the biking and a microphone near the camera to pull in street ambience." The voice-overs of the children were recorded on the final shoot day in a mini-sound studio created inside a production van. Crash sounds and other effects were added in audio post. The military is taking advantage of the medium as well, using it to recreate realistic battle scenarios. In the United States, the Army has already built simulations of cities such as San Francisco and Seoul. We don't have the security clearance to know the audio components of these immersive experiences, but one can only imagine. One of the great innovators today in immersive sound is Metastage CEO Kristina Heller. In a joint venture with Sennheiser, they have mics placed in a volumetric capture space to create holographic recreations of real people and performers.

A growing area for nonfiction VR is "additional content" for 2D titles. Technologist Alexandra Hussenot, Founder of Immersionn, a VR exploration portal site allowing visitors to discover virtual reality content from multiple sources, sees this as a growing area for filmmakers: "VR can be integrated to other mediums and not consumed in isolation. This is where WebVR is

useful. Most immersive documentaries only use a WebVR player to play the film. But it is possible to integrate web links inside the story so the user can explore various paths."

Immersive has long been used in the museum and amusement space because the nature of the permanent and long-term installations allowing bespoke theatres and interactives to be built. It is great to see the sound design tools catching up and offering more opportunities for this type of experience. Harry Potter's World in Orlando combines immersive sound and mixed media in many of the experiences. Atlanta's College Football Hall of Fame's main theater uses multiple life-like screens and a 22.1 speaker system to recreate the game day thrill. A 22.1 mix was almost impossible on most DAWs just six years ago. A modified Pro Tools system had to be used. Plus, the panning tools were limited to seven-speaker channels. Today, we can model sound arrays in 360, 180, and specialized combinations—including overhead speakers for the Z axis and panning tools that accommodate movement in these specialized sound environments.

Museums such as the Atlanta History Center and the Aquarium of the Pacific are imagining immersive experiences that include life-like visuals and sound. The tools to implement sound for these installations have been driven by the dramatic transition to object-based audio in VR/AR mixing and immersive sound tools like Dolby Atmos®.

Yet while innovators continue to press forward, in many ways VR has still not lived up to its hype. Storytelling, both fiction and nonfiction, is struggling with the platform because consumer markets have not adopted the new tech as quickly as was originally projected, due to cumbersome goggles, tethers, and the lack of a headphone standard. VR creators are still grappling with finding the right tools at affordable price-points. All of these issues will likely be resolved in the next few years. Wireless products are coming onto the market, and new low-cost production tools are also getting traction. Zoom has an ensemble of affordable, quality recorders for use in both traditional production scenarios and immersive capturing. Check out the HV VR 360 and H4N and H6. We mentioned Sennheiser's Ambeo VR mic, quickly becoming a standard in 360 audio capture. At the same price-point, another favorite is the Rode NT-FS1 Ambisonic microphone. Some of the most accessible tools are Facebook's 360 tools. They are free and work exceedingly well in most DAWs, including Pro Tools and Nuendo. The tools include 360 video integration into the post workflow and utilities to pan

and design spatial audio. Included, of course, are easy publishing tools—especially for YouTube and Facebook. Since Facebook is offering their tools for free, most of the basic 360 and VR tool sets for audio are very reasonably priced. For example, AudioEase's 360Pan Suite is priced well under $300. Most VR hardware suppliers and integrators, such Google and Samsung, offer free tools that are similar to Facebook's but are geared to their proprietary hardware. Flux's Spat is on the upper end of the price-point, but has incredible control and has expanded flexibility to create specialized speaker arrays. Zylia has released ZYLIA Studio PRO and ZYLIA Ambisonics Converter Plugins to enable those working with the Pro Tools DAW to use the ZM-1 microphone. As immersive production and post-production tools become more affordable and more widely available, AR, MR, and XR are likely to become a faster growing segment of the industry. As immersive headphone development takes a leap forward, we believe immersive sound will take its rightful place as the central ingredient needed to bring spatial audio into its full glory. In the meantime, we encourage you to experiment. There are no rules, only new ideas and new ways of telling stories.

Tips

▶ When you are in the field, make ambisonic recordings of natural and sync sound (not interviews). The decoded recordings translate extremely well into Dolby Atmos® because they contain the Z axis and carry over spatial sound image. Multiple omni microphones, placed to complement and overlap each other, are also helpful when approaching the mix stage, especially because these can provide needed ambiance elements.

▶ If you are having your film mixed in Dolby Atmos®, be sure to listen back through the renderer (RMU) to the derived mixes and tweak to achieve the surround and stereo mixes desired. Just like comparing surround and stereo mixes in traditional channel-based mixing, this will help you deliver the mix you want.

▶ If the score or other musical content is being recorded live, use additional microphones to help create dimensionality to your score. Two to four up-firing mics or omni mics placed above the musicians can provide natural height information. Omni mics hung and placed around the performers gather the information needed for an immersive sound mix. Try to place omni mics and some tight

cardioids in the middle, on the sides, and at the conductors and listeners positions. If the event or performance is live, be sure to mic the audience in the same fashion to capture reactions.

▶ Filmmakers should approach immersive sound opportunities from the beginning as they are capturing sound.

▶ Capturing as clean a sound as possible should be a given no matter what technology you use, but it matters even more in immersive environments since we are isolating and localizing sounds.

▶ Before you start an immersive mix, it is even more critical than with a traditional stereo mix to have a concrete deliverables list, so that the rendering system can be set up correctly.

▶ When setting up your session, make sure to build the beds and objects in numerical order.

▶ When mixing, test segments, render, and listen back as you go. Be aware of what you are supposed to be hearing and what you are actually hearing. This is true in any mix situation.

▶ In the post-workflow process, once a spatialized mix is rendered, you will typically also need to re-render a stereo (and possibly 5.1 or 7.1) mix version, so plan ahead accordingly.

▶ Remember you will need to send your outputs back to your editor to marry in an NLE. Most DAWs do not have the capability (yet) to lay back to VR formats.

11

Making Videos Accessible

Society is inching towards accessibility for everyone when it comes to film and digital media content. Audiences with disabilities have been speaking up for their rights for some decades. Laws in many countries, including the United States, now require audio description and captioning for projects funded by taxpayer dollars, which has created larger pools of accessible content. And now technology is making it possible to deliver—efficiently and affordably—captioned and audio described content. Audiences are also eager for content that may not have been originated in their native language. Here again, technologies, such as artificial intelligence (AI) and machine learning, are making automated processes faster, better, and more affordable. And there are plenty of humans also working to create more accessible content worldwide. The more content is created with all audiences in mind, the greater the audience demand for even more audio that is described, captioned, and translated, so it's a win-win for content creators to acknowledge and serve the disability and translation communities.

In writing this chapter, I interviewed many people involved in bringing that content to life. They agree there are two keys: (1) be ready to provide an accurate transcript of your finished program, and (2) pauses help. We're not talking about large gaps. Just small beats between dialogue sequences and scenes. Frankly, you should have them anyway. As we discuss in other

chapters, there is an important storytelling role for moments without narration or dialogue. And luckily, when considering storytelling for a wider audience, we have a great advantage in the nonfiction world over those working in fiction. In narrative film, it would be uncommon to change the film in any way for translation, other than dubbing or adding captions. But in documentary and other nonfiction content forms, such as video for training, outreach, advocacy, etc., we have the ability to build different versions. These do not have to be wildly costly reedits. But we can give ourselves the flexibility to do a modest reedit with longer shots in some scenes, in order to accommodate a translated voiceover, audio description, or caption. For example, if I know in advance that a project is likely to be translated into many foreign languages, then I will include reminders on my shot list to roll a little "pad" before camera or talent action, and to hold shots longer after action before cutting. This gives me longer "handles" on those shots, so that when editing into a sequence I have some room to adjust shot length for a translation to catch up to the action. We can simply match back those shots, knowing we can add more frames here or there without fundamentally changing the shots or the sequence of shots. As you will learn later in this chapter, there are certain languages that require more time. And audio description and some captions may also benefit from less frantic pacing. To be clear, I'm not recommending you change the pace of the entire project—that could affect the impact of your story for all audiences. But it is worth being mindful about shot pacing and editing tempo so that we have options once we begin the work of audio description, captioning, or translation. Ultimately, we can be more successful storytellers if we reach a wider audience. Let's take a look at the specific ways to make content accessible.

AUDIO DESCRIPTION AND ACCESS FOR BLIND AND VISUALLY IMPAIRED AUDIENCES

According to the World Health Organization, about 1.3 billion people worldwide are living with some form of visual impairment. According to the National Federation of the Blind, more than 7 million blind or visually impaired adults live in the United States alone. Do you really want to lose all of these potential viewers of your content? Unfortunately—and I'm sadly including myself in this group—we sometimes don't consider the needs of this audience up front, when developing productions. It turns out that it is not an excessively expensive or cumbersome process, but it does require a little advanced planning.

There is a simple way visually impaired viewers can access film content, and that is through a process called audio description. Audio description is an additional audio element that can be added to any soundtrack. Most broadcasters now have the capability to send out this signal, known as the Secondary Audio Programming (SAP) track, which you can access through the control settings on your television set. YouTube offers an Audio Description upload plugin. Once you upload your description, the plugin appears in the lower left and can be turned on and off, and volume can be adjusted.

Audio description cannot replace sound storytelling that isn't present in the first place. If the critical contextual audio elements we've been talking about throughout this book are missing—wild sound, sync sound, appropriate music and sound effects, quality interviews, snippets of dialogue between characters—then everyone, not only the disability audience, is missing out on a better story. Your film should include enough compelling audio to deliver textured and nuanced storytelling. One of the ways to ensure this as you are working on your edit is to pay attention to what we call the "radio story." Close your eyes and play back the cut. What do you hear? When you change locations, are you providing context through sound (not simply text on screen announcing the location)? Can we hear the birds in the trees for a scene in the woods, or the sounds of cars whizzing by for an establishing shot in the city? And what about your characters? Can we hear some familiar chitchat between a long-time couple before you cut to one of their interviews? Perhaps we can hear the sound of children playing in the house with a little snippet of b-roll before you launch into an interview with a busy mom. Or we hear the cacophony of a symphony orchestra warming up before you begin the scene about the conductor. When you build audio context throughout your film, including some spaces for "silence," which is really room tone for that location, your story won't exclusively lean on the description of the visuals and will be stronger for every audience.

To learn more about the process of audio description, I turned to one of the pioneers of the audio description field, Dr. Joel Snyder of Audio Description Associates. Dr. Snyder has a PhD in in accessibility and audio description from the Universitat Autonoma de Barcelona, Barcelona, Spain, and has been doing audio description for video since the 1980s. I have turned to Joel for several of my own productions. I'll use a more informal Q&A format here, to delve into some of what I have learned in my discussions with him.

Q: How and when did audio description begin?

A: Audio description began as a formal service in 1981, with a group who had performing arts backgrounds putting together concepts and techniques for describing what was happening on stage for visually impaired audiences. It went quickly from performing arts to television when WGBH approached us about audio describing public television programs. Dr. Snyder wrote the first three pilot programs that were ever audio-described. The project became the Descriptive Video Service (DVS), originally launched for use by other public television stations. Sometimes the term "DVS" is still used today to refer to audio description.

The Federal Communications Commission (FCC) issued a rule of four hours minimal description, which was later struck down in court. Then in 2010, Congress passed a law to mandate an FCC rule of nine hours a week of audio described content by the major American broadcast networks. In the United Kingdom, 15%–20% of all content is now audio described. While many VHS releases were audio described, once we moved to DVD, many of those audio descriptions were not included. In theaters, many movies are audio described because movie theaters are public places and therefore fall under the Americans with Disabilities Act. Eventually museums began picking it up for tours, etc. In his long career as an audio describer and advocate, Dr. Snyder has described sporting events, funerals, weddings, parades— wherever the visual is critical to the understanding the event.

Q: How much content is audio described now?

A: According to Dr. Snyder, in the United States, a considerable volume of content is audio described. Any content created by anyone receiving US Federal government funds (Section 508 of the Rehabilitation Act and recipients of government money) must make their materials accessible. Corporations are also required to do this now. For example, Microsoft is very sensitive to disability concerns and making all of their thousands of training videos accessible. Most major feature films, content for DVDs and Blu-rays, and content on streaming services is now also accessible. The American Council of the Blind keeps track of content being audio described and available through Amazon and Netflix (see our Resources section for these links).

Q: Even if it's not legally required, why should content creators care about accessibility to the visually impaired?

"If you aren't considering the blind and visually impaired audience, you aren't tapping what has been an underserved market," says Dr. Synder. And he's right. We're talking about millions of Americans who are either blind or have trouble seeing, even with correction. I (Amy) was recently approached at a University speaking engagement by a blind audience member who wanted to watch a film I had mentioned producing in my talk. I had to admit to her that it had not yet been audio described. (It has now.) Thinking through the timeline for release and ensuring timely release for all audiences is an important step in post-production workflow for content creators.

Q: What are the new innovations for accessibility?

A: Half a dozen apps for mobile phones have come out recently, such as Actiview, which allows your smartphone to hear what's going on in the movie theatre and then sync to an audio description track you down-loaded in advance into your app. You use your earbuds to access this track while you are watching the movie. Actiview is also available for translations. We expect to see more of these apps entering the market for smartphone users. [Author's note: These apps are a big step for-ward, as the headphones available at many movie theaters aren't always reliable.]

Q: What are the biggest obstacles when providing audio description?

A: Creating a good audio description track takes time. It is a more nuanced process than simply transcribing the content for captions. It takes the initial audio description writer about one hour for every three to four minutes of content. That material needs to be reviewed by another person experienced with audio description to be sure it is accurate and uses good storytelling techniques. Then the track gets voiced, re-corded, and edited into whatever format the client or filmmaker needs. Dr. Snyder explains:

"When I teach audio description, I emphasize the skills needed: dis-cernment to cut out unnecessary elements, a superior vocabulary, and the ability to be both vivid and concise at the same time. It is also important to have the vocal skills to perform the script."

An important component of audio description, which also applies to cap-tioning, is to ensure you are not providing more than what is available to the sighted viewer. In other words, do not give away the plot.

"If there's a gun on that desk and you know it will go off by the end of the scene, you want to incorporate a mention of the gun in your description, but you don't want to overdo it and ruin the suspense" explains Snyder.

Q: Is there something content creators should do to make your job easier?

A: Dr. Snyder is clear about his role:

"Audio describers work in service to an audience that is underserved, and are also in service to the film art form as it is given to us. It's not really our place to tell the creators to put in more pauses to make our job easier."

[I will disagree slightly here, just to say that one of the reasons we included this chapter in our book was to call attention to the workflow for accessibility. While we don't want to recommend unnecessary pauses, we find the lack of "space" in films to have a negative effect on storytelling and the ability for *any* audience to keep up with what is happening on screen.]

Q: What is the most difficult project you ever described?

A: Live description for televised events is inherently dicey because you haven't had a chance to review anything. You can do lots of preparation. For example, Dr. Snyder has voiced many Presidential Inaugurations, and spends time understanding the order of events and the key political figures and performers involved. He also likes to prepare a series of synonyms, since in a multi-hour event, he doesn't want to tell a boring story for the blind or visually impaired audience. A 15-second spot is one of the most challenging types of content. Less dialogue or narration provides at least a bit of room for creating an audio track with some space. Listening to several audio spots described by Joel, I felt like my ears were numb trying to keep up with such fast-paced, cutting action on screen, despite his heroic efforts to make the pacing less frantic.

Q: What is the workflow for audio description? Take us through the process.

A: The following are what an audio description service will need from you in order to create your track:

1. Total runtime of your film or video

2. What is/are the deliverable(s)? Do you just need the audio description track timed to fit within the pauses of the film and you will lay it back? Or do you want the service to handle this editing process? (In which case you will need to deliver the files they request to make that possible). Do you need a script in advance for approval?

3. A copy of the film in final picture-locked form—meaning you will not be making any additional changes to the timing of scenes.

4. A list of any special or unusual names or acronyms and a guide on how to pronounce them.

5. Any special factual information related to your content (for example, if you have produced a training film, the correct names of any equipment the describer will need to use as they describe scenes).

NOTES FROM A BLIND VIEWER

Itto Outini has another perspective. A Fulbright Scholar in the graduate program for Journalism and Strategic Media at the University of Arkansas, Outini believes that blind audience members like her can intuit plenty of content without audio description as long as there is a rich, contextual soundtrack. Outini uses as an example the multi-media documentary 'Half the Sky: Turning Oppression into Opportunity for Women Worldwide' (PBS, 2012) inspired by the Nicolas Kristof and Sheryl WuDunn book of the same name. She recalls a scene by the ocean:

> "I didn't need someone to tell me they are driving next to the ocean, because I could hear it. He was interviewing them in the car with the windows open. The sound quality was just great. I didn't need audio description to tell me where they were."

She also doesn't appreciate audio description that does not propel the story. Ultimately, she believes—as we do—that sound communicates a deep level of the story without words. Outini puts it quite simply: "If you are telling the story without sound, you are killing storytelling."

CAPTIONING AND ACCESS FOR DEAF AND HEARING IMPAIRED AUDIENCES

According to the World Health Organization, we know that 360 million people worldwide have moderate to profound hearing loss. This number includes 36 million American adults. That's almost 1 out of 10 who have some degree of hearing loss. So again, a significant audience for your content. The solution for this audience has been to provide captions. (There is some content that is signed, but given the vast number of different signing languages and the cost of inserting signers, this content is somewhat limited. For more on this, see the Resources section at the end of the book) (Figure 11.1).

The deaf and hard of hearing community first made inroads in captioning for feature films with the Captioned Film Act of 1958. It took more than a decade for the emergence of the First National Conference on Television for the Hearing Impaired in 1971, where two possible technologies for captioning television programs debuted. Both technologies displayed the captions only on specially equipped sets for deaf and hard-of-hearing viewers. Another demonstration of closed captioning followed at Gallaudet College (now Gallaudet University) on February 15, 1972. ABC and the National Bureau of Standards presented closed captions embedded within the normal broadcast of "Mod Squad." This fantastic achievement proved the technical viability of closed captioning.

FIGURE 11.1 Captioning makes your video more widely accessible.

Since that time, captioning has come a long way. In fact, these days hearing audiences also consume a large amount of captioned content. Facebook claims that 85% of its videos are viewed without sound (at least the first time through). All NLEs now provide an easy way to upload captions during the editing process. YouTube supports uploading captions you have created or can generated them using AI. Machine learning is pushing AI-created captions forward by leaps and bounds, making them more accurate. Today's NLEs include captioning as part of their features. Web hosting platforms also offer captioning options.

Post production expert Katie Hinsen wrote an excellent deep dive on accessibility on the Frame.io blog which I highly recommend. Called *Design for the Edges: Video for the Blind and Deaf* (September 4, 2018), the article highlights both the care and workflow required to put audiences truly on an equal footing and notes new tools that are making the creation of accessible content more affordable for content creators. These include Amara, which crowdsources captioning and translation, and Subtitle Edit, a free online tool for creating caption files. Further, AI-enhanced caption automating tools are now being incorporated into video hosting platforms, such as Brightcove.

PERSPECTIVES ON CAPTIONING FROM DEAF AUDIENCES

While television has made significant advances and most programming are now captioned, watching films in a theatre setting still creates obstacles for deaf and hard-of-hearing audience members. Dolby has created the CaptiView system, a captioning device that fits into a cupholder (Figure 11.2). And Sony has created a set of glasses that provides captioning in the field of view. But it is up to theatre owners to purchase and maintain these devices. According to patrons who use them, they often do not. As a result, many in the deaf community have been pressing for open captioning for all feature films. John Stanton, a board member of the Alexander Graham Bell Association for the Deaf and Hard of Hearing, gave me feedback on his personal experiences as a media consumer. John explained a typical problem he had on a recent visit to see the new Spider Man movie:

> "I had to throw my winter coat over the gooseneck [screen-holder] to keep it in place for me to read the caption box. Naturally, I told this to the guy at guest services when the movie was over. He didn't look like he gave a..."

FIGURE 11.2 CaptiView system in a movie theater (courtesy: Bozeman Daily Chronicle, Rachel Leathe, Photographer).

One of the top places for nonfiction content viewing is airline flights, so cutting off a large portion of the audience should concern us as nonfiction filmmakers. Thanks to efforts by travelling customers and many organizations across the disability community, accessibility of content on airlines has made some significant advances in the last few years. In 2016, the U.S. Department of Transportation established an Advisory Committee on Accessible Air Transportation. The resulting agreement made several important changes that affect customers, and those producing content that will be used on aircraft in-flight entertainment systems. Now, 100% of this content must be both audio described and captioned. In addition, the airlines' in-flight entertainment systems must be capable of supporting both closed captions and audio descriptions. If they cannot provide these systems, for example on older aircraft, then airlines must offer an alternative accessible entertainment device. In addition, airlines must offer accessible Wi-Fi for blind and visually impaired passengers to ensure that cabin announcements can be understood by all.

Captioning has not solved all problems for the deaf community. When I interviewed John Stanton about his feedback as a deaf consumer of media content, one of his concerns was that films containing music with lyrics stop captioning as soon as any singing starts—in effect, cutting off

the "sound" for the deaf viewers for large chunks of movies, particularly musicals, and any television shows in which the plot is often supported through pop song lyrics in the soundtrack. This makes watching a disrupted experience, at best. The argument from studios has been that they do not have the proper license to caption the lyrics. You can read John's impassioned legal argument against this practice in his article published in the UCLA Entertainment Law Review (2015) "Why Movie and Television Producers Should Stop Using Copyright as an Excuse Not to Caption Song Lyrics." For your own productions, you will make your decisions on how and when to caption. But now that John Stanton and others have raised my awareness, I will be much more sensitive to my captioning choices.

THE CAPTIONING PROCESS

We've been talking about captions from an audience perspective. Now let's take a look at captioning from the filmmaker point of view. Dave Evans, who owns Tempo Media in Tucson, Arizona, gave me some insights on the process. His company handles both captioning and some re-editing and translation services as well. Dave noted there are certain types of nonfiction content that make captioning easier to do than others. For example, when you simply have a talking head on camera, it is easier to sync up the captions and even use AI tools to do it. But when there are sound effects or other audio tracks to consider—and we hope there are, if you agree with our philosophy in this book—then more finesse is required. When working to caption film productions, he is mindful of not getting ahead of the plot, or putting too much verbiage on the screen at the same time. This is called the "presentation rate," and while some captioning software will tell you that it is getting too high, it doesn't tell you how to solve the problem. Solving pacing issues is one of the top challenges that Dave manages when captioning. Another issue is placement. So before filming, consider how your composition will appear once captions are added. If you are shooting an interview, do you need to frame extremely tight? Where will names and subtitles go? One of the reasons I like to shoot in 4K or 4K UHD is to have extra screen space for re-cropping or adjusting as needed for titling or captions. This only works, of course, if you are delivering in 2K or less. For most of my nonprofit clients, this is a sufficient delivery spec. Shooting in 4K gives us the added bonus of a higher resolution format for future-proofing.

MAKING FOREIGN LANGUAGE TRANSLATIONS

Foreign language translations are essential for many productions. When working on certain kinds of content, such as training content for multinational corporations or educational content for organizations reaching immigrants with a primary language different from that of the original program, you will need translation services. This means planning ahead in three key areas. First, you will need to make sure your workflow includes creating an accurate script of the final version of your project. I call this the "as aired" script, as opposed to the many different rough cut and fine cut versions that may have preceded it. And I recommend putting a PDF version of this script into your export folder as well as a documents folder that is part of your project files on your NLE. Sometimes translated or captioned versions are created many weeks, months, or even years after the initial project release, so it's helpful to have this file easily accessible to someone accessing your project editing files (Figure 11.3).

Second, you will want to think about any on-screen text. If you have a lot of text, consider breaking it up so that it is not too dense, making translation and insertion into the same space difficult. Dave Evans' experience confirms this: "We do a lot of on screen text replacement, for example replacing all the English bullet points on screen with bullet points in Portuguese, which takes up more space on screen." He also sometimes has to match a wipe to bring on a lower third name, and will have to mask the original wipe unless

FIGURE 11.3 Most NLEs have a subtitling tool (labeled sub caption).

he is provided with the project folders and files. So ideally, you will want to make those original files available to your translation and captioning agency so they have clean material to work with.

Finally, think about your pacing. We spoke at the outset of this chapter on how shot length and edit pacing can affect your ability to deliver effective versions that are audio-described, dubbed, or captioned. In the area of translations, remember that many languages have differing lengths from one another when delivering the same sentence or information. Michael Collins of Glenwood Sound, who provides translation, voiceover, and dubbing services, known as "media localization," explains that romance languages run 10%–15% longer than English, some Scandinavian languages can run shorter, and German can have a similar length, but higher syllable count than English. While he often is only able to work with the film as it is delivered, in some cases he needs the right to edit the film in order to make the overdubbing work for the film and audience. Remember that when hiring talent to voice your film in another language, you will want to consider regional accents and syntax differences. A Spanish-speaking voiceover with a Honduran accent would not necessarily be well received by Spanish-speaking audiences viewing your production in Spain.

If you are thinking about dubbing your film translation rather than captioning, consider which of the three types of dubbing would best suit your project:

1. Lip Sync—Used for scenes with dialogue, and therefore most commonly used for fiction films, this type of dubbing is the most nuanced and complex. It requires syllable-matching, and is done sentence by sentence by the voiceover artist you select. They might even have to memorize lines and try to match it with what is on screen. As you might expect, this type of dubbing can be expensive. Big Hollywood movies and large-release documentaries will spend the money to be sure every lip movement is matched with what is known as "theatrical" dubbing. A less precise version of lip sync dubbing called "modified" means the talent won't match every syllable, but will at least try to make the sentences all start and stop together.

2. United Nations-Style—In this type of dubbing, you hear a second or two of the original language; for example, in the first few words of an interview, and then you hear the voice speaking the translation.

This type of dubbing is ideal for documentary, because it gives the audience the sense of the real person on camera.

3. Timed Narration—For narrated productions, a narrator reading a translation will follow the video, the timecode on her script, or a combination. She establishes a rhythm that roughly follows the pacing of the original language and tries to align the content as well as possible with the footage on screen.

COSTS

There are a range of costs associated with audio description, captioning, and translations. Let's start with audio description. Some audio description services charge by the minute—at the time of publication, the rate was around $20/minute. Dr. Snyder's company charges a minimum base rate of $350 for 10 minutes or less of content. This fee covers writing, voicing (he does his own, typically), recording, editing, layback, and delivery in any format. So, a one-hour documentary could cost you about $1,100. When you consider the millions of additional possible viewers, that isn't a bad rate. But it is something you need to include in your budget at the start of production.

Language translation services generally charge by the word of the originating language. So, if your "as aired" script is 10,000 words, at a rate of approximately 10–20 cents per word that would run you $1,000–2,000. You will also pay a talent fee, and sometimes a recording fee, for someone to dub your production. For non-sync recording, talent typically charges by the word. For sync recording, talent will charge a per minute base rate. $75 per minute is standard in the United States.

More producers are using built-in captioning features of many NLEs or using AI tools, such as the one built into YouTube's uploader. Just be mindful that these captions may be inaccurate and incorrectly placed for a quality viewing experience. If you pay a service for captioning, the fees can range from $1 to $15 per minute, depending on if they need to do any significant on-screen text masking and replacement or even reediting to accommodate the titles. If you plan to handle your own captioning, remember that captions must be accurate to pass muster with the FCC, Described and Captioned Media Program (DCMP), and Web Content Accessibility Guidelines (WCAG).

Tips for Accessibility

▶ More than 1.6 billion people worldwide have visual impairment or hearing loss. Making our content more accessible through audio description and captioning is imperative.

▶ Remember that it takes time to audio describe scenes, so whenever possible, edit scenes with some "space" and consider adding a few beats of silence. It will help the story overall, and assist with the audio description process.

▶ Captioning is a multi-part process, starting with an accurate script. Remember that captions should include sounds, such as sound effects and sync sounds, not just spoken dialogue and narration.

▶ Consider your framing when shooting so that you have space for captions once you get into your edit.

▶ Always play through audio described and captioned content to check for accuracy and to be sure you are not letting the descriptions or captions "get ahead" of the story. You want the experience to be equally good for all audiences.

Glossary

AAF

Advanced Authoring Format is a digital file format used to allow cross-platform exchange in professional video post-production.

AIFF

Audio Interchange File Format is a standard audio file format used in most computers. It is a lossless, or uncompressed format developed by Apple in 1988 and is pulse code modulation (PCM) format. It does not carry time-code metadata, but can contain an embedded sync point to be used in programming loops for music or sound design. There is a compressed version called AIFF-C or AIFFC, which should not be confused with and used instead of AIFFs, especially in professional productions.

Ambisonic

Ambisonic audio is fully 360 spherical sound. First Order ambisonic audio carries 4 channels of audio information for w, x, y, and z or the omni, left to right, front to back, and height. Higher level of ambisonics carry more channels and greater detail of the x, y, and z channels.

ASCAP

The American Society of Composers, Authors, and Publishers is a nonprofit Performing Rights Organization (PRO) of songwriters, composers, and music publishers that manages royalties, among other services for its members.

Audio post

Audio post refers to the audio finishing process that occurs in post-production. Post production refers to the stage after the actual shooting of the production is finished, and typically after video editing has taken place. Audio post can include sound edit, sound design, and final mix.

Binaural

Binaural audio is two channels, but not stereo. It replicates how we hear sound all around us with our two ears.

BMI

Broadcast Music, Inc. is a Performing Rights Organization (PRO) representing music composers, songwriters, and publishers, and handles royalties, among other roles.

B-Roll

Video footage or stills that is rolled under a primary story line to support what the audio is portraying, usually narration or interview.

DAW

Digital Audio Workstation is a digital audio recording, editing, and mixing system that is usually computer based and is non-linear and non-destructive (meaning, it prevents generation loss of the material during the edit). Popular formats include Avid Pro Tools, Adobe Audition, and Steinberg Nuendo.

Decibel

Decibel, or dB, is a unit of measurement of the energy of audio. There are many different methods of measuring, especially between analog vs. digital. For instance, dBvu is decibel measured in volume unit which is analog and dBFS, is decibel full scale which is decibels measuring in digital full scale.

Dolby Atmos®

An object-based sound mixing software and delivery format.

DP

Director of Photography.

Dynamic range

The range of volume from the softest to the loudest. For example, an orchestral piece usually has greater dynamic range then a pop rock tune. Theatrical

Mixes have greater dynamic ranges then television programming. Dynamic range in media is most seen in the voice. Voice heavy documentaries have less dynamic range then show specials of concerts.

EDL

Edit Decision List. A text, csv, or excel sheet that contains all the video and audio edit decisions in a list fashion. Search and filter functions are often used. EDLs are often plugged into other software for conforms and online.

EQ

Equalization. The boosting or attenuation of frequencies enhancing the sound quality.

Foley

Foley is the art of performing or recreating sound effects to picture that are recorded to enhance or replace the original effects of a sound track. Jack Foley, working for Universal, had radio experience and volunteered to help turn the silent film *Show Boat*, not yet released, into a musical. His ability to perform and recreate everyday sounds for the film started the art of Foley. Foley used to be reserved for everyday sounds that could be blended into the sound track. Today Foley often takes on larger roles as sounds are created, recorded, and designed for special roles in films, such as *Star Wars'* R2D2, created by Ben Burtt.

FPS

Frames per second.

Hertz

Hertz or Hz is the standard unit of measurement for sound where one cycle of sound equals one second. So 1 Hz is one cycle per second, where 1,000 cycles per second is 1,000 Hz. Hertz often refers to frequency or pitch.

International System of Units (SI)

SI is an international system of standard scientific measurements. There are seven base units from which other units of measurements are based

on: meter for length, second for time, Ampere for electric current, Kelvin for temperature, candela for luminous intensity (brightness), and mole for amount of substance.

Linear PCM Recorder

PCM or Pulse Code Modulation refers to the analog to digital conversion of analog audio that includes the sound wave in three steps: sampling, quantization, and coding. PCM is binary and lossless. A linear PCM recorder makes analog audio digital in the order in which it is received in to the recorder. A WAV file is an example of PCM audio. A zoom recorder is a good example of a linear PCM recorder.

LFE

Low Frequency Effects is a dedicated audio channel to carry frequencies usually from 3 to 120 Hz with 80 Hz being a common crossover point. The channel is fed to a speaker called the sub-woofer, or sub, which is designed to replicate those low frequencies.

LUT

Look Up Table refers to a precise set of numbers that allow an editing system to convert one set of RGB values to another, thus changing the hue, saturation or brightness of the original footage. LUTs are often camera-specific sets of information so that footage decodes correctly. They can also be used to simulate film stocks and allow for the communication of color and tone decisions between different post-production tools.

LTO

Linear Tape Open is a magnetic tape technology typically used for data back-up. When introduced in 2000 one "tape" could hold 100 GB, now the equivalent tape for LTO 8 can contain 12 TB of data. LTO tapes are known for their long-lasting durability and encryption.

Metadata

Metadata is data that provides information about other data. Often metadata is embedded into the file itself. For instance, an audio file recorded properly on set can have timecode, character name, mic, and scene and take information all embedded into the file as metadata.

MPEG

An international standard for compressing and transmitting audio and video images, set by the Moving Picture Experts Group (MPEG).

mp3

A coding format for digital audio. Originally part of the MPEG-1 standard, it was upgraded to support more audio channels for the MPEG-2 standard.

NLE

Non-Linear Editing system. Digital editing systems that are computer rather than tape based, allowing for non-destructive editing in non-sequential order. Popular NLE platforms include AVID's Media Composer, Adobe's Premiere Pro, DaVinci Resolve from Blackmagic Design, and Apple's Final Cut Pro.

NTSC

NTSC refers to the National Television System Committee. NTSC as a format refers to the analog color system used primarily in the United States from 1953 to roughly 2011, when digital transmission took over. It is based on 29.97 frames per second for content under 60 seconds and 29.97 DF (every minute ending in zero drops two frames). The NTSC was established in 1940 to help control and develop standards for black and white television broadcasts and was refreshed in 1950 when color was introduced. Instant fighting and drama between manufacturers caused all color broadcasts to be banned, under the guise of defense during the Korean War by the Department of Defense. Finally, in 1953 the NTSC was approved for analog color transmissions and was phased out for the ATSC and digital transmission in 2011.

OMF

Open Media Framework. Sometimes known as OMFI or Open Media Framework Interchange. A platform independent file format that allows the transfer of digital media between different video, audio, and image editing systems. For example, OMF is often used to replicate audio tracks from an NLE timeline in a DAW.

OTT

OTT refers to *Over the Top*, meaning those media content distributors that stream content over the internet and not through the broadcast system. Netflix is an example of an OTT network.

Picture lock

When the picture is approved and no more editorial changes will be made to the images or length. Footage and images are often conformed or swapped out after picture lock for identical high-resolution files, but editorial remains the same.

Primary Audio

Sound that is considered essential to the story and is primary to the story. For example, an interview sound byte over on camera audio of b-roll. Both are important, but one tells the story and is critical to the message and the other reinforces the story.

PRO

Performing Rights Organizations represent music composers and copyright holders. The largest PROs are ASCAP, BMI, and SESAC.

RAID

Redundant Array of Independent Disks is a data storage technology that uses drives and drive partitions to create logical units. RAID technology automatically duplicates data across the units in a way that protects against loss if a drive fails. There are different levels of RAID providing different levels of protection. A common choice is RAID 5 because of speed and redundancy.

RAW

Footage that is unprocessed data from a camera's image sensor, and must be converted into video for viewing. Shooting RAW allows for high image quality as well as flexibility in post-production, where one can add color grading to a project's specific requirements.

RF Interference

RF Interference, also called RFI, is caused when there is a disturbance in the radio spectrum of frequencies. These disturbances are caused by electromagnetic radiation or electrostatic. All electronic devices cause some electromagnetic radiation or noise. Today, RF or RFI is also called EMI or electromagnetic interference. That buzzing noise on your cellphone or in your recording can be avoided by using RF detection software or data flagging software or by switching frequencies. Because of the proliferation of personal electronic devices, such as smartphones, the government has started regulating how much electromagnetic radiation can be released from electronics.

Sample Rate

The rate in which a sound wave is sampled during recording in order to convert it from analog to digital audio.

SAP

Second Audio Program or Secondary Audio Program is an auxiliary audio program or channel that is used to carry alternative language choices or descriptive audio for video. Because the SAP usually carries Spanish in English-speaking programming, it is often erroneously referred to as "Spanish Audio Program."

SESAC

Formerly the Society of European Stage Authors and Composers, this Performing Rights Organization (PRO) manages royalties for its members. It has simply used the letters as its name since 1940.

Sound Imaging

Sound image is how the sound is placed and played back spatially. When capturing sound attention to sound image, not just the signal is crucial. When sound is placed spatially, its perceived placement, movement, and depth is the sound image. A car going from left to right on screen has a sound of car going by from left to right to match. The image of that sound coming from a distance and travelling across us and leaving to the right is

matched with that sound. As the sound travels it becomes louder and fuller as well as travelling closer to us and then passes by and gets softer and less full as it travels into the distance. This is more of an example of imaging for a stereo mix (immersive audio has more information in it) but the same principals follow through. Since we listen with our ears in the space, the placement of the speakers and our bodies/ears effect sound image. The optimal location for our ears when listening to sound in regards to imaging is the "sweet spot." In some instances the sweet spot is extremely tight and even the slightest nod of our head can color and change the sound.

Sound Blankets

Large blankets that are made out of thick sound absorbing material and used to deaden sound.

Stem

A Stem is an audio file that contains a specific element that, combined with other stems, can reconstitute the full mix. Stems can be made for an entire soundtrack, just one music cue, or a particular audio element such as the voiceover track. Stems can also refer to files that combine mixed sound elements, such as a stem for the music and effects track, known as "M and E." Music Stems are essential to sound mixing, because they allow mixers to isolate elements that might interfere with one another, to make the best possible audio mix. Stems are typically required deliverables for any final mix.

Storyboard

An illustration or sketch of how a video may progress according to the script and intent of the story, to better understand the flow of story for the shoot and creative decisions. More often used in short form.

TRT or Total Run Time

The total length of a piece from first frame to last frame, not including academy leader, 2 pop, or End Pop.

Verité

In its purest form, verité documentaries are observational, without commentary from a narrator. The idea is for the film to be "truth." The range of

approaches for modern documentary films and docu-style productions is broad, and beyond the scope of this book. Here, we use "verité" to mean any approach that brings the audience into a real-world story or situation.

Walla

Sounds layered to imitate the murmur of a crowd in the background.

WAV

Developed by Microsoft and IBM and introduced in 1991 but is used across all computer formats today. Pronounced wave, it's a linear Pulse Code Modulation format and is a lossless codec. BWAV (Broadcast WAV) is preferred in media as it contains timecode metadata. Higher resolution WAV files now support multichannel files, such as 5.1.

Wild Sound

Wild Sound is sound that is recorded wild, or not in sync with camera footage on location or in the field. Wild sound is used to enhance sound design for a piece, especially for ambiances. Capturing wild sound is often overlooked but is one of the best ways to improve sound design and ensure authenticity.

Resources

CHAPTER 5 – VOICEOVER NARRATION AND STORY

SAG-AFTRA rates https://globalvoiceacademy.com/sag-aftra-rates/

CHAPTER 8 – MUSIC LICENSING

US Copyright Office: https://www.copyright.gov/help/faq/index.html

Fair Use Best Practices: http://cmsimpact.org/codes-of-best-practices/ and http://cmsimpact.org/code/documentary-filmmakers-statement-of-best-practices-in-fair-use/

A Handy Checklist for Fair Use: https://copyright.cornell.edu/sites/default/files/Fair_Use_Checklist.pdf

An Article on the Tom Waits – Frito Lay Case: https://www.nytimes.com/1993/01/20/business/singer-wins-frito-lay-case.html

An Article on the Bette Midler rights of publicity case: http://articles.latimes.com/1992-03-24/entertainment/ca-4461_1_supreme-court

Rights Clearing Agents and Audio Agencies:

- ▶ www.rightsworkshop.com

- ▶ www.diamondtime.net

- ▶ www.themusicbridge.com/

- ▶ rightsflow.com/

- ▶ www.songclearance.com/

- ▶ www.jinglepunks.com/

- ▶ www.rumblefish.com/

Information on Licensing for Films in Festivals:

www.bmi.com/licensing/entry/festivals

www.ascap.com/music-users/licensefinder

Performing Rights Organizations:

American Society of Composers, Authors and Publishers (ASCAP): https://www.ascap.com

Broadcast Music, Inc. (BMI): https://www.bmi.com

SESAC (SESAC): https://www.sesac.com/

Other Helpful links:

http://entertainment.howstuffworks.com/music-licensing6.htm

https://www.pdinfo.com/

http://www.pdmusic.org/

http://www.ascap.com/licensing/termsdefined.html

https://www.ascap.com/help/ascap-licensing

Additional Licensing resources:

https://cdbaby.com/license-cover-song.aspx

https://www.easysonglicensing.com/default.aspx

https://www.sagaftra.org/production-center/contract/806/ getting-started

CHAPTER 9 – MUSIC SCORING

An excellent overview of music from Arab countries exists at: https://al-bab.com/music-section/arab-music-introduction

South American music samples are available here: https://musicedmasters.kent.edu/music-from-world-cultures-south-america/

This children's educational site does a good job of giving an overview of African styles and genres: https://www.allaroundthisworld.com/learn/africa-2/kinds-of-african-music/

This "getting to know the orchestra" clip from the Portland Youth Philharmonic is a helpful introduction to the sounds of western orchestral instruments: https://www.youtube.com/watch?v=Sr-l2m8twX0

The podcast interview with James Gunn regarding his Guardians of the Galaxy scoring process can be found here: https://www.kcrw.com/news-culture/shows/the-treatment/james-gunn-guardians-of-the-galaxy

CHAPTER 10 – IMMERSIVE SOUND

White papers and other useful information on spatial audio:

https://facebook360.fb.com/spatial-workstation/

https://www.iis.fraunhofer.de/content/dam/iis/en/doc/ame/
Conference-Paper/BleidtR_SMPTE2014_Object-Based_Audio.pdf

https://www.techradar.com/news/first-look-sony-360-reality-audio

http://www2.iis.fraunhofer.de/mpeghaa/papers/AES137_MPEG-H_
v14_final.pdf

https://en-us.sennheiser.com/microphone-3d-audio-ambeo-vr-mic

https://www.roadtovr.com/sennheiser-magic-leap-unveil-ambeo-ar-
one-spatial-audio-headphones/

http://www.speech.kth.se/prod/publications/files/1663.pdf

CHAPTER 11 – ACCESSIBILITY

Youtube Captioning Hack with Michael Kammus: https://youtu.be/9nPH0 EHXUhs

The American Council of the Blind keeps track of content being audio described and available through Amazon and Netflix – see our resources for the links at: http://www.acb.org/adp/amazonad.html and http://www.acb.org/adp/netflixad.html respectively.

"Why Movie and Television Producers Should Stop Using Copyright as an Excuse Not to Caption Song Lyrics" by John Stanton, UCLA Entertainment Law Review (2015): https://escholarship.org/content/qt4bd4n43d/qt4bd4n43d.pdf

For more excellent background on making videos accessible, we refer you to our industry colleague and thought leader Katie Hinsen, who researched this thoughtful article on this subject: https://blog.frame.io/2018/09/04/creating-video-for-blind-and-deaf/

Examples of videos with audio described by Dr. Joel Snyder:

The Color of Paradise: https://www.youtube.com/watch?v=l9RFTKxZqkw&t=23s

The Empire Strikes Back: https://vimeo.com/304897720

2015 Obama Video Christmas Card: https://www.youtube.com/watch?v=ywLWxuq3ozA&t=7s

Night of the Living Dead: https://www.youtube.com/watch?v=7huY40uBajc&t=5s

"Lost Dog"-Budweiser Super Bowl commercial: https://www.youtube.com/watch?v=CNrmcB6rgew

"Shakira"-Activa Super Bowl commercial: https://vimeo.com/289315160

Popeye cartoon: https://vimeo.com/304908457

Chase Bank: https://www.youtube.com/watch?v=uedv0STU4x4

Other useful links and websites:

http://www.ncicap.org/about-us/history-of-closed-captioning/
(National Captioning Institute)

https://www.afb.org/default.aspx

http://www.acb.org/adp

http://www.ncicap.org/

https://www.nad.org/

https://dpan.tv/

http://www.johnlubotsky.com/deafcinema/

https://www.nad.org/2010/12/28/
historic-nad-film-selected-for-preservation-by-library-of-congress/

https://www.amazon.co.uk/Hollywood-Speaks-Deafness-
Entertainment-Industry/dp/0252068505/ref=sr_1_
1/026-5247461-1693218?ie=UTF8&s=books&
qid=1190845188&sr=8-1

Note: Links were active at time of publication.

Bibliography

Hinsen, Katie. "Design for the Edges: Video for the Blind and Deaf," Frame.io Insider Blog (September 4, 2018) https://blog.frame.io/2018/09/04/creating-video-for-blind-and-deaf/

Rose, Jay. *Producing Great Sound for Film and Video* (Focal Press, 2015)

Snyder, Joel, PhD. "The Visual Made Verbal: A Comprehensive Training Manual and Guide to the History and Applications of Audio Description" (American Council of the Blind)

Stanton, John. "Why Movie and Television Producers Should Stop Using Copyright as an Excuse Not to Caption Song Lyrics", UCLA Entertainment Law Review (2015) https://escholarship.org/content/qt4bd4n43d/qt4bd4n43d.pdf

Viers, Ric. *Location Sound Bible: How to Record Professional Dialog for Film and TV* (Michael Weise, 2012).

Filmography

Beat the Street, Directed by Leon van Oord, Produced for Samsung Benelux / Cheil (2016) http://wemakevr.com/beat-the-street/

Du Velger Selv/It's Up to You, Directed by Kajsa Næss, produced by Lise Fearnley, sound design by Svenn Jacobsen (2013) https://vimeo.com/221229907

The Girl Effect, Produced by Nike Foundation (score by Elias Arts founder/composer Jonathan Elias and composer/recording engineer Nate Morgan, 2001)

JFK, Directed by Oliver Stone (Warner Brothers, 1991)

Let the Fire Burn, Directed by Jason Osder, School of Media and Public Affairs, George Washington University, PBS Independent Lens, (2014) www.youtube.com/watch?v=lSPQ66mu5Y0

Moving Stories, Directed by Rob Fruchtman and produced by Cornelia Ravenal, Mikael Södersten, and Wendy Sax (2019)

Saving Sea Turtles, Co-directed and produced by Jenny Ting and Michele Gomes (2019)

Scattering CJ, Directed by Andrea Kalin, Produced by David Lobatto, Spark Media, (not yet released)

Voices/Peace, Directed and produced by Amy DeLouise, released by Presbyterians for Middle East Peace (2012) https://vimeo.com/45073933

Index

Note: **Bold** page numbers refer to tables; *italic* page numbers refer to figures.